D0635870

The Apostle Bas-Relief at Saint-Denis

Sumner McK. Crosby

New Haven and London, Yale University Press

1972

NB
543
C7

Copyright © 1972 by Yale University.
All rights reserved. This book may not be
reproduced, in whole or in part, in any form
(except by reviewers for the public press),
without written permission from the publishers.

Library of Congress catalog card number: 71–179471
International standard book number: 0–300–01504–6

Designed by John O. C. McCrillis
and set in Baskerville type.
Printed in the United States of America by
Connecticut Printers, Inc., Hartford, Connecticut.

Distributed in Great Britain, Europe, and Africa by
Yale University Press, Ltd., London; in Canada by
McGill-Queen's University Press, Montreal; in Latin America
by Kaiman & Polon, Inc., New York City; in India by
UBS Publishers' Distributors Pvt., Ltd., Delhi; in Japan by
John Weatherhill, Inc., Tokyo.

Yale Publications in the History of Art, 21

Vincent Scully, Editor

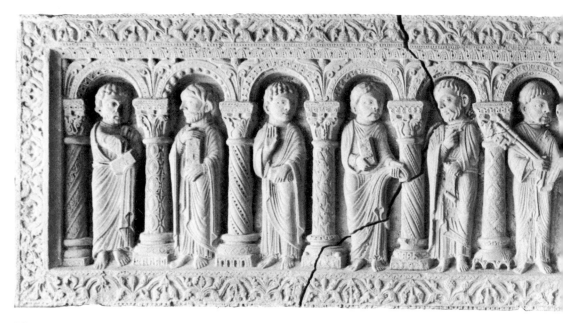

The apostle bas-relief at Saint-Denis, 1141–43

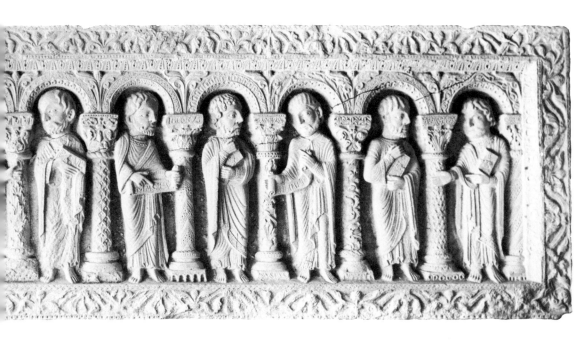

Foreword

One must have seen Sumner Crosby at Saint-Denis fully to comprehend the relationship between a scholar and a monument whose study has been his life work. As he looks at the statues on the portals, his eye follows on the stone the precise line that divides the medieval sculpture from the restorations; as he wanders beneath the pavement through a sort of Cyclopaean chaos, his torch points out and dissociates, with equal ease, the remnants of the fifth-century church, the Merovingian, the Carolingian foundations . . . Such familiarity is of course the basis for Crosby's unrivalled authority as a historian of the royal abbey; it is also the sign of a personal attachment.

This long and intimate devotion deserved a reward. It came when in the course of Crosby's tireless excavations an extraordinary piece of twelfth-century sculpture came to light, both enchanting and puzzling. The place and the position in which it was found, its original destination, its provenance, the fact that it has been left incomplete confronted the mind with so many riddles. No one was better equipped to meet the challenge than Crosby himself. The present book relates the discovery; it then deals with the gradual unravelling of the problems, and offers their final solution.

As a piece of scholarly detection, it is exemplary. It illustrates the necessity for the patient following of various lines of investigation until the right one emerges. It exhibits the way in which one should combine written and physical evidence; from some texts of Suger, for instance, Crosby deduces the intended use of the bas-relief, and the reasons for its ultimate discard, while a thorough and perceptive analysis of its stylistic features yields solid data upon the origin of

55279

the artist, and his training. At every turn, a vast store of erudition is exploited to provide historical prototypes and geographical recurrences; once the bas-relief is set in its proper context through precise comparisons, everywhere supported by illustrative material, it remains to define its unique quality. Attention now focuses on the variations from the norm: the peculiarities of technique and iconography, the unusual detail, the favourite motif, the deliberate inconsistencies finally mark out the individual.

Such intense concentration on a single object does not narrow down the significance of the study. In that respect also, Crosby's monograph provides a model, and teaches a lesson; for in the end not only has an enigma been solved: new light has been thrown on such major problems as Suger's personal role in the decoration of the abbey; and the famous formula, "Saint-Denis, cradle of Gothic art," has acquired new shades of meaning.

The supreme merit of a learned book is perhaps to give the reader a sense of participation. This is precisely what we experience as we follow Crosby, step by step, in his masterly enquiry: we share in the quest, in the discovery, and in the elucidation.

JEAN SEZNEC

Preface

The apostle bas-relief, now displayed as a retable in the chapel of
Saint Osmana in the choir of the onetime royal abbey church of
Saint-Denis* just north of Paris, was, as the early pages of this book
will describe, an unexpected discovery (Frontispiece, Fig. 9). Such
dividends, of course, are the goads that motivate all archaeologists,
who often complain that their excavations complicate or confuse
problems rather than provide lucid solutions. Many discoveries
attract attention because of their novelty, but only a few demand
intensive study because of their visual fascination and because of
their unexpected significance in an important moment in the his-
tory of art. The apostle bas-relief claims attention on all counts.

In the twenty-five years since we lifted the stone slab from the
sarcophagus and discovered its astonishing and richly carved un-
derside, I have frequently shown the photographs and drawings
that are published here for the first time. To list all my friends and
colleagues from whose enthusiastic counsel this monograph has
benefited would prolong this preface beyond reason. I extend my
especial gratitude to Jurgis and Helen Baltrušaitis who nurtured
my initial thoughts and encouraged me to present the first report
on the discovery to the Académie des Inscriptions et Belles-Lettres in
Paris. François Bucher, Louis Grodecki, and Philippe Verdier con-
tinue to send me hints and suggestions relevant to this study. As
graduate students Margaret Collier, Amy Vandersall, and Philip
Lozinski struggled with numerous perplexing details and made
many provocative observations. Again I wish to express my respect

* Saint-Denis will always refer to the abbey, Saint Denis (without the hyphen) to the
man, and St.-Denis to the village.

and appreciation to the officials of the Ministère des Monuments Historiques, who granted the permission to excavate in the abbey church, and to Monsieur le Chanoine Levavasseur, former curé of the basilica, whose patience my work extended so often and so sorely. During the winter of 1955 the relief underwent repairs at the restorer, Chez André, in Paris. At that time Alain Jobert executed the exquisite drawings of every detail of the decoration. Many other municipal officials and curators of museums, particularly in Liège, Belgium, and in Paris, gave me permission to examine and photograph objects. To them I remain deeply indebted. Pamela Blum, my research associate, deserves credit for any felicity of phrase in the ensuing text and for endless hours spent tracking down details and verifying all references. To Sarah, my wife, who operated the movie camera as we removed the bas-relief from its sarcophagus, and who has commented constructively on the different drafts and versions of everything I have written, my humble and loving thanks.

New Haven S. McK. C.
June 1971

Contents

List of Illustrations

All photographs without a credit line are by the author. Text figures will be found on pages 27, 29, 54, and 76. Figs. E, F, and N are del. Fred Bland; the others are after Alain Jobert.

Introduction

... S(an)c(t)i domni Dioni[nsis p]eculiares p[atroni n]os[tri]. ...

"Saint Denis, our particular patron"—as early as 625 A.D., on the original papyrus of the first Frankish royal charter extant, Clothaire II used these words to show his special esteem for the first bishop of Paris and for the abbey dedicated to him.[1] This privileged position of the saint in the early Middle Ages continued throughout the long history of the French monarchy, and identified Saint-Denis as a royal abbey, one of the most powerful monasteries in medieval France.

Dioninsis, or Dionysius, translated into French as Denis, appears at the head of the list of the bishops of Paris.[2] In his famous *Historia Francorum* Gregory of Tours also described him as the first bishop of Paris sent from Rome to "end this present life under the sword" during the reign of the Emperor Decius (250–51).[3] Scholars now accept this mid-third-century date for the martyrdom. On the basis of archaeological evidence, they also believe that he was buried in a Roman cemetery, north of Paris on the site of the present church in the industrial suburb of St.-Denis.[4]

When describing the general desolation of the region of Paris at the end of the fifth century, Saint Geneviève, the patron saint of the city, called the tomb of its first bishop a "horrible place" and encouraged the devout to build a chapel over his grave.[5] These early years remain obscure, but the small community evidently prospered. Between 565 and 570 Arnegonde, wife of Clothaire I, chose it as her burial place. Hers was the first in a long sequence of royal burials at Saint-Denis.[6] At approximately the same time the community offered a rich target for the soldiers of Sigebert, who

carried off a golden eucharistic dove, a bejeweled altar cloth, and at least two hundred pieces of gold money.[7]

The Merovingian kings of the seventh century assured the future prosperity of the abbey with privileges of immunity from taxation and from many feudal obligations, with gifts of land, and the right to hold an important fair and to profit from its revenues. These early rights remained the basis for Saint-Denis's wealth—rights renewed and expanded over the centuries as each new king took the throne. Dagobert, the son of Clothaire II, stands out among the early benefactors to such a degree that popular legends still acclaim him as the abbey's founder. About 630 he enlarged the early chapel into a basilican church and, having chosen Saint-Denis as his burial place, decorated it with "gold and gems and many precious ornaments."[8]

Under the Carolingians Saint-Denis became a royal abbey. Pepin the Short, who decided to replace the fading Merovingian dynasty —"les rois fainéants"—with new blood, received the crown from the hands of Pope Stephen II at Saint-Denis on July 28, 754. In 768, having returned to the abbey to die, he ordered his burial in the middle of the main entrance doorway. The coronation and the burial of King Pepin sealed the alliance of the abbey and the crown. From this time on the history of Saint-Denis related intimately with that of the royal family. Pepin's adviser and arch-chaplain, Fulrad, as abbot of Saint-Denis, directed the building of a new church dedicated on February 24, 775, in the presence of Charlemagne and his court. The solid foundations and skillfully built walls of this Carolingian church still testify to the importance of the revival in learning and the arts at that time.[9]

About 835 the monks of Saint-Denis, under the direction of their abbot, Hilduin, and at the command of King Louis the Pious, wrote the *Historia sancti Dionysii,* better known as the *Areopagitica.*[10] This text, with understandable enthusiasm, proclaimed the identity of Dionysius, the bishop of Paris, with Dionysius the Areop-

agite, considered at that time a disciple of Saint Paul and the author of the *Celestial Hierarchy*. This Greek manuscript described the hierarchies of the heavenly hosts and in Neoplatonic terms established light as a primary source for faith and inspiration. A Latin translation by John the Scot, about 870, established it as a major source for Christian theology during the rest of the Middle Ages. Its fame obviously reflected on that of the abbey of the same name. Abbot Hilduin's *Areopagitica* also enhanced the legend of Saint Denis by locating the place of his martyrdom on the slopes of Montmartre, a hill originally known as the Mons Martis, or mount of Mars, north of the Île de la Cité. The legend was further embellished by the invention of the miraculous achievement of the saint, who, after his beheading, bent forward to pick up his head and carried it from Montmartre to his burial place at St.-Denis. In 867 Charles the Bald, Charlemagne's grandson, assumed the title of lay abbot of Saint-Denis. This climax to the association of the abbey and the monarchy also brought with it the risks of absorption of the monastery into the royal fisc.

Recovery from the devastations of the Norman invasions and the eclipse of the Carolingian kings by the Ottonians of the Holy Roman Empire obscured the abbey in the tenth century. Although in retrospect the future seemed brighter with the election of Hugh Capet in 987, the Île de France remained a cultural wasteland during the eleventh century in comparison with the more flourishing duchies of Normandy and Aquitaine. Saint-Denis, however, survived. Recognized as a symbol of royal legitimacy, it became the traditional burial place of French kings and queens. After Hugh Capet, only three kings, Phillip I, Louis VII, and Louis XI, favored other locations.

About 1080 Saint-Denis, for some curious, as yet unknown reason, also received funds from William the Conqueror for the building of a large tower, an enhancement of the old Carolingian church.[11] Only ten years later, in 1090, the abbey accepted as an

oblate[12] a ten-year-old youth named Suger, of humble parents and modest stature, but destined to bring new renown and splendor to Saint-Denis.[13]

In the abbey school Suger became friends with Prince Louis, later Louis VI (the Fat), establishing a relationship that made him an intimate of the royal family and ultimately the trusted adviser of the king and of his son, Louis VII. In 1147 when the latter left on the ill-fated Second Crusade, Suger was appointed regent of France.

Elected abbot of Saint-Denis in 1122, Suger always dreamed of embellishing the church which had nurtured him, or even better of building a great new structure. This he began in the late 1130s, so that by 1140 a new western entrance with a splendid façade, including three richly decorated portals, could be dedicated on June 9. Only four years later another elaborate ceremony celebrated the completion of a new choir, including an "elegant and praise-worthy extension, in [the form of] a circular string of chapels, by virtue of which the whole [church] would shine with the wonderful and uninterrupted light of most sacred windows, pervading the interior beauty."[14] This new structure, the "cradle of Gothic architecture," received a number of elaborate decorations, among them the apostle bas-relief.

The genesis of this book dates back to early in the first year of my graduate study at Yale. In a seminar given by Marcel Aubert and Henri Focillon, the winter assignment focused on independent research of a topic selected from a prepared list. I chose "The so-called school of Saint-Denis in Carolingian miniature painting," not because of an interest in miniature painting or Saint-Denis, about which I knew nothing, but because of curiosity about the definition of a "so-called school." Instructions to my students today include caution about the naive selection of research topics. Entanglements may develop that can dominate a lifetime.

My research that winter resolved none of the problems about

Carolingian painting at Saint-Denis. The royal abbey did, however, become firmly embedded in my conscience, so that the many problems of its long history emerged as more and more provocative. As the Yale seminar progressed, we approached discussions of Gothic architecture. Once again Saint-Denis proved an ever-present hurdle. Almost every scholar concurred in recognizing Abbot Suger's twelfth-century church as the first Gothic structure, but none could document that claim. Rather brazenly I worked on Suger's church as a second-year project, which then developed into the subject for my doctoral dissertation, accepted at Yale for the Ph.D. in 1937. By then the need to find answers to the variety of questions formulated by the dissertation became an obsession. In 1938, with the official support of Professors Aubert and Focillon, I presented a request to the administration of the Monuments Historiques in Paris for permission to excavate. A sequence of excavations ultimately uncovered, in 1947, the apostle bas-relief described in the opening pages of this book.[15]

Initial excitement about the discovery led to a paper read before the august members of the Académie des Inscriptions et Belles-Lettres and, on my return to Yale in the autumn, to a few newspaper releases. The reactions in France were certainly enthusiastic but also included observations on the humiliation occasioned by an American having made such unexpected discoveries in a monument of great national interest. Nevertheless, I received permission to excavate through the summer of 1948. In 1953 my general summary of the history of the abbey and of its site appeared in Paris.[16] From then until 1961 departmental concerns at Yale and the editing of a survey of art history interrupted the intensive study of excavation discoveries. Since 1948 this book has matured from a report on the discovery of the bas-relief and a simple description to a study intended to demonstrate for students the steps involved in a complete examination of an unknown work of art.

I sincerely hope that this search into the original program of the

bas-relief and the analysis of its intrinsic qualities will prove rewarding to a wide variety of students of the history of art and of the humanities in general.

1. *The Discovery*

Unanimous skepticism greeted my first proposal to dig under the existing pavement of the onetime royal abbey church of Saint-Denis. Although texts told of a sequence of buildings erected before the twelfth century, and Abbot Suger specifically mentioned measurements of the old church used in the building of his new one, scholars for the most part believed that the archaeological evidence I sought had been destroyed in the eighteenth and nineteenth centuries. Eyewitness accounts of the vandalism during the Revolution recorded that in 1793 Parisian mobs invaded Saint-Denis and emptied the graves of the hated royalty.[1] Then during the extensive nineteenth-century restorations the pavements of the nave and transepts were twice removed and relaid.[2] Most art historians believed that few vestiges of the earlier buildings could have survived both the pillaging and the restorations, and concluded that my proposed excavations would waste both time and money.

Initially my excavations proposed to supplement the discovery of early foundations reported by Viollet-le-Duc following his work in the 1860s. His published plan did not include either the eastern portions of the crypt or the western bays of the nave and entrance.[3] My first excavation, therefore, was a small exploratory hole in the crypt, which revealed nothing of interest other than surprisingly meager foundations, or footing, for the northern wall of the crypt ambulatory. My instructions from Paris directed that I fill in the first hole before uncovering the next few feet in the adjacent area to the east. As work progressed, a wall perpendicular to the foundations just mentioned came to light, indicating that the ninth-century chapel added to the eastern end of the Carolingian church had

flat terminations to the side aisles. Although a minor detail, the discovery provided new information about the plan of one of the pre-twelfth-century buildings.

Written permission for that first excavation did not arrive until I was leaving France in August 1938; but my request to continue exploratory *sondages* during the summer of 1939 immediately produced blanket permission to excavate at Saint-Denis. The first important trench opened in the western end of the south side-aisle of the nave early in July 1939 disallowed all pessimistic conjectures about the survival of masonry from early buildings on the site of the present church. The excavation uncovered more than thirty feet of an almost perfectly preserved section of the twelfth-century wall joining the entrance bays of Suger's church to the old Carolingian nave, as well as foundations for the southwestern corner of that eighth-century building. The discovery of two twelfth-century bases under the existing exterior wall proved even more startling, since no counterpart for them existed in Viollet-le-Duc's plan. A parallel trench along the south side of the nave uncovered the plinths for the bases of the bays of junction and one complete base in situ. The work stopped early in August 1939 as tension mounted over the Nazi menace, and the workmen hastily filled in the trenches except for two small sections in the south aisle.

The quite unexpected, somewhat enigmatic discoveries of 1939 naturally whetted everyone's curiosity, and the French authorities willingly agreed to renew permission for further excavations in the summers of 1946 and 1947. These excavations began in the arms of the north and south transepts, gradually extended to the west along the north side-aisle and finally, in 1948, moved into the western bays of the nave. As they progressed we found that most of the fill had been disturbed. In several instances the early masonry which often lay directly under the pavement had been cut into in order to accommodate later burials. From Gallo-Roman and early Merovingian times Saint-Denis enjoyed favor as a burial site, favor

which it retained for fourteen successive centuries. In addition to royalty, abbots, monks, and illustrious secular leaders received the honor of burial in this prestigious site. The workmen continually found dismembered bones dispersed throughout the fill, an indication that graves had been disturbed by the digging of trenches for the foundations of successive buildings or holes for later burials. Some of the earliest burials were directly into the earth or in wooden coffins which eventually disintegrated. We uncovered numerous pierced pottery vases of different shapes and sizes, partially filled with charcoal which was thought to function as a disinfectant at the time of burial. Here and there in the fill a fragment of architectural ornament survived, but except for a small, badly damaged stone head of a man in chain mail (possibly carved in the thirteenth century), and a well-preserved twelfth-century capital,[4] little of artistic interest came to light.

Early in June 1947 we continued the excavation of the south transept, begun at the base of the pier just to the north of the tomb of Francis I (Fig. 1, lower left corner). As we enlarged the excavation we discovered additional early masonry, including the embrasures of a large twelfth-century portal (Fig. 1, lower center). Quite unexpectedly we came upon a number of undisturbed burials.[5] One occupied a massive, roughly hewn stone sarcophagus which may date from Merovingian times, although apparently reused at a later date. A Maltese cross, crudely carved in low relief, decorates the larger end, which faces west. Another large sarcophagus of plaster (Fig. 1, bottom center) contained the remains of a thirteenth-century abbot or bishop. His hands, covered by gloves knitted in an unusual stitch, still clasped a wooden, gilt crozier. Embroidered borders worked in gold and silver thread decorated his vestments.[6] During the afternoon of June 3 a workman cleaning the northern edge of the excavation uncovered a modest plaster sarcophagus sealed with a stone cover (Fig. 2, right; Fig. 3). In spite of the location of the cover only ten inches below the existing pavement, the

burial appeared undisturbed. Further clearing revealed a most un-usual feature—carving on both ends of the lid (Fig. 4). When we had removed the fill around the sarcophagus, we could see that the undersurface of the edges also had decoration. I then telephoned Marcel Aubert, Membre de l'Institut and Conservateur-en-Chef at the Louvre, and asked him to be present the following day for the removal of the sarcophagus lid. When that moment came, none of us was prepared for the splendor of the carving which embellished the entire undersurface.

On the previous day, having observed a crack running diagonally across the stone, we inserted metal clamps to secure it. However, at the first attempt to lift the stone another crack appeared and caused the lid to come off in two pieces (Fig. 5). The clean break fortunately did no damage to the carving, and the pieces fitted together so perfectly that now, with the relief securely mounted, the break is hardly visible. Unquestionably the shallow depth of the grave had not left enough earth to insulate the lid from pressures, which caused the cracks. Except for these and minor damage to the outer border from wet plaster used to seal the sarcophagus, only the head and right arm of the first figure and the drapery of the seventh show serious damage. In fact, the carving of the stone has survived in an almost perfect state of preservation.

The relief, upon its removal from the sarcophagus, appeared dark gray in color, the result of moisture absorbed while under-ground. We placed it on laths on the pavement behind the tomb of Francis I and protected the surfaces with a wooden cover. As the stone dried out the color gradually changed to the chalk-white as-sociated with very fine limestone just cut from the quarry. Unfor-tunately numerous problems, some administrative, caused the bas-relief to lie under the box in the same spot for seven years. During this period dust seeped through and dulled the pristine clarity of the stone. But probably no method could have been devised to

protect and preserve the newly quarried appearance through those years without ill effects to the stone itself.

Many other unusual features distinguish the bas-relief. With the exception of the concave molding inside the decorative border of the left side, and the background of the figures under the arcade, ornamental designs completely cover the surfaces. The wealth of minutely executed detail delights the eye and begs for more than the brief moment allotted this work of art in today's hurried guided tour of the treasures at Saint-Denis. The decorative details, almost as crisp and fresh as the moment they were carved, define the borders and crowd the bases, columns, capitals, arches, and spandrels of the arcade that frames the figures.

Those familiar with Christian art recognize the twelve figures as the apostles. Two large keys, the attributes of Saint Peter, easily identify the left central figure (Frontispiece, Fig. 23). Inscriptions identify all but two of the other figures. From left to right the order of the apostles is as follows:

1. Saint James the Minor (Fig. 13) No inscription; identified by process of elimination

2. Saint Thomas (Fig. 15) Name on book held in hands

3. Saint John the Evangelist (Fig. 17) Name in archivolt over his head

4. Saint Simon (Fig. 19) Name on book held in right hand

5. Saint Andrew (Fig. 21) Inscription badly damaged; possible *A* visible on scroll identifies him by process of elimination

6. Saint Peter (Fig. 23) Keys in hand

7. Saint Paul (Fig. 27) Name on book held in hands

8. Saint Matthew (Fig. 29) Name on scroll held in hands

9. Saint James the Major (Fig. 33) Name on abacus of capital over his right shoulder

10. Saint Philip (Fig. 35) Name on scroll held in hands

11. Saint Bartholomew (Fig. 37) Name on molding inside border of
 right end
12. Saint Mathias (Fig. 39) Name follows that of Saint Bar-
 tholomew on molding as above, no.
 11

Although very similar in their general characteristics, the figures emerge as separate individuals with varying poses, gestures, drapery, and arrangements of hair and beards. The minuteness of many of the designs, particularly the decorated borders of the drapery, suggest that the artist carved with a point rather than a chisel, almost as if working in a precious metal or in ivory. He frequently used a drill with bits of different sizes, a common medieval practice not only in stone carving but also in ivory.

For some reason the carving of the bas-relief was never finished. Evidence of the sudden cessation of work appears in small details such as the blank eyeballs of the figures to the left of Saint Peter; all the others, except Saint Matthew, have small drilled pupils. Furthermore, the costumes of the four apostles on the left lack the decorative borders which ornament all the other garments. The decoration of the right end provides positive proof of the incomplete condition (Figs. 48, 49). Here the elements of the lowermost palmette design are roughly incised, whereas the carving directly above has more depth, and the details of the design at the top approach completion. This unfinished end illustrates graphically how the artist proceeded.[7] First he incised the outline of his design, gradually cutting it deeper into the stone, and finally he achieved the modeling and added the ornamental details which give the decoration its lively, rich effect. The insight gained from the incomplete work transports the viewer into the presence of the artist at the moment he laid down his tools. Possibly a defect appeared in the stone, causing the entire piece to be discarded. Or perhaps an unexpected change in the program of a project made the nearly completed bas-relief obsolete. Had the artist died or been forced to

leave the workshop, another could have finished the few missing details. Apparently the work ceased because of a decision to abandon the sculpture. Eventually, at a later date and again for unknown reasons, the bas-relief became a cover for the modest sarcophagus of an unidentifiable person—a use for which it was certainly never intended. Perhaps the men who chose it for the cover admired the quality of the carving. They placed it face down for protection, and because of this the bas-relief has survived in an extraordinary state of preservation.

To make this unpretentious sarcophagus, plaster was poured into a roughly excavated area in the fill under the pavement. A wooden rectangular box pushed into the wet plaster acted as a form and created the cavity. Before the plaster dried completely, the inner surface was given a smooth finish. This technique, a common practice in the thirteenth century, also formed the two similar but larger sarcophagi found nearby. One of the neighboring tombs had been emptied, the other contained the remains of the bishop or abbot mentioned earlier. Possibly the dimensions of the bas-relief determined the modest size of the sarcophagus which it covered. Plaster identical with that forming the sarcophagus sealed the bas-relief in place, an indication that the use of this cover dates from the time of the burial.

The type of boot worn by the deceased adds to the evidence dating the burial in the thirteenth century. Made of soft leather (still in excellent condition and quite pliable when the tomb was first opened) with pointed toes, the shoe conforms to the type known as *estivaux*, a style current in western Europe during the later part of the thirteenth century (Fig. 7).[8] Although previously undisturbed, the contents of the burial revealed nothing to identify the deceased. The costume of coarse dark cloth tied at the waist by a rough cord resembled that of a simple monk (Fig. 6). Yet the location of the burial immediately to the southwest of the high altar, together with the use of the bas-relief as a cover, seem to indi-

cate that the person enjoyed the high esteem of his brethren. Perhaps he had occupied a position of some dignity but wished a simple burial in the true spirit of his monastic vows. Since his grave was located in a crowded area, its shallow depth has little significance. Experience must have taught the monks that they could not dig far without encountering either other sarcophagi or the solid masonry foundations of earlier buildings.

The presence of the bas-relief at Saint-Denis in the thirteenth century seems compelling proof that it originated in one of the abbey workshops; the notion of importing an unfinished relief for use as a coffin lid lacks credibility. Quite obviously it was not carved then, for even a cursory glance reveals the major differences between its style and that of the royal effigies executed in the 1260s.[9] However, it has many decorative motifs and significant sylistic features in common with the sculpture of the western portals of Saint-Denis and with other decorative details throughout the twelfth-century structure.[10]

2. The Program

The use of the unfinished bas-relief to cover a thirteenth-century burial reflects an improvisation with no reference to the relief's original function. Undoubtedly such a major work of art was begun for a specific purpose which would have governed, among other things, the iconographic content of the decoration. In fact, the internal evidence of the bas-relief, when considered in relation to the documented twelfth-century projects at Saint-Denis, points to one particular, elaborately conceived program which might have accommodated such a richly decorated panel presenting the Twelve Apostles under an arcade.

From early Christian times the explicit symbolism of the apostles as a group made them a favorite theme in art. According to the Gospels of Matthew and Luke (Matthew 19:28, Luke 22:30) the choice of twelve disciples as an inner circle to receive special training referred directly to the Twelve Tribes of Israel. During the Middle Ages they were regarded as a corporate body, a collegium, representing the Christian Church and, when depicted with Christ, they symbolized Christianity itself.[1] Because of their direct association with the *Credo* or Apostles' Creed, their representation embodied an affirmation of faith.[2] Saint Augustine also associated the Twelve Apostles with the twelve gates of Jerusalem through which the faithful enter into the Kingdom of God.[3] This symbolism made them particularly appropriate, at an early date, for the decoration of sarcophagi and baptismal fonts. The apostles also became an accepted theme on portable altars, pyxis, and reliquaries, and found favor as well for the decoration of book covers and other objects. In more monumental sculpture they appear as a group in tym-

pani, on lintels over the entrance to a church, or on the embrasures of portals. They also became a favorite theme for altar retables, where they always flanked a central figure of Christ or of the Virgin Mary—a feature not present in the bas-relief.

At first glance the proportions of the long, rectangular stone suggest that the relief might have been designed as a lintel over a doorway. Many such lintels with the apostles under arcades still survive.[4] However, decorative carving on the edges of both ends of the Saint-Denis relief clearly indicates that these surfaces were meant to be exposed. As part of the masonry of a doorway only the face of the relief would have been visible. We must, therefore, exclude a lintel as the intended function for this sculpture.

In agreement with this conclusion, and for want of an alternative, M. Formigé postulated the relief's purpose as an altar frontal.[5] Neither the proportions, the iconography, nor the details of the carving support such a solution. The relief measures 2.05 meters long by 52 centimeters high (6 feet 8 1/2 inches by 1 foot 8 1/2 inches), dimensions incompatible with the proportions of other altar frontals, which normally, because of the height of the altar, were higher than they were wide.[6] Without question the proportions of the bas-relief seem more compatible with those of a retable made to adorn an altar in much the same way that the bas-relief is now displayed. Two other factors, however, weigh against this proposal.

A number of twelfth-century retables have survived. Their decoration often includes figures of the Twelve Apostles under arcades surrounded by a decorative border.[7] The figure of Christ, without exception, occupies the central position with six figures on each side (Fig. 68). The arrangement of the Saint-Denis relief makes no provision for such a figure.

Internal evidence also indicates that the relief was designed to join some other decorated panel at right angles—an unlikely arrangement for a retable. The decoration of the edge of the left end

consists of a border formed by a continuous rinceau-palmette motif similar to that framing the arcade of the front face (Figs. 49–51). This border design turns at right angles at both top and bottom of the left end. The border design which breaks off at the back edge of the stone includes the tips of leaves intended to complete a palmette design on an abutting panel. This strong evidence that some adjoining piece would have continued the decoration has unconditional confirmation in the decorative plan roughly blocked out in the fragmentary area framed by the border. The portion so framed has the same height as the central panel containing the arcade on the front face. The carving in the upper corner within the border clearly depicts leaves similar in scale to the palmettes occupying the spandrels of the arcade. Moreover, the plan of this fragmentary central area includes a rough indication of a capital and a column corresponding in size to the capitals and shafts of the arcade. In short, not only the iconography but also the decoration of the bas-relief deny its possible use as a retable and favor its function as part of a larger ensemble.

Another possibility remains which satisfies the implications of all the details of the relief. A venerable tradition, originating in early Christian times, favored the representation of the apostles under an arcade on the side of a tomb or sarcophagus. Was the bas-relief intended as a side for Suger's tomb? The suggestion is certainly appealing.

The encyclical letter attached to Suger's official biography records that after the abbot's death on January 13, 1151, his remains were solemnly committed to the ground—"terrae corpus solemniter commendarunt"—in the presence of King Louis VII, members of the court, six bishops, numerous abbots, the grand master of the Knights Templar, and many knights and monks;[8] but neither the place nor manner of burial is described. The next mention of Suger's tomb records that in 1259, on the completion of the new south transept and doorway into the cloisters, Abbot Matthew of

Vendôme ordered the transfer of the bodies of six of his predecessors, among them Suger, to the left and right of that door.[9] As a result of the thirteenth-century translation, we know nothing about the original tomb.[10] Suger's own concern for his place in posterity[11] and the high esteem in which his contemporaries held him might serve as arguments for a richly decorated tomb in his memory. On the other hand I question whether during his lifetime he would have countenanced an elaborate undertaking while the decoration and building of his church remained incomplete. Moreover, a sarcophagus with such a richly carved side seems incongruous for a burial in the ground, out of sight and under the pavement.

An alternative and more compatible program existed. As the central, focal point of the new choir Suger built an important new altar dedicated to Saint Denis and his legendary companions Rusticus and Eleutherius. That altar, designed to expose the sacred relics to "visitors' glances in more glorious and conspicuous manner,"[12] implemented Suger's characteristically bold decision to remove these relics from their protective "vault" in the eighth-century *confessio* under the high altar.[13] His equally characteristic concern for the protection of the relics against theft resulted in the erection of a rather complicated and unusual ensemble.

Unfortunately the altar disappeared from Saint-Denis long before the Revolution. In 1567 the Huguenots occupied Saint-Denis, and in addition to irreparably damaging the great library, they stripped the precious metals and gems from the reliquaries of the saints and reduced the altar to such a miserable condition that it was dismantled and rebuilt out of other fragments in 1627.[14] A description of the altar before its destruction appears in Jacques Doublet's famous history of Saint-Denis.[15] He evidently copied much of his information from an inventory of the abbey's treasures made in 1534,[16] with a result so garbled that many details remain uncertain.[17]

Doublet's description identifies three major parts of the altar:

first, the altar table itself; second, the structure enshrining the reliquaries; and third, the wooden tabernacle containing three symbolic sarcophagi (Figs. 10, 11). In front, on the western side, stood the altar table, a rectangular slab of gray porphyry with an elaborate golden altar frontal. Directly behind this, a large rectangular construction, often referred to as the "tomb" sheltered the three small caskets containing the relics of the patron saints Dionysius, Eleutherius, and Rusticus. Built of black marble, the "tomb" measured 8 *pieds* long by 7 *pieds* wide by 5 *pieds* high (2.60 meters by 2.28 meters by 1.62 meters; or 8 feet 7 inches by 7 feet 6 inches by 5 feet 4 inches).[18] Eight square piers 2 1/2 *pieds* high (81 centimeters; 2 feet 7 3/4 inches) supported a marble slab decorated with several moldings. The piers footed on a marble base 1 *pied* high (32.5 centimeters; 12 3/4 inches). Between the piers gilded copper screens in wooden frames gave the faithful a view from the east of three small, richly decorated reliquaries suspended by chains from a vault which projected into the area under the altar table.

A wooden tabernacle in the form of a small basilica with a nave and side aisles rested on the "tomb" and rose high above the altar table. The columns of the aisles measured 2 1/2 *pieds* high (81 centimeters; 2 feet 7 3/4 inches), those of the nave, 6 1/2 *pieds* (2.11 meters; 6 feet 11 inches). The nave, which also measured 2 1/2 *pieds* wide, included a type of clerestory or open arcade which rose above the side aisles with ten colonnettes on each side. On the exterior of the side aisles four corbels supported five round arches. The tabernacle functioned as a large reliquary designed to focus attention on the new resting place of the patron saints. In its nave and side aisles, three empty sarcophagi symbolized the function of the altar as the saints' tomb. Placed in the nave, the largest sarcophagus was elevated above those in the side aisles, presumably to facilitate its viewing through the open sides and ends of the tabernacle. In his very vague description of the altar, Suger mentioned this central

sarcophagus without clearly distinguishing it from the tabernacle in which it was placed. He cited his decision to place the sacred relics in the new choir and then wrote: ". . . since one of the side-tablets of their most sacred sarcophagus had been torn off on some unknown occasion, we put back fifteen marks of gold, and took pains to have gilded its rear side and its superstructure throughout, both below and above, with about forty ounces."[19] Any interpretation of Suger's cryptic references must take into account the distinction in the text between the fifteen marks of gold, a significant sum associated with the sarcophagus (from which a side had been torn), and the smaller amount of gold, forty ounces, used for gilding "its rear side and its superstructure," both inside and out. By "superstructure" I assume Suger meant the wooden tabernacle sheltering the sarcophagus. The "most sacred sarcophagus" must allude to the one which originally contained the relics in the old crypt and which, quite appropriately, accompanied the relics to their new location to function as a symbol of their presence below. Suger apparently allocated those fifteen marks to replace the side that "had been torn off." This replacement project provides the most plausible explanation for the decision to carve the bas-relief.

Other documentary evidence not only explains the cessation of the carving of the relief before completion, but also reinforces my hypothesis concerning its program. Surprisingly, Doublet's description of the altar, not Suger's, records an inscription on the back of the *cercueil* in gilt bronze letters that read:

Fecit utrumque latus, frontem, tectumque Sugerus[20]

If *cercueil* referred to the black marble "tomb" behind the altar table and if the inscription applied to the entire structure, the identification of only the "side, front and roof" as the work of Suger credits him with too little.[21] Since Suger ordered the building of the entire altar and erected both the shrine and tabernacle, the inscription must pertain only to the "most sacred sarcophagus,"

which Suger was forced to restore because of the earlier damage to it. Evidently he replaced the front and the roof or cover as well as the torn off side. Doublet also described the front of the middle *cercueil* as joining the altar—a front end decorated with several enamels on gilt copper and with several agates, some of which were carved in the fashion of cameos with men's heads.[22] Recent research identifying a carved Carolingian crystal in the British Museum as part of the original decoration of the Saint-Denis altar provides an example of the type of carved gems used (Fig. 62 B).[23] Significantly the decoration of the border of the left edge of the bas-relief includes a man's head or mask and a hand. This motif occurs only once in the varied decoration of the relief (Fig. 51). The border presumably continued a decorated border on an adjoining panel. Therefore, as an echo of the cameos, the mask in the bas-relief border would have harmonized with and complemented the carved gems of that newly decorated front. The decoration of the opposite, or right, edge of the bas-relief, although unfinished, has a self-contained border design (Fig. 49 A). The inscription recorded by Doublet states that the front, not the back, of the sarcophagus was replaced. Accordingly the right end of the new side panel would simply have abutted the still existing back end of the old sarcophagus. The seemingly arbitrary treatment of the two ends of the apostle bas-relief becomes quite understandable, if the proposal is accepted that the relief was intended to function as the side panel of the "most sacred sarcophagus."

The dimensions of the bas-relief also conform to this proposed function. Since the documentary evidence will not permit an accurate reconstruction of the altar, some dimensions must remain speculative. Nevertheless the proportions of the sarcophagus placed in the nave of the tabernacle could not have been monumental. Doublet gives the width of the nave as only 2 1/2 *pieds* (about 81 centimeters; 2 feet 7 3/4 inches). The dimensions of the bas-relief, 2.05 meters by 52 centimeters (6 feet 8 1/2 inches by 1 foot 8 1/2

inches), though smaller than many tomb sides, appear commensurate with the proportions of a sarcophagus that fitted into a space 2.60 meters by 81 centimeters (8 feet 7 3/4 inches by 2 feet 7 3/4 inches).

Formal aspects of the carving of the bas-relief also correspond to the requirements of the sarcophagus displayed in the nave of the tabernacle. Doublet described the "most sacred sarcophagus," a prominent symbol in the altar complex, as "plus haut eslevée que les autres." Several details of the bas-relief confirm that the artist planned for its viewing from below (Fig. 8). A concave molding just inside the outer, framing border runs along the top of the relief and down both ends, but not along the bottom. As a result the bases of the columns and the feet of the apostles rest or stand directly on the lower border. By eliminating the concave molding along the bottom, the artist could not only avoid the illusion of instability in the figures and arcade, but could also carve the feet and lower portions of the apostles' bodies closer to the frontal plane of the relief than the rest of their figures (Fig. 55). When viewed from below these subtle variations would increase the impression of the figures' height, and the oversized heads would assume more normal proportions in relation to the bodies.

As noted earlier, the Twelve Apostles appeared on sarcophagi from early Christian times and therefore seem appropriate iconographically for the new side of the old sarcophagus. However, the presence of Saints Peter and Paul in the center or place of honor has raised the question of whether Suger would have countenanced "such formidable competition" with the patron saints of Saint-Denis.[24] The dedication of the high altar to Saints Peter and Paul suggests a special cult devoted to them. However, since Suger and his contemporaries believed that Saint Denis had been a disciple of Saint Paul, not only the dedication of the altar but also the central position of this apostle on the bas-relief may have commemorated that discipleship rather than honored a competing cult.

Suger's writings, furthermore, provide an explanation for the unfinished state of the bas-relief's carving and the obviously sudden decision to abandon it entirely. In describing the new frontal for the altar table to the west of the bodies of the patron saints, he wrote:

> While we, overcome by timidity, had planned to set up in front of this [altar] a panel golden but modest, the Holy Martyrs themselves handed to us such a wealth of gold and most precious gems—unexpected and hardly to be found among kings—as though they were telling us with their own lips: "Whether thou wanst it or not, we want it of the best"; so that we would neither have dared, nor have been able to, make it other than admirable and very precious in workmanship as well as material.[25]

The text contains an explicit reference to a change in the decoration of the altar.[26] In an earlier passage regarding the "most sacred sarcophagus," he said that he put back fifteen marks of gold to replace the "torn off" side.[27] Exactly the same circumstances and rationale which inspired his change from modest materials to "the best" materials for the altar frontal evidently moved him to put aside the nearly completed stone bas-relief and to replace the side of the old sarcophagus with a truly golden panel, so that the saints would not take offense. His text quoted above continues with the inference that decisions to improve the quality of the materials were not limited to the altar frontal. "Here and elsewhere," he wrote, after describing the unexpected opportunities to purchase collections of jewels, "we could find by experience: let there be a good work in the will—then, with the aid of God, will it be in perfection." The chance to replace the decoration of his altar, begun in a "modest" fashion, with precious metals and jewels happily accorded with Suger's expensive tastes. We also benefit from this preference which allowed the bas-relief to survive.

This identification of the program, or intended use, of the relief also provides accurate limits for the date of its carving. The project for the construction of the new altar in honor of the patron saints could hardly have been formulated before construction of the new choir was under way. Suger records that the foundations for the new eastern end were begun on July 14, 1140;[28] but it is unlikely that plans for the new altar were conceived until the following year or two. The choir, he also records, was dedicated with great pomp and ceremony on June 11, 1144. Work on the bas-relief must have stopped early enough to allow for the construction of the new side panel to be finished for this ceremony when Samson, archbishop of Reims, performed the consecration.[29] Work on the apostle relief must, therefore, be dated in the early 1140s, between 1141 and 1143, not in the late 1140s or 1150s as proposed by some scholars.[30]

Both formal and stylistic details of the bas-relief accord with the plausible explanations for its intended use, ultimate discard, and date. Since those details also disclose an artist's predilections, their study must precede speculations about the artist himself and his background.

3. The Object

Suger recorded that he "summoned," "chose," or "convoked" the "best" artists from "many regions" to build and decorate his new church.[1] Unfortunately he did not explain how he summoned them or the terms of their employment. From later medieval documents we infer that the twelfth-century workshops, as well as those that built the great thirteenth-century cathedrals, were organized in sheds or temporary lodges along the flanks or immediately adjacent to the building under construction. A master mason directed all of the various activities, but no documents describe the actual procedures or responsibilities of the individual artists.[2]

When for instance, the artist was assigned the project of carving the Saint-Denis relief, he undoubtedly received instructions to represent the Twelve Apostles, and possibly even to place them under an arcade with Peter and Paul in the center. Instructions probably further specified an ornamental border to frame the group, and decorated ends to adapt the bas-relief to its place on the "most sacred sarcophagus," with further emphasis on the "exquisite workmanship" needed to harmonize with the new altar. Beyond this one hardly dares speculate. But even if instructions prescribed ornamentation for the surfaces of the arcade, they could hardly have specified decorative details and patterns or the manner of carving. The artist's responsibility and his challenge undoubtedly lay in the selection and invention of the decorative motifs, and in such details lie clues to his taste and identity.

THE ORNAMENT

Although the study of ornament is not new,[3] the historian of medieval art finds little to guide him if he wishes to evaluate the

significance of ornament in any given context. No corpus of Romanesque or Gothic motifs yet exists.[4] The ubiquity of ornament as architectural decoration and on objects in all media in the eleventh and twelfth centuries resulted in seemingly infinite variations on almost every possible theme. A compilation of such themes presents a bewildering task. To bring order to his analysis, the art historian must follow a number of different lines of investigation. First he must identify the basic designs, describing objectively the elements of each individual motif. The classification of the different categories of these motifs[5] leads to the identification of unusual or characteristic examples, and provides an opportunity to speculate about the absence of other common designs. The study of historical prototypes and their geographical occurrence continues the organization of the evidence.

Some patterns derive from motifs so universally applied that they have little historical value. Yet these motifs may have intrinsic qualities which indicate certain predilections of the artist. An unusual design or combination of elements deserves investigation in the hope of discovering interrelations among different groups of artists.[6] Historians of art also frequently search for the symbolic connotations of a decorative motif.[7] This exercise requires caution because the modern historian, with his wide perspective of past centuries and of radically different cultures, can imbue some ornamental device with a meaning that would have amazed the artist. In many instances the artist chose a motif only because it suited his instinct at that moment.

A final consideration in the analysis of ornament concerns the manner in which the patterns embellish or obscure the surfaces to which they are attached, applied, or of which they are a part, for this defines the nature of the ornament.[8] By determining its character the historian becomes qualified to comment on both the artistic and the historical significance of the decoration of an object.

The study of the Saint-Denis bas-relief demonstrates the many

facets of the analysis of ornament. In a continuous band of decora-
tion, for instance, the primary motif must be isolated. By unex-
pected emphasis on one aspect of a motif an artist can vary its vis-
ual effect in a series. For example, numerous variations of a palmette
occur on the relief's first seven abaci; on the bottom torus of base
5; on the inner archivolts 1, 4, 8, 11, and 12; and on *e,* the concave
border just above the arches (Figs. A–D; see Fig. 86 for location
of these and following numbers and letters on the bas-relief). By

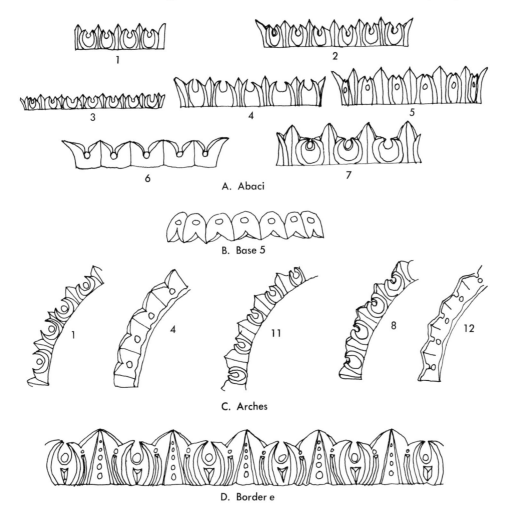

A. Abaci

B. Base 5

C. Arches

D. Border e

55279

definition, the palmette (ultimately derived from the tuft of leaves at the top of a palm) consists of a foliate design, symmetrically organized on either side of a central vertical axis. Often on the bas-relief, however, the axis does not receive the strong accent, and the space between each palmette, usually defined by a drilled hole, catches the light so abruptly that the eye is deceived into reading the design as organized on each side of the void rather than the axis.

The contrast of negative and positive areas, or the relation between figure and ground, may prove equally deceptive. In relief sculpture an incision or cutout portion reads as negative or as the ground, whereas the raised or projecting areas appear positive, defining what is called the figure. A comparison of the spiral decorations on shafts 3 and 5 demonstrates this concept (Figs. 16, 20). On the former, 3, alternate bands have drilled holes (negative) surrounded by a circular incision, whereas on the latter a series of raised beads (positive) ornament the alternate bands. In the outer bands of arches 1 and 2, the zigzag motif lends itself to even more subtle variations (Figs. 12, 14). On arch 1, where raised beads occupy negative triangles, the eye is attracted primarily by the positive areas. On arch 2, the positive and negative triangles have almost equal value, and only when compared with the pattern on arch 1 do the negative areas seem emphasized. Again, on the bottom tori of bases 2 and 3 where the depth of the relief gives the positive and negative areas nearly equal value, the figure and ground seem almost interchangeable. Naturally, these relationships depend largely on the source and angle of the light modeling the surfaces, and properly so, for such interactions are essential to the function of ornament, which by definition attracts and distracts the eye.

In the analysis of ornament, a reduction of design motifs to a common denominator facilitates their identification. Take for example the zigzag motif, which appears in its simplest form on the top edge of abacus 4 (Fig. 18). The double zigzag occurs more

frequently (see abaci 1, 2, and 3, and arch 2; the outer band of the upper border; and the band below the feet of the apostles (Figs. 43, 47). Arch 7 has somewhat haphazardly executed triple zigzags with beading on the middle one (Fig. 26). On arches 4 and 9, and on shaft 13, a cutting away of the triangles both above and below the motif leaves only the raised lines of a double zigzag as positive elements, resulting in quite a different effect (Figs. 18, 32, 38).

The zigzag combines and divides in a number of ways. The bottom and top spiral bands on shaft 1 show the combined form in its simplest manner, i.e., two incised zigzags opposed, with resulting diamond-shaped spaces between them (Fig. 12). On the base of column 1 the same design reads as a series of X's because of its vertical division on alternate axes (Fig. E). The second band on shaft 1 and the bases of columns 2, 3, and 4 show different ways of treating this same combination (Figs. 12–19). On arch 8, shaft 6, and base 7, three or more zigzags combine with holes drilled in the diamond spaces to give the effect of a diapered ground (Figs. 22, 26–28). An unusual example of subdivision decorates arch 6. There the decoration of the outer bands appears as a series of X's and diamonds, separated by vertical beaded bands (Fig. F); but on analysis, this sequence also subdivides into an alternation and separation of the basic combined zigzag.

E. Base 1

F. Arch 6

Still another variation occurs on the third band of shaft 1 and in a complicated, combined form on shaft 8, where the overlapping of one side of the zigzag on another results in a design resembling

a folded ribbon (Figs. 12, 28). The triple zigzag with beads added in the interstices, found on shaft 8, produces an agitated overall pattern which obliterates the ground. Enlarged versions of the zigzag appear on shaft 9 as a chevron, and a similar enlargement in combined form on shaft 6 produces diamonds (Figs. 32, 22).

Since the zigzag is only one of the many basic designs underlying the decoration of the bas-relief, other approaches help to identify and classify the designs. On analysis ornamental patterns fall into two fundamental categories: those created by mechanical devices, such as the straightedge or compass, commonly recognized as geometric forms; and those associated with natural or growing forms, identifiable as organic designs. Geometric motifs include both plane and solid figures, as well as the combination of both in the nonorganic architectural forms, such as the column, the arch, or the dome. Organic designs stem from vegetal or animal forms. Examples of all these types occur in the decoration of the bas-relief and are analyzed in Appendix 1.

A distinguishing feature of the majority of the ornamental motifs is the degree to which techniques other than stone carving have modified the basic geometric and organic designs. Outstanding and easily identifiable examples of such modifications include the arcaded bases 6 and 9, the jewellike patterns of shafts 2 and 6, and the outer bands of arches 9 and 11 (Figs. 32, 36). Forms such as these were created by the goldsmith when he twisted wires, dropped granulated beads of gold, or made mounts for precious stones or other translucent materials (Fig. 62 A).

In a few instances the predominant influence of metal techniques transformed vegetal motifs into basically geometric designs. Three such patterns ornament the three abaci of the capitals on the far right of the bas-relief (Figs. 36, 38). Abacus 11 shows a palmette design stylized to its simplest elements. A rudimentary compass could have traced these curvilinear forms. Abacus 12 has a sequence of eight-petaled rosettes in circles, executed as in metalwork; and

the third example, a type of rinceau with three stylized leaves or petals pointing up or down from the undulating line, decorates abacus 13.

The decorative border *h* which frames the entire rectangle provides another prime example of the influence of metalwork (Figs. 44–47, 52–54). At first glance the graceful curving leaves of the palmette designs appear in the category of vegetal forms, but closer observation reveals the stylization of all details. The artist considered each part of the design as a separate unit which he then assembled into the completed ornament, as though he were fashioning a brooch, or other jewelry decoration. A circular ring, or clasp, at the base of each palmette gathers and holds the foliate forms, the ends of the beaded rinceau, and the base of the axial motif. The modern observer may note with amusement the resemblance of this axial motif to a golf ball balanced on its tee (Fig. 54). Though flippant, the simile emphasizes the independence of the vertical pedestal from the spherical finial with its stylized surface treatment. Almost identical rinceau-palmette designs occur on the shafts of columns 10 and 11, and on the borders decorating the two ends of the stone slab (Figs. 34–37, 49, 50).

The study of ornament remains incomplete without a discussion of historical prototypes and their geographical occurrence, as well as possible symbolic connotations inherent in certain motifs. Although many of the ornamental patterns on the bas-relief appear in the arts of ancient, even prehistoric cultures, the Saint-Denis artist had little concern for their genealogy. Over the centuries the royal abbey had amassed a fabulous treasure of metal and ivory book bindings, golden altar embellishments, and liturgical vessels that often incorporated portions of objects made by Hellenistic, Ptolemaic, Roman, Islamic, or early medieval artists. The sculptor of the bas-relief could have studied many of these objects as they were repaired or refashioned in the abbey workshops; but he would have studied them for their intrinsic qualities, not their historical

venerability. Unfortunately only a few rare items of that immensely rich collection have survived;[9] and, since no hypothetical reconstruction of a lost item could have accurate assumptions about the minute details with which we are concerned, speculation about the influence of these treasures remains inconclusive.

Some historians have observed that a preference for abstract, or geometric, decoration tended to identify the art of the "barbarian northern" nations, whereas they have associated organic and vegetal decoration with the antique, "southern," Mediterranean civilizations.[10] This distinction loses its importance when we realize that by the twelfth century both categories of ornament had widespread use in western Europe. For example, the palmette motif—adopted as a common pattern for the gold bezels holding precious stones, for openwork metal crests, for decorative borders in illuminated manuscripts, and for ivory and stone carving—crossed boundaries both technical and geographic. The same holds true of the acanthus leaf and rinceau motifs, familiar in the vocabulary of Greek and Roman ornament, which also found wide acceptance in Carolingian, Ottonian, and Byzantine workshops. On the bas-relief two of these ubiquitous motifs in combination form the rinceau-palmette, a design with an equally long history and wide geographic distribution.

The palmette with a strongly accented vertical axis is a characteristically Greek achievement.[11] Roman artists used it widely in both elaborate and simplified designs, often with an axis topped by or composed of stylized forms similar to the pinecone or a cluster of grapes. A lead sarcophagus in the Dumbarton Oaks collection in Washington, D.C., provides a typical example of the motif in Roman decoration (Fig. 70).[12] Continued as a basic decoration by late Roman and early Christian artists,[13] it reappeared in many Carolingian manuscripts and ivories[14] and on the metal grills of the Palatine Chapel at Aachen, where the vertical accent of the palmette closely resembles the axial motif of the bas-relief border

design (Fig. 71).[15] Ottonian artists continued to favor variations of the same theme,[16] and from them it passed into the decorative vocabulary of artists from the valleys of the Meuse (Mosan) and of the Rhine in the twelfth century (Fig. 73).[17] It also appeared in southern France in the early eleventh century, particularly in Languedoc in the twelfth century, and variations were carved on many Burgundian portals and capitals before Suger's workshops were organized.[18]

The recurrent use of a specific variation of the palmette design on the Saint-Denis bas-relief has interesting connotations. The same palmette-rinceau of the bas-relief's border occurs in the decoration of the western portals (Fig. 59), on capitals in the crypt and choir (Figs. 57, 58), in the ornament of the stained glass windows (Fig. 63), and in metalwork associated with the abbey during the twelfth century. The above analysis of this version of the palmette ornament noted the clear definition of all of its parts, especially of the vertical axial motif.

Undoubtedly this device originally derived from nature: a stem with a fruit or bud. By the twelfth century the stylization of these natural forms became so highly conventionalized that their identification depends primarily on the context or surroundings. Spherical or oval in shape, covered by vertical, horizontal, or diagonal crisscrossing, striations, or a variety of pierced or raised patterns, the motif has been called the spadix of the arum lily; the fruit of the fir tree, or pinecone; a cluster of grapes; a corncob (Turkish wheat); a pomegranate; an artichoke; a strawberry; an apple; or simply a bud. While the golf ball is irrelevant, so are many of these other identifications.

In her studies of floral ornament Denise Jalabert noted that a sheath or floral pattern often enclosed the vertical axis in certain palmettes. She identified this variation as an imitation of the arum lily with its surrounding spathe and vertical spadix. Although she suggests that its first appearance in western art may have been in a

mid-eleventh-century manuscript decorated at Saint-Denis, she traces its origins to an early combination of the Persian lily with the sacred Hindu lotus bud, to the "depths of Persia even to the heart of Asia" (Fig. 65).[19] On the bas-relief curling leaves frame the axial motif of the palmette, but, because they do not enfold or enclose it, association with the lily seems remote.

Small rounded protuberances or beads cover the majority of the spherical finials of the palmette design (Figs. 42, 54). In several instances the details closely resemble a series of scales with pointed ends, more like a pinecone than any other natural form. This fir or pinecone, in French the *pomme de pin,* has a wide variety of associations. Cabrol and Leclerq's *Dictionnaire* gives the general, more familiar interpretation: "We know that the custom of decorating fountains with a pinecone had its origins in pagan antiquity of the near east; Christianity adopted it and transformed this symbol into the fruit of the tree of life."[20] As the fruit of the tree of life, it also became the bread of life, encompassing everything needed for daily sustenance.[21] Contemporaneously with the work at Saint-Denis, the writings of both Hugo of Saint-Victor and Rupert of Deutz contain such an interpretation.[22] In its association with the tree or fountain of life, the pinecone alone became a symbol for the fountain and thus for the four rivers of Paradise, which flowed from this fountain in the center of the Garden of Eden. Strzygowski ascribes this meaning to the famous bronze cone placed in the atrium of Old St. Peter's, before the middle of the twelfth century, as well as to the gigantic cone of the Palatine Chapel at Aachen.[23]

Another scholar proposed that in "Graeco-Roman paganism, the fruit of the pine discharged prophylactic, sepulchral, and phallic functions." The thyrsus, the emblem of Bacchus, or Dionysius, consisted, he noted, of a "stalk crowned by the fruit of the pine." This emblem also pertained to Sylvanus Dendrophorus, the old Roman god of the forests, who became one of the principal Celtic

deities. The Franks who settled in the Low Countries and northern France and ultimately established the Merovingian dynasty venerated the fir cone placed at the end of a stalk or pillar. Possibly not only the famous *pyr* or monumental cone of Augsburg, which from Roman times appeared on the arms, coins, and seals of that town, but also the early seal of Liège, with its *perron,* or pillar, topped by a pinecone, resulted from some Gallo-Roman or early medieval synthesis of ancient symbols.[24]

Two other interpretations also associate this motif with the cult of Bacchus, or Dionysus. Symmetrically arranged tendrils springing from a vase or a clasp, often with clusters of small grapes on stems, have been called the "Dionysiac vine," whose origins have been traced to the ancient Near East.[25] In Roman decoration a pedestal or candelabrum, surmounted by a flame, often accompanies libations offered to Bacchus. When reduced to a small scale or otherwise stylized, the flame closely resembles a pinecone, so that distinction between the two becomes difficult; but the associations with Bacchus remain.[26]

The significance of the use of the palmette with stem and axial bud by Suger's twelfth-century artists is enhanced when we realize that the design was a familiar motif in the decoration of the abbey church as early as the eighth century. A palmette with a grapelike cluster on a stem provided the basic design carved in low relief for some of the massive bases supporting the colonnades between the nave and side aisles of Abbot Fulrad's church, dedicated in 775. The most striking example survives on a base removed from Saint-Denis, presumably during the restorations of the nineteenth century (Fig. 56).[27] The panels on each side of the almost square base, as well as the corners of the top surface, have fully developed palmette designs with multiple curving foliate patterns. On one side, stalks or stems terminating in stylized finials project from the clusters of stylized leaves. Another side has an even more elaborate design with a vase in the center, from which the foliate forms

emerge together with the vertical motif supporting a spherical finial almost identical to the axial design of the bas-relief border. The presence of the vase with foliate forms springing from its mouth presents such a close analogy to the definition of the "Dionysiac vine" that one toys with the thought that its early use at Saint-Denis purposefully evoked an even earlier symbolism.

Although this particular variant of palmette design appears frequently in the decoration of twelfth-century reliquaries and altars in the Meuse-Rhine valleys as well as on abaci carved in Toulouse, and on capitals in Burgundy, unquestionably the evidence also points to its continuous popularity in the Saint-Denis workshops.[28] The medieval preoccupation with etymology, nomenclature, and multiple symbolic interpretation makes an association of an ancient Dionysiac symbol with Saint Dionysius, the first bishop of Paris and patron saint of the monarchy, seem as plausible for the twelfth century as it seems incongruous today. The use of symbols with classical connotations, only infrequently documented as early as the middle of the twelfth century, became increasingly popular less than a century later. Whether the bas-relief provides a precocious example remains a possibility worthy of speculation; but rigid objectivity demands the qualifying thought that in the case of this particular design its distinctive, decorative character alone may account for its popularity at Saint-Denis.

The other elements of this border design deserve brief mention. Curling leaves not unlike those on either side of the axial motif are frequently labeled as the "Byzantine leaf."[29] Certainly very similar foliate patterns decorate a number of objects unquestionably of Byzantine origin. However, these same rich leaf forms appear as decorative borders in Carolingian illuminations and ivories. In the twelfth century before the workshops of Saint-Denis were organized, Romanesque sculptors, illuminators, and metalworkers freely used the motif in its fully developed form. To identify these curling leaves on the borders of the relief as indications

of Byzantine influence at Saint-Denis overlooks these more readily available sources of influence.

Equally convenient prototypes existed for the beaded band of the rinceau, an ornamental device of ancient origin, which gives unity to the border decoration. Also stripped of connotations of natural forms by the single or double rows of beads and by the regular curves of the undulations, the rinceau harmonizes perfectly with the abstract, stylized character of the palmette design. Although, as noted earlier, the drops or granulations of goldwork may have inspired this form, similar designs appear typically in Winchester manuscript illumination in the tenth and elventh centuries. Almost identical forms occur on English bone carvings, bronzework, and stone sculpture from that time forward, and by the twelfth century the motif appeared frequently in both Burgundy and Languedoc.[30]

An unusual design with a vase as the axial motif appears in almost identical form on capitals 3 and 5. No exact prototypes have come to my attention, but the presence of vases on capitals can be traced back to antiquity. Among the early medieval examples, a group of twelve capitals known from the writings of Eusebius have the most interesting associations for the bas-relief. In describing the Holy Sepulchre church built by Constantine in Jerusalem, Eusebius recorded that twelve silver craters (the familiar form of the Greek vase or jar) surmounted the twelve columns of the hemicycle. The number of columns signified the Twelve Apostles.[31] Certainly this symbolism was known at Saint-Denis in the twelfth century, for Suger also equates the twelve columns of the hemicycle of his new church with the apostles.[32] Possibly the crater capitals of the Holy Sepulchre were also known at Saint-Denis; yet only two vase capitals appear in the arcade of the bas-relief. Instructions to the artist may have mentioned vase capitals, but possibly he balked at repeating the design more than once. The monotony of a sequence of similar capitals beneath spandrels occupied by identical

palmette designs would have run counter to his obvious delight in variety.

In addition to the vase motif a second singular ornamental design may be identified, rather fancifully, as an *oeuf à la coque* (Fig. 28). Once again I have found no exact prototype, although a somewhat similar design appears in the border of an ivory book cover, probably of Mosan provenance, ca. 1100, and in a decorated initial in the Bible of Mazarin.[33]

The third unusual motif, the flame or wave pattern on shaft 4 and base 5, was not a common design in the twelfth century. In two instances, this design is associated with scenes of sacrifice; but elsewhere it appears as conventionalized rocks or ground.[34] At Saint-Denis, in addition to the two examples on the bas-relief, the motif occurs on the third base of the right side of the south portal of the west façade (Fig. 59), as well as on a stone fragment now in the Louvre Museum, a fragment reputedly found during excavations in the cloister of Saint-Denis in the nineteenth century.[35] Its use by Suger's artists seems purely decorative.

Two important overall considerations remain: first, whether, among the eighty different designs on the bas-relief, other equally familiar patterns are conspicuous by their absence; and second, how the artist treated the ornament in relation to the surface it decorates.

An enumeration of familiar motifs that do not occur on the bas-relief proves informative in eliminating areas of possible influence upon the artist. In addition to the palmette and acanthus designs inherited from the ornament of classical antiquity, Romanesque artists often used the fret, the bead and reel, the egg and dart, and dentils, in much the same manner as the artists who decorated the many surviving Roman monuments in southern France or the Rhone valley. If the Saint-Denis artist had been trained in Burgundy or Provence, motifs such as these would almost certainly appear among the patterns. Similar observations pertain to the

interlace or whorl, so familiar in the decoration of Norman and English monuments of the eleventh and twelfth centuries. In other words the ornament of the bas-relief, which, at first glance, seems to present a repertory of eleventh- and twelfth-century designs, does not include a number of patterns which one would expect to find if the artist had been trained in an Anglo-Norman milieu, or in Burgundy or southern France.

A final consideration bears upon the overall organization of the design of the bas-relief, and the manner in which the patterns embellish or obscure the surfaces as well as the way in which the artist related the ornament to the area it decorates. The repetition of the figures of the apostles under the continuous series of arches immediately establishes the basic stability of the composition, while the bordering frame firmly contains the rhythmic sequence of the arcade. The uninterrupted palmette frieze above the arches, the identity of the spandrel palmettes, the continuity of the beaded rinceau uniting the alternating palmette motifs of the outer border, all emphasize the concept of sequential, repeated accents. The insistent variety of motifs on the arches and the column shafts and bases contradicts this concept of continuity.

If considered in themselves, the designs on the arches are appropriate to the semicircular frames they decorate. Not only the repetitive accents of variations on the zigzag, but also the band palmette, the sequence of arches, or circles, nailheads, imitation jewels, and overlapping leaves conform to their frames, although some more than others affirm the continuity of the curve. Their simple enumeration, however, reveals their variety. The choice of decorative patterns for the capitals and abaci appears equally appropriate; but a basically haphazard variation denies any intended order in the sequence of similar designs on capitals 3, 4, and 5, or the repetition of the Corinthianesque forms on capitals 9 and 10.

The ornament of the shafts of the columns displays a more arbitrary selection and use of motifs. From left to right the designs

on the shafts alternate between the spiral patterns of shafts 1, 3, 5 and the lozenge, flame, or diamond patterns of shafts 2, 4, and 6. But this relatedness ceases to obtain among the remaining shafts, although the spiral recurs at the extreme right end on 13. Unlike the fluting used in antiquity, none of the patterns accents the vertical supporting function of the shaft. The spiral imparts a restless movement, equalled by the sense of motion in the flame pattern, the double zigzag ribbonlike motif on shaft 8, and the horizontally repeated zigzag of shaft 12. The lozenge or diamond designs on shafts 2 and 6 and the chevron of shaft 9 appear as decorations superimposed on the cylindrical surfaces they adorn. The treatment of the familiar pinecone-palmette motif of the border frame on shafts 10 and 11 deserves especial attention. On shaft 10 the arrangement of the pinecone with its stalk accords with the vertical axis of the column. But on shaft 11 the rinceau runs the length of the column while the palmette, arranged horizontally, seems to wrap the decoration around the shaft, so that to read it requires a tilt of the head.

Such a nonarchitectural arrangement displays the artists's basic insensitivity or disregard, even disdain, for the structural forms he was decorating. Apparently he leafed through the pages of a corpus, or copybook, of decorative patterns, selecting here and there those designs which he found particularly attractive, inventing variations on a number of them, and then deciding to see how many different motifs he could include to cover all of the surfaces presented by the architecturally inspired frames of the arcade (Fig. 64).[36]

The predilections of the sculptor of the bas-relief conform very closely to the tastes of an artist concerned with objects of small scale, whose surfaces he would instinctively decorate with minute designs incised in metal or by the application of filigree, granulation, enamels, or jewels. The discussion of the individual decorative motifs revealed again and again the artist's manner of rendering a

design as though he were a goldsmith. The inference is clear, but any conclusions about the artist of the bas-relief must also take into account his treatment of the figures of the apostles and the significant components of his figure style.

THE APOSTLES

The ornamented surfaces of the bas-relief attract the eye and delight the mind with variety and unexpected detail. Fulfilling its function admirably, the decoration enriches the environment in which the artist presents the apostles. With the apostles the major theme of the relief, the manner of their representation demands attention, since it provides additional objective evidence about both the artist's idiosyncracies and the quality of his work. The intricate character of ornament required analysis in terms of the abstract order of geometry and of patterns suggested by the organic world of nature. The image of man has the human figure as a constant reference. Even the untrained eye discerns variations from the norm. Proportional relationships of parts of the body, the rendering of anatomical detail, the treatment of drapery and postures, unusual gestures, and the relation of the figure to the environment—those, though familiar observations, when viewed in the aggregate distinguish individual interpretations of the image of man.

As one first approaches the bas-relief, attention focuses on the large bald head of Saint Paul, the central right figure facing Saint Peter, who is identified by his immense keys to the kingdom of heaven. Saint Paul's disproportionately large head creates the impression that all the figures are sturdy and squat. Actually, as discussed in Appendix 2, the ratio of the heads to the total heights of the figures varies from 1:4.12 to 1:4.70. These oversized heads would appear in more normal proportions to the bodies if viewed from below (Fig. 8).[37] More significant to the overall composition is the recurrence of certain measurements common both to the

figures and to the arcade. Among those correlated measurements which Appendix 2 presents in more detail, the basic height of the figures, 32.5 centimeters (12 3/4 inches), equals twice the height of the column shafts, and twice the intercolumniation measured from shaft center to shaft center. Furthermore, the correspondence of the measurement of the heads, roughly 7 centimeters in height, to measurements of important parts of the arcade apparently had more significance in the artist's plan than the head to body ratio (Fig. 41). The recurrence of this dimension not only gives stability to the architectural frame but also relates the figures themselves to that frame.

This close association between the apostles and the arcade framing each figure emerges as an outstanding feature of the bas-relief. Defined by Henri Focillon as the "homme arcade,"[38] this particular relationship demonstrates a fundamental principle of Romanesque sculpture—the role of the frame as a controlling factor in the organization of design. Indeed, any discussion of the figures of the apostles requires constant reference to the arches, almost resembling halos, that surround their heads, to the curve of the capitals which seems to dictate the slope of the shoulders, to the column shafts which prescribe the height of the bodies, and to the plinths of the bases at the level of the feet. This intimate association of the figure with its immediate environment emerges as a primary consideration for an understanding of the bas-relief.[39]

The profiles of the faces are equally distinctive and therefore an immediately noticeable feature of the figure style (Fig. 45). The nasal ridge of the prominent, straight noses continues the plane of the relatively low forehead in an uninterrupted line. High arching curves springing from the nasal ridges define the lines of the eyebrows and create large sockets for the bulging eyes. The lower areas of these sockets, in the absence of sharply accentuated cheekbones, receive some definition from the flaring nostrils. Consequently, an interesting contrast exists between stylized and natural forms,

treated in each instance somewhat differently. Although the heads conform to the same general type, the sculptor took pains to distinguish one from another.

Despite the erosion of the stone, similar straight noses and arched brows still dominate some of the facial contours in the medallions of the works of the months that decorate the jambs of the right portal of the west façade of Saint-Denis, notably those representing April, May, August, and September (Fig. 61). Such profiles also occur on a number of historiated capitals of the crypt, particularly in the scene showing Saint Benedict, seated, receiving the homage of the Goth, Galla (Fig. 60); and in other figures on crypt capitals such as those depicting a procession of the relics of Saint Denis, which, although badly recut, retain the character of their original features, including the large noses.

Adolph Goldschmidt has identified this distinctive profile as the "characteristic type for Belgian-lower-Rhenish work of the eleventh century."[40] K. H. Usener also described it as characteristic of the work of Renier de Huy and his followers in the same region during the first third of the twelfth century.[41] A Mosan gilt-bronze triptych, attributed to a follower of Godefroid de Huy, from the Duthuit collection and now in the Petit Palais in Paris, provides a striking example of almost identical profiles (Fig. 76); and similar profiles distinguish the seated evangelists who form the feet for the pedestal of the Cross of Saint Bertin, now in the Saint-Omer museum.[42]

The artist's manner of depicting the eyes of the apostles depends closely on his particular stylization of the profiles. Designed to fill the cavities under the arching eyebrows, the almond-shaped lids and eyeballs appear disproportionately large in relation to other facial features. As noted earlier, drilled holes indicate the pupils of the eyes of all but one of the apostles on the right side of the relief. In keeping with other examples, such as the head of Saint Peter from the twelfth-century tomb of Saint Lazarus in Autun,

now in the Louvre, these drilled pupils probably would have been filled with black mastic.[43] By increasing the lifelike appearance of the heads, this convention would have accented the contrasts between stylized and natural forms in the figure style. The delineation of the eyelids also deserves attention since this stylization differentiates the hand of the artist of the bas-relief from the sculptors of the western portals. The unmarked lower rims of all of the eyes, except those of Saints Thomas and Paul, contrast with the clearly fashioned flat upper and lower lids of the eyes of some of the surviving original heads from the central portal figures.[44] Significantly, another example of eyes of the type of the relief apostles appears on the right angel holding relics of the True Cross in the above-mentioned Mosan triptych from the Duthuit collection.

Because the heads of the apostles all present a three-quarters view, sometimes nearly a profile, the artist had to carve only one ear on each head. This he did with some diffidence or difficulty. In most instances the ears appear as awkward protuberances placed more or less at random in relation to other facial features, although they conform with the different arrangements of the hair. Rendered roughly as ovals with figure-eight cavities to support the articulation of the external meatus, the ears of Saints John and Simon are typical (Figs. 17, 19). Apparently such crudely fashioned ears conformed with contemporary practice, for the heads of the Saint-Denis statue-columns in the Walters Art Gallery in Baltimore have similar contours.

In contrast to the stylized eyes and ears, the apostles' mouths introduce a note of realism. The sensitively rendered lips, sometimes bowed, and the pronounced philtrums of the upper lips reflect the artist's careful observation and interest in facial detail, while slight variations enhance the individuality of each figure.

The arrangements of the apostles' hair and beards provided the artist with the most noticeable device for differentiating the figures. In every instance more or less parallel striations depict the locks

or segments of hair, but the arrangement varies from figure to figure. In general these arrangements follow six patterns:

1. Long in back, separated into locks that cap the forehead (Saints Andrew, Peter, and Bartholomew; Figs. 21, 23, 37)
2. Separate wavy locks similar to the above but longer and thicker (Saints Thomas and Paul; Figs. 15, 27)
3. As no. 2, but the locks overlap (Saint Matthew; Fig. 29)
4. Wavy separate locks with tightly defined, spiral curls at the ends (Saints James the Minor, John and Mathias; Figs. 13, 17, 39)
5. Overlapping pincurls (Saint James the Major; Fig. 33)
6. Long, waved hair arranged with a center part and drawn back from the face over or behind the ear (Saints Simon and Phillip; Figs. 19, 35)

In contrast to the dissimilarity in the treatment of the eyes, almost identical conventions define the hair and beards of both the apostles and the original heads surviving from the central portal of the west façade.[45]

As a final consideration in the analysis of anatomical details, the apostles' hands and feet show the same stylistic compromise between generalized, conventional rendering and depiction of carefully observed detail. The frontal poses allowed little variation in the positions of the feet, which stand firmly on the ledge between the bases of the arcade (Figs. 47, 55). Most of the toes of the bare feet appear normally proportioned and articulated. Only those of the three apostles at the right end seem elongated and rather hastily carved. While gestures vary and the elongation of the fingers seems exaggerated in a few instances, the hands despite their minute scale give the impression of natural forms—another reflection of the artist's desire and ability to imbue the figures with reality.

The apostles' clothing, although insistently varied in detail, con-

forms to a single type. The artist achieved his effects by both styl-
ized and natural rendering of the drapery. Each figure wears an
ankle-length tunic, known in the Middle Ages as the *bliaud,* cov-
ered by a long, loosely fitted ankle-length cloak, or mantle.[46] The
graceful flowing folds of the mantles recall, quite appropriately
for the apostles, the apparel of antiquity. The artist, who never
repeated an arrangement of the mantle, has shown how differently
these simple garments could be worn. Either gathered in one hand,
under an elbow, or dropping vertically from the forearm, the
drapery emphasizes the various gestures and contributes to the
rhythmic unity of the group.

The *bliaud,* which fits closely around the neck, is usually distin-
guished by tight sleeves of a goffered material, presumably linen.
The fabric, retaining the folds impressed on it by a hot iron, has a
design variously identified as the accordion pleat, the plaited
fold, the wattle, waffle or beehive weave, or simply crumpled stuff.[47]

Ornamental bands with geometric designs trim the edges of the
bliauds and mantles, except for those of the four apostles to the left.
Possibly those missing borders belong on the list of details left un-
finished when the bas-relief was put aside. When the borders
consist of applied bands incorporating jewels and other ornaments
they are called *galons;* when jewels are stitched on and the patterns
woven into or embroidered on the fabric in golden or metallic
thread, the borders are called *orphreys.*[48] These decorated borders,
traceable back to antiquity, also occur throughout Byzantine art
as a mark of distinction especially of royalty or of the higher hier-
archies of angels. Since richly decorated borders ornamented
Christ's costume on the lost golden altar frontal given by Charles
the Bald to Saint-Denis (Fig. 75), this may be another detail for
which prototypes existed in the abbey's treasure.

The goffered folds of the sleeves of the tunics, the orphreys of
both tunics and mantles, contribute to the decorative effect of the
apostles' costumes, but only as subordinate details. The arrange-

ment and the simple treatment of the folds of the drapery create
more dominant patterns which balance the complicated designs of
the arcade. These controlled accents depend on both natural and
stylized forms. The repetition of triangular folds on the upper part
of the tunics of Saints Simon, Peter, and Matthew and again on the
mantles over the thighs of Saints Thomas, Andrew, and Philip are
noticeable stylizations. Equally unnatural or conventionalized folds
enliven the bottoms of most of the tunics. The swirl and gathered
knot over the right ankle of Saint James the Major (comparable to
the folds over the left ankle of the third Elder of the second archi-
volt, right side of the western central portal) provide the most
exaggerated example of this stylized agitation. These essentially
decorative patterns, a fundamental characteristic of Romanesque
drapery, do not, however, dominate the general effect established
by the treatment of the majority of the costumes. Their rhythmi-
cally repeated folds, which curve and fall in lines expected of a
light textile, represent a different concept for the handling of dra-
pery. To claim that the tunics and mantles define the contours of
the apostles' bodies would be an exaggeration; nevertheless, the
drapery neither denies those contours nor exists independently of
them. Nor does the cloth cling to the body as in the Byzantine
"damp fold."[49] Yet the rolled edges of the mantles and the softly
modeled folds repeat the curves of the anatomy, emphasizing the
roundness of arms or thighs. Although weathering of the remaining
original surfaces of the western portal figures makes comparisons
difficult, the sleeves of some of the angels, particularly those in the
center of the first archivolt of the central portal, show a similar
treatment of the drapery. The similarities disappear, however, if
comparisons are attempted with the stylized folds of the clothing
of the seated apostles on the central tympanum, or with the angel
pushing a soul toward Hell in the first archivolt. The stylizations
of that angel's drapery bespeak familiarity with Romanesque carv-
ings of the Languedoc.[50]

Prototypes for the handling of the drapery of the bas-relief exist, not in the Languedoc or Burgundy, but in the metalwork of Renier de Huy and his followers in the vicinity of Liège. Notable examples occur in the scenes of the baptisms of Christ and Craton on the baptismal font in Saint Bartholomew's, Liège (Fig. 77), on figures of the Saint Hadelinus shrine in Visé, and on the pedestal of the Cross of Saint Bertin.[51]

One particular detail of the apostles' drapery deserves brief mention because Émile Mâle, commenting on the same detail recorded in a Montfaucon drawing of a statue-column from the right portal of the west façade, described it as a "most singular manner," "a bizarre disposition."[52] On the bas-relief Saint Simon grasps the lower part of his mantle and pulls it across his body in the same way as the statue-column so that the end of the loop of material gathered in his left hand almost resembles a knot (Fig. 19). This arrangement or gesture, actually not uncommon, represents the natural way to gather and draw the awkward lower portions of the mantle away from the feet, thereby allowing freer movement.[53] On neither the bas-relief nor the statue-column does the gesture suggest movement; in both instances the artists evidently used it to enhance the rhythmical relations between the figures.

This conscious ordering of the gestures and poses of the apostles distinguishes the bas-relief and identifies an important characteristic of the Saint-Denis style. The earlier discussion of the order of the apostles noted briefly their arrangement in groups and the resulting subtle rhythms. Such rhythmical accents occur in many twelfth-century sculptural compositions; but only a very few reveal the deliberate intention of creating both close relations between smaller groups of figures and overall unity as well.[54] This concept of the interrelationship of parts to the whole can best be demonstrated by a brief description of the figures.

From left to right the first group consists of Saints James the Minor and Thomas. The simple device of turning their heads to-

ward each other establishes a conversational relationship (Frontis-piece, Figs. 13, 15). Saint James turns his back to the column which abuts the left border of the enclosing frame. This positive stance with its almost unbroken vertical line from the right shoulder down to the ankle lures the viewer's eye away from the frame and into the grouping of the apostles. The loss of the right forearm and hand unquestionably weakens the intended horizontal accent of the arm, which after leading the eye to the right originally carried it up toward the capital of column 2. The line of the arm must have echoed the diagonal of the book held in the left hand. The evidence supplied by the rough area on the left acanthus volute of capital 2 suggests that the lost hand actually touched the capital (Fig. 13). The angle of the broken surface above the loop of the sleeve con-firms this supposition, and the broken nose triangulates the area where the damaging blow occurred. The lost gesture would have affirmed the relationship between the first two figures, while the folds of the mantle falling directly from the covered left hand pro-vide the stabilizing accent necessary to the unity of the first figure.

Saint Thomas's head, almost in profile, turns abruptly over the right shoulder to face Saint James. His right arm continues the diagonal of Saint James's book, and the slight curve of his right hand carries that unifying line along his left shoulder and on down the natural curve made by his left arm and hand which supports the bottom of the book. The undercut edge of Saint Thomas's mantle, as it falls from the right forearm, gives a sharp linear ac-cent, repeated by the vertical position of the book and the shorter vertical folds of the left edge of the mantle. Saint Thomas stands solidly on his feet, his gestures self-contained, but the insistence of his regard to his right demands another figure or object to com-plete the implied movement. Saint James provides this stability, while the subtle arrangement of their gestures and the curves of the mantle hemlines unite the two figures into a single composition.

Saint John, the third figure from the left (the only youthful,

beardless apostle, according to custom) stands alone (Fig. 17). His head, turned slightly to his left, breaks any relationship with Saint Thomas but does not insist on a complementary factor on the other side. The somewhat awkwardly executed right hand, with its palm facing outward in a gesture of greeting, emphasizes his isolation.[55] The vertical folds of the mantle falling from his left wrist balance the gaze of his eyes, so that the figure stands independently of the others. The delicate modeling of the lower part of his mantle and the folds of the bottom of the tunic again demonstrate the artist's sensitive skill and his devotion to every detail (Fig. 47).

Saints Simon and Andrew, the next group to the right, turn toward each other, which immediately establishes their interrelationship (Figs. 19, 21). Further linked by their gestures, the two apostles exhibit subtle variations on the positions of the arms and hands of Saints James and Thomas. Not only Saint Simon's pose, enlivened by the distinctive treatment of the mantle held in his left hand, which overlaps the shaft of the adjacent column, but also the change in the position of the book, here held in his right hand, reflect the artist's search for variety. Saint Andrew, like Saint John, holds a scroll, whose vertical lines repeat those of the edge of his mantle, undercut and falling from his arm. Again the curving lines of the borders of the two mantles provide an additional visual link. Although complete as a composition, the group has one small detail that calls attention to the presence of Saints Peter and Paul in the center of the relief: with his right index finger Saint Andrew points over his left shoulder toward the pair.

The line of Saint Andrew's finger leads directly to the top edge of Saint Peter's great keys. Then the abrupt strong diagonal of the keys leads the eye down to his right hand held horizontally in a natural position across his torso. Simple details such as the dome of Saint Paul's large, bald head and Saint Peter's monumental keys further attract the observer's attention (Figs. 23, 27). The turn of

their heads and the relating gesture of Saint Peter's left hand across the column's shaft in a line continued by Saint Paul's right forearm and thumb contribute to the visual and psychological unity of this focal group. Unfortunately the damage to the lower portions of Saint Paul's costume obscures the possible effect of the drapery design, although the deep shadow of the right edge of the mantle corresponds to similar vertical accents in other figures. The slant of Saint Paul's book leads the eye on to the next group. The right index finger of Saint Matthew pointing to his name on a scroll seems to continue the diagonal line of the book.

Saints Matthew, James the Major, and Philip form the first group on the right side of the bas-relief (Figs. 29, 33, 35). By grouping three rather than two figures, the artist found a clever variant on the arrangement of the five figures on the left side. Saints Matthew and Philip both turn to Saint James, establishing a psychological unity among these three figures who are visually contained and connected by the scrolls of the outer figures. Overlapping the shafts of the columns, the scrolls point to the central Saint James. With his two arms tightly clasping the book to his chest, Saint James performs perfectly his axial function, which receives emphasis from the long vertical line of the right side of his mantle.

Saints Bartholomew and Mathias turn toward each other to form the final group on the right (Figs. 37, 39). Saint Mathias gestures toward Saint Bartholomew with his right arm extended and the hand overlapping the column shaft. His left index finger points in the same direction and emphasizes the relationship between the two figures, who are linked again visually by the curve along the hemlines of their mantles. The poses and gestures of this group almost mirror those of Saints James the Minor and Thomas at the other end. Balancing each other at opposite ends of the arcade, Saints James the Major and Mathias face and gesture toward their fellow apostles. Such an arrangement, clearly deliberate, confirms

the artist's lively concern with the relations of the individual fig-
ures to each other and with the concept of the apostles as a unified
group.

These gestures and the arrangements of the drapery have also
been interpreted as indications that the artist used the statue-col-
umns of the western portals as his models.[56] This observation,
made shortly after the discovery of the bas-relief, emphasizes the
difficulties and dangers involved in a comparison based on docu-
ments rather than on examination of the original work of art. The
statue-columns, known only from a few fragments and from the
early eighteenth-century drawings published by Bernard de Mont-
faucon,[57] quite obviously were conceived on a monumental scale.
One of the figures of the relief apostles, if placed in front of one of
the statue-columns, would not equal in height the head of one of
the latter.[58]

However, the near contemporaneity and identity of provenance
of the two groups of figures, together with the above-mentioned
similarity in gesture and drapery arrangements, deserve comment.
The earlier discussion which postulated a copybook as a source for
the wide variety of ornamental motifs raises the possibility of a sim-
ilar common source available to all in Suger's workshops, a copy-
book on which they relied for general iconography, poses, and
gestures.[59] However, the Montfaucon plates do not reveal any in-
terrelationships generated by the gestures of the statue-columns.[60]
In my opinion the deliberate organization of the apostles in groups
and as a whole reveals a critical concern of the bas-relief artist and
suggests the superficiality of any resemblance of his work to the
statue-columns.

Although the order of the apostles from left to right could have
some significance, their sequence on the bas-relief, with the excep-
tion of Saints Peter and Paul in the center, seems random. Various
medieval systems reflected an order among the apostles: the calen-
drical sequence of their feast days, the order in which they under-

took their missions, their order in relationship to the Twelve Tribes of Israel, or the order ascribed by tradition to their participation in the statement of the *Credo*. But, as a survey has shown, artists often disregarded these systems, an indifference especially characteristic of the twelfth century.[61] The arrangement, however, of the apostles in groups of twos and threes, as though conversing, distinguishes the composition of the Saint-Denis relief.

Depicted in apostolic dialogue, or grouped *in disputatione,* these conversing apostles carry on a tradition that goes back to antiquity and signifies the essential function of the disciples as teachers of men. Medieval teaching took the form of a *disputatio* or discussion of true and false.[62] One of the most celebrated twelfth-century teachers, Peter Abelard, renowned for his disputations, sojourned briefly in the abbey after his mutilation in 1119. The occurrence of the *disputatio* motif both in the bas-relief and in the grouping of the apostles in the tympanum of the central portal of the west façade may well reflect a special awareness of the importance of Abelard's "new" dialectic.[63]

PALEOGRAPHY

The studied control of the apostles' disputative gestures, which again and again stretch across the framing arches to unify the composition, shows a formal sophistication quite lacking in the inscriptions that identify the figures. A brief analysis of the inscriptions provides the final step in evaluating the objective evidence provided by the carving—evidence that supports a date in the second quarter of the twelfth century. In addition, the idiosyncracies of the lettering reveal something more about the background and training of the artist.

The totally haphazard arrangement of the names of the apostles written in an angular majuscule suggests an illiterate artist, who copied his letters and abbreviations from other inscriptions or a copybook and then struggled to fit the letters into limited spaces.

An extreme example occurs in the name *Thomas*, on the book held by the second apostle from the left (Figs. G, 15, 24). Some of the other inscriptions at Saint-Denis show the more regular, more *soigné* character of twelfth-century writing as it moved toward the Gothic script.[64] Yet the irregularities and ligatures of the bas-relief inscriptions are not at all unusual for that time.[65] Similar contractions occur on a number of mid-twelfth-century objects, including the mosaic medallion at Saint-Denis depicting the monk Albericus,[66] and the corbels in the radiating chapels where the original inscriptions record the date of consecration as June 11, 1144 (Fig. 66). Except for the *-as* in *Thomas*, the lettering on the bas-relief uses normal ligatures, which occur as abbreviations for the ending *-us* (Figs. H–J, 27, 29, 35). Distinctive among the letters are the *A, N,* and *T* (Figs. K–M). The *A* and the *N* appear fre-

G.–J. Inscriptions of Saints Thomas, Paul, Matthew, and Phillip

G

I

H

J

K. The letter *A* L. The letter *N* M. The letter *T*

quently among the mason's marks recently uncovered by the clean-
ing of the interior of the western bays at Saint-Denis. These marks
belong to the first campaign of Suger's building program.[67]

A more distinctive feature of the inscriptions on the bas-relief is
the manner of their carving. Rather than incising his letters in
the characteristic manner of stonework, the sculptor carved most
of them in raised relief (Figs. 15, 19, 27, 29, 35).[68] Although called
"unworthy of a stone carver,"[69] such raised inscriptions prove not
uncommon in the twelfth century. These embossed letters imitate
the repoussé of metalwork technique (Fig. 78).[70] In the carving of
the bas-relief the recurring evocation of techniques other than stone
carving, especially those associated with metal, serves as a specific
clue to the artist's identity.

4. *The Artist and His Style*

Unlettered, as were most of his fellow artists, the sculptor of the Saint-Denis bas-relief betrays his origins and training by a number of idiosyncrasies, identified in the preceding pages. The delicate, minute execution of decorative details, often applied to surfaces with scant regard for the area or its function, the designs assembled of component parts, and the direct imitation of forms developed in the working of precious metals, all emphasize his knowledge and instinctive use of techniques familiar to a goldsmith. In the eleventh and twelfth centuries the area distinguished for its metalwork, above all others in western Europe, was Lotharingia. The prominent profiles of the apostles, referred to as characteristic of Lotharingia,[1] as well as the natural treatment of the folds of their drapery and the repeated use of the pinecone-palmette motif in the relief borders and on capitals and shafts, add supporting evidence to a Lorraine provenance for the artist.

That region appeared as a geographical entity at the death of Lothaire I in 850, when his kingdom, the Francia Media in the subdivision of Charlemagne's empire, was redivided into two parts. Allocated to Lothaire II, the northern portion—accordingly Lotharingia, or Lorraine in modern times—signified the lands north of the Vosges, including originally the lower Rhine Valley and the Lowlands.[2] These northern areas were still regarded as part of Lorraine in the early twelfth century, for Guibert de Nogent called Godfrey, Count of Namur in Belgium, a "Lorrainer."[3]

Among the many regions from which Suger "summoned" his "skillful crowd" of artists, he mentioned only one area by name. The reference cites "several goldsmiths from Lorraine—at times

five, at other times seven,"[4] who completed in less than two years the great gold and enamel crucifix consecrated at Saint-Denis on June 11, 1147, as Louis VII departed for the Second Crusade.[5] Suger's selection of artists from this northeastern region is not surprising for unquestionably he saw their work when he attended the Reichstag in Mainz on August 24, 1125, or when, in all likelihood, he accompanied Pope Innocent II on his trip to Liège in 1131.[6] The identification of the artist of the bas-relief as a Lorrainer affirms the presence of artists from that region in the Saint-Denis workshops before work on the Great Cross was begun. Although scholars have noted influences from the Mosan-Rhenish area in the iconography and in many stylistic details of the decoration of both the western portals and the stained glass windows of the radiating chapels at Saint-Denis, the extent of this particular ingredient in the style of Suger's workshops has not as yet been adequately defined.[7] The bas-relief provides an excellent opportunity to examine the character of the contributions of these "northern" artists, when work at Saint-Denis was in full progress.

In general appearance, in the details of the ornament, and in the figure style of the apostles, the relief as a work of art has a number of unusual features. The varying stylistic labels used by art historians to describe it—"Romanesque," "late Romanesque," "transitional," "both Romanesque and Gothic"—reflect its singularity.[8] The last phrase I myself selected in 1953, as I began this detailed study. Some explanation of my understanding of these terms seems essential at this point.

In my vocabulary, Romanesque refers to western European art of the eleventh and twelfth centuries with several specific characteristics: A preoccupation with decorative designs was of primary significance to the style, and often resulted in arbitrary or fantastic combinations of both animal and vegetal forms in close accord with an architectural setting.[9] This architecture, predominantly monastic, provided sanctuaries from the turmoil of feudal anarchy. In

his condemnation of Romanesque sculpture Saint Bernard de Clairvaux used the unforgettable phrase "that marvelous and deformed comeliness, that comely deformity."[10] His concept and Henri Focillon's reference to the "epics of chaos" which obsessed the Romanesque mind[11] are fundamental to my definition. Yet those qualities do not encompass all eleventh- and twelfth-century works of art, for many reflect regional variations endemic in the complex society of the period.

Gothic art is distinct from the Romanesque. Increasingly during the twelfth century emphasis shifted from a rural to an urban economy, producing a different sense of values and a growing confidence in relative security. Saint Bernard's assertions of the positive function of love and charity,[12] a renewed fascination with the Neoplatonic emphasis on light as the ultimate source of inspiration and faith,[13] and Abelard's insistence on reason and individual choice fostered a growing respect for man.[14] As a result the artist became less preoccupied with fantasy and imminent disaster. His attention focused on the image of man as God's representative on earth, and his art reflected increasing confidence in the possibility of salvation through an understanding of the Holy Scripture together with the sympathetic intercession of the Virgin Mary. Clarity of representation and subtle exposition of dogma produced figures and scenes of didactic significance, inseparably united with the fabric of buildings pervaded by light, which presented man's vision of the Heavenly Jerusalem.[15]

Early Gothic, centered in the royal domains of the Île de France, during the middle and second half of the twelfth century, in my opinion refers to the artistic productions which reflect this proto-scholastic attitude in varying degrees. Since, in the course of history, all creative efforts are by their nature "transitional," that term loses significance as a rubric for a particular style. Early Gothic inescapably betrays many Romanesque features, but its emphasis is different. Comparisons of the bas-relief at Saint-Denis with other

sequences of figures under arcades show the ambivalent yet excit-
ing search for new formulas that distinguished the art produced at
the royal abbey, "the cradle of Gothic art," in the late 1130s and
early 1140s.

The concept in Christian art of placing a series of figures under
arches can be traced back to the second and third centuries in Asia
Minor.[16] The theme became current in the Latin West as early as
the fourth century and continued to be especially popular for
the decoration of sarcophagi and baptismal fonts as well as reli-
quaries, portable altars, and altar frontals.[17] On his trips through
southern France and in Italy Suger must have seen a number of
early sarcophagi presenting apostles under arches on one of the
long sides, such as that now in the Arles museum (Fig. 74).[18] His
selection of this theme for the replacement of the lost side of the
"most sacred sarcophagus" destined for the tabernacle of the new
altar reflects his awareness of an iconography that was both vener-
able and appropriate. In addition, Saints Peter and Paul in the cen-
ter of the bas-relief not only honored Saint Denis as Saint Paul's
disciple, but also provided a direct reference to Rome from which
Saint Denis had set out to establish Christianity in the Paris re-
gion.

The representation of apostles under arcades on early Christian
sarcophagi, however, differs markedly from the manner of their
depiction on the bas-relief. The "antique" or "classic" manner,
perfectly exemplified by the sarcophagus at Arles, shows the ar-
cade as a decorative framework within which the figures move at
ease, unrestricted by any limits. If Suger's artist had wished to
emulate this early tradition, he had at hand, among the treasures
at the abbey, an excellent example which Suger admittedly greatly
admired. The resplendent altar frontal, given to Saint-Denis by
Charles the Bald about 870, adorned the high altar west of the new
choir.[19] This large gold panel showed three figures under arches
on each side of the larger figure of Christ in Majesty (Fig. 75). Pre-

sented as individual saintly beings, each with a halo, all six of the figures turned toward Christ and all held books, with similar if not identical gestures. Functioning as decorative frames, the arches extended high above their heads. Although the space between the column shafts restricted the figures to a limited degree, the arched frames in no way dictated their proportions, as do the arches of the bas-relief.

Certainly Suger recognized this "classic" manner of showing figures under arcades. He also knew more contemporary systems. In 1108, for example, a new altar was dedicated at Saint-Benoît-sur-Loire, where Suger may have studied in his youth.[20] The miserable condition of the fragments that have survived preclude complete analysis, but some distinctive features are observable. Their feet on arcaded pedestals, seated figures with halos face frontally under a decorated arcade. Variants on a spiral design decorate all the column shafts, and variations on a simplified palmette motif occur in the capitals. In the spandrels and the arches a sequence of arcaded architectural forms present an early version of the turreted canopies that appear so frequently on early Gothic portals.[21] While these features produce a richly ornamented effect, as a concept they remain distinct both from the decoration and from the figure style of the bas-relief.

On a lintel over the portal of Châteauneuf-sur-Loire, twelve crudely carved apostles stand under a continuous, unornamented arcade (Fig. 80).[22] Suger unquestionably saw them when he was summoned to Châteauneuf in 1135 to attend the gravely sick Louis VII.[23] These stocky, puppetlike figures fill the arches; but, aside from the fact that Saint Peter, with a large key, occupies the central position, this series bears no resemblance to the bas-relief.

Two even more enigmatic figures under arches can be seen today inserted into the masonry of the north transept gable of Saint-Hilaire in Poitiers.[24] Suger probably saw them, possibly in their original location, when he went to Poitiers in 1137 for the marriage

of Louis VII and Eleanor of Aquitaine.[25] Here adossed birds fill
the spandrels and vegetal designs decorate the capitals. The man-
ner in which the figure on the right gestures across the shaft of
the intervening column relates the two as a pair. At Saint-Hilaire
the style of these two figures contrasts strongly with the adjacent
pair in a fragmentary arcade inserted into the transept masonry
at the same time. On the basis of their crude appearance, the latter
two have been assigned an earlier date and associated with fourteen
figures under arches, inserted more or less haphazardly into the
masonry of the western façade of the small church at Azay-le-Ri-
deau.[26] Although these figures belong to a tradition distinct from
that of the Saint-Denis apostles, several of the figures deviate from
the rigidly frontal pose to grasp the shaft of the adjacent column—a
precocious example showing some relaxation of the Romanesque
law of the frame.

Another monument of this Poitou region with figures under ar-
cades turning toward each other in groups of two is the tomb at
Airvault of Abbot Pierre de Saine-Fontaine, who died in 1110
(Fig. 81).[27] One side of this tomb shows nine figures within a wide
border. They stand on oddly shaped pedestals under a solid arcade
with shafts decorated by spiral and chevron designs in much the
same manner observed on the Saint-Benoît-sur-Loire altar. The
rustic, yet powerful, carving of the figures contrasts sharply with
the subleties of the Saint-Denis apostles; but the evident desire to
relate the figures to each other represents a principle which also
interested the artist of the bas-relief.[28]

Another variant on sequences of figures in architectural frames
remains for consideration. In this group the figures are small in
scale, and the architectural frames often fragmentary. Composed
of pilasters or half-columns attached as purely decorative elements
to a common background, those components do not necessarily
connect to form the architectural entity of an arcade. Such highly
decorative sequences embellish the sides, tops, or ends of many

portable altars or reliquaries of varying shapes and sizes produced by the artists of the Mosan-Rhenish areas in the eleventh and twelfth centuries. Neither stone nor marble, these figures were either incised into a metal surface or made in repoussé relief (Fig. 78). Normally, brightly colored cloisonné or champlevé enamels enriched the architectural forms.[29] Created not from a single homogeneous mass, these reliquaries and altars were made in units, then assembled and attached to a wooden or metal core. In terms of the relationship between the figures and the architectural frames this series follows more closely the "antique" or "classic" tradition than the Romanesque "homme arcades" of the lintels, altars, or tombs described in the preceding pages, since each figure, whether seated or standing, remains independent of the decorative frame.

As already mentioned, Suger must have seen examples of these Mosan-Rhenish altars or reliquaries during his trips to Mainz in 1125 or to Liège in 1131, or elsewhere because of the mobility of such artifacts. He also evidently commissioned an ivory casket which shows the influence of these "northern" artists. Evidence for such a casket exists in three small plaques in the Louvre, with figures under arches identified as Saint Denis, Rusticus and Eleuthereius, and the Twelve Apostles (Fig. 67).[30] The specific identification of Saint Denis and his legendary companions attests that these plaques were made at, or for, the royal abbey, and the style of the figures suggests an artist of Mosan origin.[31] In the study of the bas-relief these plaques provide interesting evidence of the interaction of influences in Suger's workshops.

The small ivory figures, only 7.5 centimeters (3 inches) high, stand in open arcades with their names inscribed on the slanted intrados of the arches almost touched by their heads. Their minute scale obviously creates a different effect from that of the much larger figures of the bas-relief, but the open arches free them from the constraint of the relief arcade. As the plaques were designed to be attached to a background of different material, probably gilt

bronze, these open arches were intended to reveal the contrasting mounting. The ivory differs from the relief in many other details, including the uniformity of the simple beaded decoration on the arches, the undifferentiated stylized foliate capitals, and the undecorated column shafts and bases. Even with allowances for differences in scale, the folds of the drapery on the ivories appear more arbitrary and agitated. In both groups, however, the apostles turn toward each other with gestures that indicate they are conversing, or *in disputatione*.

Earlier references to the conversation or "dialogue" of the apostles identified it with an antique theme relating a philosopher and student, or poet and muse. Early Christian art appropriated the convention to represent the apostles as teachers of Christian dogma.[32] Quite a number of marble sarcophagi from southwestern France, usually dated in the sixth or seventh century, show the apostles grouped in pairs, conversing.[33] Although an infrequent theme in Carolingian art, a very lively dialogue appears on an ivory plaque for a reliquary casket of the tenth century, now in Quedlinburg.[34] The examples cited above of figures under arcades from the Loire Valley and Poitou in the eleventh and twelfth centuries seem unrelated to the dialogue theme. Other Romanesque examples, however, of figures *in disputatione* include the apostles from the chapter house of Saint-Étienne in Toulouse, the figures on the right jamb of the Vézelay portal, and the relief showing six apostles in pairs under arches in the Basel minster (Fig. 85).[35] Eilbertus of Cologne also attached importance to the theme, for he represented it on the sides of his Darmstadt portable altar and on the top of the Mauritius portable altar (Fig. 79).[36] In fact the tendency toward theatrical gestures and vocalizations had become so noticeable in the liturgy that Abbot Aelred of Rievaulx (1150–66) felt impelled to censure the practice.[37] The censure, unlike those of Bernard de Clairvaux, had little effect. The depiction of the dialogue of the apostles continued with increasingly lively gestures

and animated postures characteristic of the Pentecost retable from Saint-Castor in Koblenz, now in the Cluny Museum, Paris, and the famous reliefs in the choir of the Cathedral of Bamberg, as well as in liturgical dramas and mystery plays.[38]

At Saint-Denis three works of art with apostles *in disputatione* have survived: the apostles flanking Christ in the tympanum of the central portal, the three ivory plaques of the casket in the Louvre, and the bas-relief. Although a familiar theme by the mid-twelfth century, the manner of its presentation at Saint-Denis differs in each instance.

The master of the tympanum apostles, for instance, presented his figures in two seated groups united by pose, gestures, and carefully composed rhythmic designs of the drapery (Fig. 69). Each group exists as a unit in the overall composition of the tympanum, separated from each other by the dominating figure of Christ, from the lower Resurrection zone by the continuous horizontal ledge on which their feet rest, and from the upper portions by Christ's outstretched arms and the scrolls he holds. Crossed legs and the impossible pose of the third apostle from the right, with feet contorted so that the toes meet and the insteps form a *V*, perpetuate familiar Romanesque conventions. At the same time the artist promoted visual, didactic clarity—a Gothic desideratum—with empty, undecorated spaces between the groups, around the central figure of Christ, and above the apostles' heads carved in full relief from the background. The inclusion of the Virgin Mary, seated with the apostles on Christ's right, is an iconographic innovation.[39] She holds the edge of her mantle in her hands with a gesture that subtly refers both to her grief at the death of her son and to her importance as a supplicant for the salvation of mankind at the Last Judgment. Her presence reflects the growing cult of the Virgin, which culminated in the representation of her Coronation on Gothic portals.

The "Mosan" ivory carver isolated his apostles in separate open spaces in a classical manner. The figures, however, are almost as

high as the arches, and the slopes of their shoulders conform to the shape of the adjacent capitals. The contorted animal forms in many of the spandrels adhere even more closely to Romanesque principles of decoration. Although the figures turn toward each other and their restrained gestures indicate their conversations, there are no observable Gothic tendencies. This artist followed very closely the traditions of his Mosan background.

The artist of the bas-relief, also of Mosan origins and training, reacted within the new international environment of Suger's workshops in a different manner. His work reflects a willingness to experiment with interchanges of techniques and media and with unfamiliar concepts of form. His early training as a metalworker enabled him to conceive and to carve richly decorated surfaces in stone that would harmonize with the other resplendent decorations of the new altar.

A similar concern with harmonious forms appears in the works of the month, carved on the jambs of the southern doorway of the western façade. There the medallions of solid garlands, joined by lionlike masks, resemble the work of bronze casters who were summoned by Suger to make new doors for this and the central portal (Fig. 61).[40]

The artist of the bas-relief also attempted to reconcile the Romanesque concept of forms dominated by architectural frames, possibly expounded by sculptors from the Languedoc or Burgundy at work on the decoration of the western portals, with a more Mosan, and ultimately Gothic, concept of interrelated figures. The results include the unresolved tensions, unexpected incongruities, and contrasts that endow the bas-relief with its particular allure and challenge. Immediately apparent is the conflict between the figures and the solid columns and arches of the arcade. The hands of Saints James, Peter, and Mathias reach out in conversational gestures to touch or overlap the confining architectural frame. Holding scrolls, the hands of Saints Matthew and Philip also ex-

tend beyond the allotted space, as does Saint Thomas's left hand clutching his folded mantle.

The numerous and deliberate inconsistencies in scale add to the stylistic tensions of the relief. The seemingly massive arches are scarcely larger than the apostles' heads. Scaled to the human figure such an arch would measure only about 30 centimeters (ca. 12 inches) across its base, whereas the columns, which with their bases and capitals reach the level of the apostles' eyes, would rise to a height of about 1.60 meters (5 feet). These proportions obviously belong to a grotesque architectural construction. Details showing similar incongruities include Saint Peter's keys which, on the human scale, would measure about 80 centimeters in length (over 2 feet 6 inches). The jewellike arcaded bases of columns 6 and 9 negate their architectural function of support, while the minute scale of the decorative motifs contrast sharply with the proportions of the arcade. The conscious use of modular relationships between the figures and the arcade and between parts of the arcade itself, mentioned earlier and in Appendix 2, dominate these inconsistencies in scale to establish an overall harmony.

Contrasts in the manner of the carving of the relief also suggest an amalgam of artistic ideas. In accordance with another principle of Romanesque sculpture, the relief was carved into the block of stone with careful respect for the frontal plane. Nothing projects beyond this surface, but at the same time undercutting of the figures defines their contours as though to free them from the surrounding arches and to create for each a spatial environment characteristic of early Gothic sculpture.

The proliferation of the decorative motifs over the entire surface of the bas-relief also creates a visual conflict. This "surornamentation" establishes a continuous plane against which the apostles struggle to affirm their identities by gestures and by their rounded contours.

Similar discrepancies, or lack of homogeneity, must be recog-

nized in any attempt to define or understand the style of Suger's workshops at Saint-Denis. Experts have often been disturbed by noticeable differences between, for instance, the style of the statue-column heads in the Walters Art Gallery, Baltimore, and the smaller statue-column now in the Metropolitan Museum, New York. These differences have led them to question whether such dissimilar examples could have been produced by the same workshop at more or less the same time. Special, rather unusual circumstances prevailed at Saint-Denis, so that the critic must be prepared to accept conflicting evidence. Different traditions can be recognized in the sculpture of the central portal of the west façade, as well as among the capitals of the crypt.

Combinations of different materials and of examples of widely differing artistic production seem to have delighted Suger. The few surviving objects from his treasury and descriptions of destroyed altars and other major creations confirm his predilection for variety and contrast, a preference he himself recorded: "Moreover, we caused to be painted, by the exquisite hands of many masters from different regions, a splendid variety of new windows, both below and above. . . ."[41] In Suger's international workshops mosaicists, enamel workers, bronze founders, goldsmiths, and painters of stained glass worked beside the stonemasons. Interchanges of techniques, various styles, unprecedented experiments with results for which no prototypes can be discovered must be accepted as the norm at Saint-Denis. As these artists, and others who were familiar with their work, continued to explore the new concepts and forms, they resolved some of the conflicts and created more coherent, harmonious ensembles. Perhaps the best example of this resolution may be seen on the western portals of Notre-Dame at Chartres, carved between 1148 and 1155, only a few years after the Saint-Denis portals and the bas-relief.

At Chartres twelve apostles, flanked by the standing figures of Enoch and Elijah, are seated under arches below the *Majestas*

Domini of the central portal (Fig. 83). The arrangements of the hair and beards share stylized conventions that belong to the same categories and answer the same descriptions as those of the bas-relief. Almost identical palmette motifs decorate the spandrels between the arches, and the nailhead motif found on arch 2 of the bas-relief decorates all the arches over the Chartres apostles' heads. Other familiar motifs of the bas-relief, such as the pinecone-palmette design or the combined zigzag pattern of column 8, occur in the ornament of the Chartres Royal Portals (Fig. 72).[42] Several of the heads of the small seated figures on the jambs of the Chartres doorways have proportions and profiles similar to the Saint-Denis apostles (Fig. 83).[43] Other details, not pertinent to the study of the bas-relief, also prove close contacts between the two workshops. In every instance the relatively low relief, the linear outlines, and crisp modeling of the Saint-Denis ornament contrasts with the deeper undercutting and more rounded contours of the Chartres examples—characteristics denoting a slightly later date for the Chartres portals. The Chartres apostles have more normal proportions, and the composition of the group is conceived as part of an architectural program rather than as a separate entity within an elaborately decorated ensemble. At Chartres the sequence of arches over each apostle's head is supported by only four columns, which emphasizes the horizontality of the group as a band related in height to the figures in the lowest zones of the adjoining archivolts. Some formal conflicts still exist, however, since these four columns divide the apostles into groups of three, whereas they converse in groups of two; but the major tensions existing between the Saint-Denis apostles and their decorative arcade have been largely resolved at Chartres.

Three other early Gothic tympani present seated apostles under arcades—the south portals of the cathedrals of Le Mans and of Bourges and the west portal of Saint-Loup-de-Naud. In all three, the heavy, continuous arcade and the relatively squat proportions

of the figures have prompted the suggestion that this series relates more closely to the Saint-Denis relief than to Chartres.[44] The almost exclusively geometric ornament, the turreted decoration of the arches and spandrels, and the arcaded pedestals under the apostles' feet resemble another series mentioned earlier which includes the altar of Saint-Benoît-sur-Loire and the tombs at Airvault and Saint-Junien. When combined with the influence of the Royal Portals of Chartres this tradition, identifiable with the Loire Valley and the Poitou, provides, in my opinion, more suitable prototypes for those other royal portals than does the Saint-Denis relief. The bas-relief relates to this series only in a general way as a representation of the apostles under arcades.

The statement that the bas-relief was "carved by an imitator of the style of the [Chartres] royal portal and, specifically, by a disciple of the master of La Charité-sur-Loire," is, I believe, equally mis-leading.[45] The lintels, or lower zones, of the two tympani from La Charité certainly relate closely to the lower zones of the south portal of the Chartres façade; but, in accordance with their geographic location, the Charité scenes exhibit features intermediate between Burgundy and Chartres—features notably absent from the Saint-Denis relief.[46] Although several of the La Charité figures have disproportionately large heads not unlike the bas-relief apostles, the profiles and stylizations of hair and beards differ as mark-edly as the handling of the drapery.

Notable similarities exist, however, between the Saint-Denis apostles and those of the Last Supper tympanum carved for a doorway of Saint-Bénigne in Dijon (Fig. 82).[47] Although the profiles are treated differently in Dijon, the hair, beards, and general physiognomy are almost identical. The even more marked simi-larities in the folds of the drapery, decorated with rich orphreys and goffered pleats, establishes their relatedness. Lacking the framing and determining arches, the seated Dijon apostles con-form instead to the space imposed by the semicircular typanum.

That conformity depends on changes in scale from the dwarflike, seated figures at each end to the monumental Christ in the center and the slender elongated apostle standing at his left. The arbitrary adjustment of the scale conflicts with the figures' natural gestures. Some hold bowls or cups, another has placed his hand in a friendly manner on the shoulder of the sleeping Saint John. As at Chartres, the influence, if not the actual presence, of the artist of the Saint-Denis relief is strongly sensed even though the Last Supper, carved in much higher relief, presents a more harmonious ensemble.

The spirit of the bas-relief artist also pervades the scenes of the Sacrifice of Abraham on a capital from Saint-Médard in Soissons, mentioned earlier in the context of the flamelike motif (Fig. 84).[48] The heads allow a significant comparison with those of the bas-relief, especially the head of Abraham, which, while carved with less precision, belongs to the same family as those of the apostles. Although the artist of the Soissons capital had some difficulty accommodating his figures to the available spaces, and his delineation of their drapery seems rough, nevertheless he achieved a degree of realism in their actions.

In addition to the bas-relief artist's relationships with workshops in the Île-de-France and Burgundy, one finds a persistence of his artistic ideas in Godefroid de Huy's workshop, or in the work of the latter's followers, in the regions northeast of Paris. The "Belgian-lower-Rhenish" profile continued in favor for several decades.[49] Other distinctive details, such as the palmette-pinecone design, also maintained their popularity in this same group.[50] Moreover, these goldsmiths found the "dialogue" of the apostles a useful theme for experimenting with varied movements and gestures. Examples, in repoussé relief, include the Servatius shrine in Maastricht and the retable from Saint-Castor in Koblenz, now in the Cluny Museum in Paris. In these works the apostles, presented in twos, show how varied the arrangements could be. The single figures of the evangelists eventually functioned as supports

not only in the portable altar of Stavelot, but also in the Saint-Bertin pedestal. In this transformation the artists translated the vocabulary of movements into freestanding three-dimensional sculpture and provided the necessary prototypes for the "Gothic" figures of Nicholas of Verdun in the last decades of the twelfth century.[51] The continued appearance of stylistic features of the bas-relief both in ornament and in the figure style of the early Gothic portals of the Île-de-France and Burgundy and in the metalwork of the Mosan-Rhenish regions proves that the unfinished work at Saint-Denis did not exist in an artistic vacuum. The bas-relief's artist's preoccupations were those of his generation—confirmation of the validity of this relatively unknown work of art.

Since scholars still dispute the degree of Suger's actual participation in the building and decoration of his new church, an additional question may be asked about the bas-relief: Does it provide evidence relevant to the great abbot's involvement in the work of the artists he summoned to Saint-Denis?

The decision to remove the sacred relics of Saint Denis and his companions, certainly the most treasured possessions of the abbey, from the relative security of the old *confessio* to the new choir, could have come only from Suger himself, and he alone had the authority to implement it. The idea of the altar as a tomb, with a symbolic tabernacle containing the "most sacred sarcophagus," must also have been conceived in consultation with him. The inscription on the back of the sarcophagus, recorded by Doublet, but missing from the abbot's own account, states that he, Suger, replaced its side, front, and cover.[52] The original plans for the restoration of the old sarcophagus called for a tablet of gold and precious stones to decorate the front or western end, which formed part of the altar. The adjoining long side, therefore, was intended to complement the metalwork, which explains Suger's choice of a Lotharingian artist to carve the bas-relief in the first place. The bas-relief reflects Suger's deepest convictions about the function and

appearance of works of art. Its discovery has brought us into his very presence.

> Thus, when—out of my delight in the beauty of the house of God—the loveliness of the many-colored gems has called me away from external cares, and worthy meditation has induced me to reflect, transferring that which is material to that which is immaterial, on the diversity of the sacred virtues: then it seems to me that I see myself dwelling, as it were, in some strange region of the universe which neither exists entirely in the slime of the earth nor entirely in the purity of Heaven; and that, by the grace of God, I can be transported from this inferior to that higher world in an anagogical manner.[53]

The bas-relief, left unfinished and carved in a modest material, transports us directly to the royal abbey in the early 1140s, filled with artists trained in all crafts, concerned with Suger's challenge to surpass the glorious achievements of all time. Few products of those workshops have survived in such pristine condition. Even though the sculptor of the relief failed to qualify in terms of Suger's highest standards, his efforts to honor "our lord Saint Denis, our particular patron" provide new insights into a singularly important moment of artistic development.

Appendix 1

GEOMETRIC, VEGETAL, AND SINGULAR MOTIFS

This detailed analysis of the different types of geometric and vegetal ornament supplements the discussion on pages 25–31.

GEOMETRIC MOTIFS

1. The basic *zigzag* and its variants discussed on pages 28–30.

2. *Circles*. A simple sequence of drilled holes accented by one or two raised rims. Examples of this decorate the inner archivolt of arch 10, astragal 9, the upper tori of shaft 10, and bases 9 and 10, and the plinth of base 12 (Figs. 32, 34, 38). Similar circles occur in the bands of the spiral on shaft 3 and the chevron on shaft 9, as well as on the bottom band framing the lower border (Figs. 16, 32). On the inner archivolt of arch 7, a series of drilled holes provides the major accent (Fig. 26). Joined by an undulating double band, this series becomes a continuous pattern resembling a curvilinear zigzag. Small triangles under each hole further elaborate the design. In another variation found on arch 5, small leaves fill the spaces between the drilled holes (Fig. 20).

3. *Ovals*. Two segments of circles arranged symmetrically combine to create the oval designs on arches 5, 9, and shaft 2, as well as the lozenges on the covers of the books held by Saints James the Minor and Major, Bartholomew, and Mathias (Figs. 13, 33, 37, 39).

4. *Hemispheres or beads*. These appear in continuous series between two ridges as, for example, on the inner frame of the upper border and on astragals 10, 11, and 13, and on the upper torus

of base 9 (Figs. 34, 36, 38). They also combine with many other motifs to provide accents and often transform a simple design into a more dynamic one (note particularly the beaded rinceau of the major border *h*). Larger hemispheres decorate the inner archivolt of arch 2. Alternate ones have perpendicular incisions which may indicate the origin of this pattern in metal nails or rivets used to attach metal or ivory plaques to a wooden core or background.

5. *Spiral.* Basically a circle pulled into the third dimension, this form underlies the principle of the decoration on shafts 1, 3, 5, and 13, and on base 11 (Figs. 12, 16, 20, 38, 36). It also provides the basis for the rope motif on astragal 8 (Fig. 28).

6. *Arcades.* Minute open arcades, quite unusual in stone sculpture, decorate the bases of columns 6 and 9 (Figs. 23, 33). Base 6 in its entirety, i.e., from the bottom of the shaft to the horizontal band on which the base is placed, presents a complicated profile not found in architectural forms. Its lower portion resembles a canopy resting on three semicircular arches. The foliate decoration on the outer edges, the loops between the arches, and the arches themselves, are the essence of metalwork. Such a form could only function as a support for a small object; it must derive ultimately from some jewel mounting.

The second arcaded base, 9, also light and open, has five instead of three arches which spring from minuscule spiral shafts that resemble columns made of twisted wire. In jewelwork such arcaded mountings had the function of enhancing the sparkling effect of jewels by allowing light to shine through from beneath (Fig. 62A). Here they heighten the decorative effect and accent the small scale of the architectural frame.

A third arcade occurs on the base of column 3 in rhythmic succession to the two already examined (Fig. 16), although its four arches lack the characteristics of metalwork. Here the relatively heavier arches conform more closely to sculptural or carving techniques than to those of working precious metals, but they provide

a sharp visual accent equal to that of bases 6 and 9. Base 12 continues the numerical progression of a strong rhythmic accent, occasioned in this instance by drilled cavities (Fig. 38).

Arch 9 contains another arcade carved in relief with tiny spiral columns (Fig. 32). The so-called capitals or finials of the columns consist of balls or beads, like drops of granulated gold, which fill the spandrels between the low segmental arches. Here, unlike the open arcades of the bases, a series of small ovals surrounded by beads or serrated edges fill the area under the arches. The sculptor has created the illusion of little jewels held in place by decorated metal bezels, again devices familiar to the art of a goldsmith.

VEGETAL MOTIFS

1. *Acanthus.* Columns 9 and 10 have capitals quite obviously derived from Corinthianesque prototypes (Figs. 32, 34). Their foliate ornament resembles the familiar acanthus leaf, stylized and simplified in many ways, but with the essential elements of a relatively long spine, symmetrically serrated edges, and a curled-over tip. Similar leaves appear on capitals 4 and 12 (Figs. 18, 38). On arch 10 they form a sort of garland that fills the frame of the arch (Fig. 34).

2. *Palmette.* The design of the palmette, as described in the text, originally emulated the tuft of leaves at the top of a palm tree. Symmetrical natural forms provided the inspiration, at a very early date, for purely decorative designs such as the anthemion in Greek ornament. The palmette competes with the zigzag as a favorite motif of the artist of the bas-relief. Typical examples, repeated each time in almost identical form, occur in the spandrels of the arches. On the other hand, capitals 4, 7, and 11–13 show the possibilities for variation inherent in this design. The palmette appears prominently as a continuous band under the upper border *e*, on five arches (1, 3, 8, 11, 12), on many abaci (1–6, 7, 10), and on bases (2, 5, 8). It also provides the basic pattern for the major

border and the designs carved on both ends, analyzed in detail in the text (Figs. 44, 46, 48, 50, 52, 53). A palmette design with a human head, or mask, replacing the central axial motif used elsewhere, appears in the upper corner of the decorative band on the left end of the bas-relief. Just below, a hand rests on a clasp or shield. Neither grotesque nor deformed, the head and hand provide the only anthropomorphic motifs in the ornament (Fig. 51).

3. *Rinceau.* Forming a continuous, undulating band or vine, the rinceau can also be described as the segments of tangential circles or ovals with spiral or curving foliate patterns within each

N. Rinceau motif

segment (Figs. 47–48). In its typical form it appears only once, on arch 12 (Fig. 38), and even here the design varies from the left side to the right. In combination with the palmette, it forms the outer border design *h*, discussed on pages 31–36 (Fig. N).

SINGULAR MOTIFS

Three separate and totally different decorations appear on the bas-relief, which do not belong in any of the above categories. They consist of the two vase capitals, the *œuf à la coque* on capital 8 and the flame motif on base 4, as discussed on pages 37–38 of the text.

An exact count of the decorative patterns remains controversial for probably no two people would agree about the precise categories or the identification of variants within these categories. Nevertheless, a rapid check of the detailed drawings reveals more than eighty different designs, not including some twenty designs on the borders of the apostles' garments, which depend entirely on geometric

patterns (Figs. 25, 30, 31, 40). The basic classifications outlined here simplify and bring order to this great diversity. Over one-half of the designs may be identified as geometric, and the rest as vegetal. Within the geometric forms, approximately two-thirds, or one-quarter of the total, consist of variations on the zigzag; the majority of the rest depend on the simple circle or drilled hole. Among the vegetal types, the continuous palmette with its variants predominates, occurring approximately twenty times or one-quarter of the total, proportions close to those of the zigzag. The majority of the other vegetal designs derive from the acanthus leaf pattern. In short, about one-half of all the designs relate either to the zigzag or to the continuous palmette band, and the remaining one-half are divided between patterns associated with the circle and the acanthus leaf.

Appendix 2

PROPORTIONS

Based on measurements, proportions consist of mathematical ratios which relate parts of objects or buildings to each other and to the whole. Because of the apparently wide discrepancies between width and height in the details of Gothic buildings and the diversity of their ornament, and because for centuries the men who built the cathedrals were considered barbarians—"Goths" with little learning—the study of medieval proportions seemed inappropriate or beside the point. Today students acknowledge the great significance of proportions in medieval architecture but, lacking agreement, propose a bewildering and amazing number of systems as solutions for the "masons' secrets."[1] A number of interesting relationships among the measurements of the figures of the apostles and the arcade and the framing border of the bas-relief seem significant.[2] I present them not as evidence of a particular system but rather as additional proof that artists in the twelfth century were thoroughly aware that modular controls produced harmonious results.

The figures of the apostles dominate the sculpture. Their heights closely approximate a major unit of measurement used in the twelfth century—the famous *pied de roi,* which equaled 32.484 centimeters. Seven out of the twelve figures measure 32 centimeters or 32.5 centimeters, and the remaining five range between the narrow limits of 31.5 centimeters and 33 centimeters. These dimensions coincide with the basic "foot" too closely to be acci-

dental, and significantly, they provide the basis for other meas-
urements in the decoration. The height of the column shafts, for
instance, measures 16 centimeters, plus or minus—one-half the
figure height. The same measurement, 16 centimeters, recurs in
the width of the arches between the shafts of the columns measured
from center to center (Fig. 41).

The median length of the noticeably large heads, which give the
figures their squat proportions, is roughly 7 centimeters, resulting
in a ratio of approximately 1:4 1/2 between the heads and the
total heights of the figures. Deviations from this ratio occur in the
figure of the young Saint John, who has a head to height ratio of
1:4.70, and in that of Saint Paul, whose unusually large head
produces a ratio of 1:4.12 (Figs. 17, 23). Nevertheless the median
head measurement seemed to provide the module for a number of
important parts of the arcade, including the overall height of
the capitals, the height of spandrels, and the height of the upper
border from the top of the arcade to the outer edge of the small
outer border. The same dimension was given to the width of the
column bases. Other component parts share equivalent dimensions.
For instance, the width of the abaci of the capitals equals the width
of the lower border, and the height of the column bases equals that
of the core of the capitals.

The recurrence of these interrelated dimensions again suggests
careful planning rather than coincidence. The artist, who designed
the figures and other elements of the decoration to enhance the
effect of the relief when viewed from below, apparently also exer-
cised great care to create a harmonious, stable design by relating
the major features of his work by a common denominator of meas-
urements. The subtlety of these interrelationships and the insistent
variations within the modular controls give the relief both its
stability and its vitality.

Notes

INTRODUCTION

1. Paris, Archives Nationales, K₁, N. 7. Facsimile in Philippe Lauer and Ch. Samaran, *Les Diplômes Originaux des Mérovingiens* (Paris, 1908), pl. 1; Karl F. A. Pertz, ed., *Diplomata Imperii*, I, No. 10, *Monumenta Germaniae Historica* (Hanover, 1872), p. 13 (hereafter cited as *MGH*), Fernand Cabrol and Henri Leclercq, *Dictionnaire d'archéologie chrétienne et de liturgie*, IV, pt. 1 (Paris, 1920) : 625.

2. The earliest list of the bishops of Paris that has survived is in a ninth-century sacramentary in the Bibliothèque Nationale in Paris (B.N. Lat. Ms. 2291, fol. 6ᵛ); Louis Duchesne, *Les Fastes Episcopaux de l'ancienne Gaule*, II (Paris, 1900) : 460. See also Félix G. de Pachtère, *Paris à l'epoque Gallo-Romaine* (Paris, 1912), pp. 122–23, 129; and Élie Griffe, *La Gaule chrétienne à l'époque romaine*, I (Paris, 1947) : 64–66.

3. *Historia Francorum, Gregorii Turonensis Opera* 1.30, ed. Wilhelmus Arndt and Bruno Krusch, *Scriptores Rerum Merovingiarum*, I, *MGH* (Hanover, 1885), pp. 47–48. See also Godefroid Kurth, "De l'autorité de Grégoire de Tours," *Études Franques,* II (Paris, 1919) : 117–206; and Griffe, *La Gaule chrétienne*, I : 74–75, 90–91, 110.

4. Jules Formigé claimed to have discovered in 1956 the original burial pit for Saint Denis and his two companions, Rusticus and Eleutherius, under the present high altar at Saint-Denis. See "Les travaux récents de la basilique de Saint-Denis, Séance du 3 avril, 1957," *Académie des Beaux-Arts*, 1956–57 (Paris, 1958), p. 82, and *L'Abbaye Royale de Saint-Denis* (Paris, 1960), p. 2, fig. 2. Careful examination of the pit has not confirmed this claim, although other evidence supports the theory that the original burial of Saint Denis was in this vicinity. See Michel Fleury, "Communication. Nouvelle campagne de fouilles de sépultures de la basilique de Saint-Denis, Séance du 9 mai, 1958," *Académie des Inscriptions et Belles-Lettres* (Comptes Rendus), L (1959) : 140. For discussion of the complicated problems relating to the early legends, see Sumner McK. Crosby, *The Abbey of St.-Denis, 475–1122* (New Haven, 1942), I : 24–33.

5. "Nam terribilem esse et metuendum locum ejus nemini ambigendum est." *Vita Beate Genovefe Virginis* 6.15, ed. Charles Kohler, *Étude critique sur le texte de la vie latine de Sainte-Geneviève de Paris*, Bibliothèque de l'École des Hautes Études, XLVIII (Paris, 1881) : 20.

6. Michel Fleury and François Lenord, "Les Bijoux Mérovingiens d'Arnegonde," *Art de France*, I (1961) : 7–18.

7. Gregory of Tours, *Liber in Gloria Martyrum* 71, *Gregorii Turonensis Opera*, ed. Arndt and Krusch, *Scriptores Rerum Merovingiarum*, I, *MGH*, pp. 535–36. Sigebert, son of Clothaire I, was king of Austrasia, the eastern portion of the Frankish, or Merovingian, kingdom. In 570 he unsuccessfully attempted to take over Neustria, the western portion.

8. See Crosby, *St.-Denis*, I : 57–58. New archaeological evidence to be discussed in the forthcoming revised edition of that volume proves that Dagobert did enlarge the earlier chapel on the site of the present building.

9. For a resumé of Saint-Denis in Carolingian times, see my *L'Abbaye Royale de Saint-*

Denis (Paris, 1953), pp. 15–20; and May Vieillard-Troiekouroff, "L'Architecture en France du temps de Charlemagne," *Karl der Grosse* (Düsseldorf, 1965), Vol. III, *Karolingische Kunst*, ed. Wolfgang Braunfels and Herman Schnitzler, pp. 336–55.

10. In regard to the Areopagite legend see Raymond J. Loenertz, "La Légende Parisienne de S. Denys l'Aréopagite," *Analecta Bollandiana*, LXIX (Brussels, 1951) : 234–37; Gabriel Théry, *Études Dionysiennes* (Paris, 1932), I; and P. Godet, "Denys l'aréopagite (Le pseudo-)," *Dictionnaire de Théologie Catholique* (Paris, 1920), IV, pt. 1, pp. 435–36.

11. The only documentary evidence for this gift of William the Conqueror to Saint-Denis is in Guibert de Nogent, *De vita sua* 3.20, *Patrologia Latina*, ed. Migne (Paris 1844–80), CLVI, cols. 960–62 (hereafter cited as *Pat. Lat.*); or Guibert de Nogent, *Self and Society in Medieval France*, ed. John F. Benton, trans. C. C. Swinton Bland (New York and Evanston, 1970), p. 228. See also Léon Levillain, "Les plus anciennes églises abbatiales de Saint-Denis," *Mémoires de la Société de l'Histoire de Paris et de l'Île de France*, XXXVI (1909) : 163.

12. *Oblate* refers to the medieval custom of offering sons of poor parents to an abbey as a means of securing for them an education and possibly a career. See *New Catholic Encyclopedia* (New York, 1967), X : 610–11.

13. The most recent studies of Suger include Erwin Panofsky, *Abbot Suger* (Princeton, 1946); Marcel Aubert, *Suger* (Rouen, 1950); Crosby, *L'Abbaye Royale*, pp. 24–30; Otto von Simson, *The Gothic Cathedral* (New York, 1956), pp. 61–90.

14. Suger, *De Consecratione* 4 (Panofsky, *Suger*, p. 101; Albert Lecoy de la Marche, ed., *Œuvres Complètes de Suger*, Paris, 1867, p. 225).

15. Crosby, *L'Abbaye Royale*, pp. 55–56. For my summary account of these excavations see "Sous le dallage de l'Abbaye Royale de Saint-Denis," *Archeologia*, XIV–XV (1967) : 34–38, 71–75.

16. Crosby, *L'Abbaye Royale*.

THE DISCOVERY

1. The "procès-verbal" by Dom Poirier of the exhumation of the royal tombs, between the 12th and 25th of October, 1793, was published by François Auguste Vᵗᵉ de Chateaubriand, *Génie du Christianisme*, 7th ed. (Paris, 1822–23) IV : 421–48, and by the Baron de Guilhermy, *Monographie de l'Église Royale de Saint-Denis. Tombeaux et Figures Historiques* (Paris, 1848), pp. 52–83. It describes the frenzied search for all royal remains and mentions specifically the destruction of the pavement of the south transept area, where the bas-relief was found.

2. Between 1811 and 1813 the architect Pierre F. L. Fontaine raised the level of the nave and transept over six feet in order to reduce the difference in levels between the upper choir and nave. Between 1860 and 1867 Viollet-le-Duc, in order to assure the solidity of the piers, restored the pavement to approximately its original, thirteenth-century level. See Crosby, *St.-Denis*, I : 8–11.

3. Eugène Viollet-le-Duc, *Dictionnaire raisonné de l'Architecture Française*, IX (Paris, 1868) : 227.

4. The capital is now in the entrance hall of the Maison de la Légion d'Honneur in the eighteenth-century claustral buildings of the abbey to the south of the church.

5. Five undisturbed burials may be seen in Fig. 1: two in lower center, one in upper left, and two in upper center. Whenever such a burial was uncovered, I notified officials in Paris and asked that experts be sent to examine the contents.

6. For a more complete description, see Margaret T. J. Rowe, "Fragments from the Tomb of an Unknown Bishop of Saint Denis, Paris," *The Bulletin of the Needle and Bobbin Club*, LII (1969) : 26–33.

7. This right end is noted and illustrated in Whitney S. Stoddard, *The West Portals of Saint-Denis and Chartres. Sculpture in the Île-de-France from 1140 to 1190. Theory of Origins* (Cambridge, Mass., 1952), p. 60, and pl. X, 4. Another example of unfinished twelfth-century sculpture survives in the capital of the Wise and the Foolish Virgins now in the Musée des Augustins, Toulouse (Inv. 392). See Meyer Schapiro, "The Romanesque Sculpture of Moissac, I," *Art Bulletin*, XIII (1931) : 348, fig. 128; Paul Mesplé, *Toulouse, Musée des Augustins. Les Sculptures Romans* (Paris, 1961), no. 34; William Wixom, *Treasures from Medieval France* (Cleveland, 1967), pp. 56–57.

8. In 1947 the original boots were deposited in care of the administration of the Monuments Historiques. Michèle Beaulieu has very kindly consented to study the evidence available in photographs and tracings. She stated her tentative conclusions in a letter to the author, dated July 20, 1967:

Je crois cependant pouvoir affirmer qu'elles ne sont pas du XII° mais au moins du XIII° siècle et peut-être du XIV°. . . . Je croirais assez volontiers qu'il s'agit de bottes ou estivaux qui paraissent avoir été hautes et souples rouges ou noires. Les prêtres en portaient, si l'on en croit les fabliaux, notamment celui dit *Fablel d'Aloul* du XIII° siècle. Je ne crois pas qu'il faille essayer de faire la différence entre bottes et estivaux sauf peut-être que les premiers étaient fourrées et pas les secondes.

These *estivaux* were black and showed no remnants of fur. See also Camille Enlart, *Manuel d'Archéologie Française* (Paris, 1916), vol. III, *Le Costume*, p. 266; Eugène Viollet-le-Duc, *Dictionnaire raisonné du Mobilier Français* (Paris, 1871–75), III : 161–63, 167–70, and IV : 332–33; Jules E. J. Quicherat, *Histoire du Costume en France* (Paris, 1875), pp. 157–58.

9. Crosby, *L'Abbaye Royale*, p. 64, figs. 91, 92.

10. See below, p. 33.

THE PROGRAM

1. Karl Künstle, *Ikonographie der Heiligen*, II (Freiburg-im-Breisgau, 1926), pp. 93–102.

2. Wilhelm Molsdorf, *Christliche Symbolik der Mittelalterlichen Kunst* (Leipzig, 1926), pp. 186–87; Karl Künstle, *Ikonographie der Christlichen Kunst*, I (Freiburg-im-Breisgau, 1928), pp. 181–82.

3. Saint Augustine, *Enarrationes in Psalmos 86, Pat. Lat.*, XXXVII, col. 1103.

4. For mention of some of the twelfth-century examples see below, pp. 60–62.

5. Formigé, *Abbaye Royale*, pp. 131, 134, fig. 101. An altar frontal decorates the lower, front portion of the altar table, whereas a retable functions as a decorative panel above and at the rear of the altar slab.

6. The golden altar frontal given by Emperor Henry II and Queen Kunigende to the Basel minster in 1019 measures 1.20 meters long by 1.77 meters high (3 feet 11 1/4 inches by 5 feet 9 5/8 inches). Similar proportions govern the measurements of many extant twelfth-century Spanish frontals, as well as the antependium from Gross-Komburg in Franconia, a work nearly contemporary with the Saint-Denis relief.

7. A typical example, unfortunately heavily restored, may be seen at Saint-Denis on the altar of the chapel of Saint Firmin, adjacent to the chapel of Saint Osmana, where the bas-relief is displayed. See Formigé, *Abbaye Royale*, pp. 128–30, figs. 99, 100. A number of similar retables, executed in metal, have been preserved in Denmark. See Marcel Aubert, "Les autels en métal doré du Danemark à l'époque romane," *Bulletin Monumental*, LXXXVI (1927) : 137–44.

8. *Litterae encyclicae conventus sancti Dionysii de morte Sugerii Abbatis* (Lecoy de la Marche, *Œuvres*, pp. 408–09).

9. Michel Félibien, "Petite Chronique de Saint-Denys," *Histoire de l'Abbaye Royale de Saint-Denys en France* (Paris, 1706), pp. 190–91.

10. Suger's new tomb, a thirteenth-century cenotaph, was imbedded in the thickness of the wall to the left, or east, of the doorway where the effigy of René Orléans-Longueville lies today. The stone evidently disappeared during the Revolution. See "Plan de l'Eglise Impériale de St. Denis avec la disposition des sépultures telles qu'elles étaient avant leur destruction en 1793" (Bibliothèque Nationale, Cabinet des Estampes, Fonds Destailleur, Départements, Ve g, fol. 105). See also *Dessins de Roger de Gagnières* (Bib. Nat. Estampes, Pe 11a [pet fol.], fols. 81, 82, 93). According to Félibien, on the front of the thirteenth-century tomb a stone with engraved designs bore the inscription *Hic jacet Sugerius abbas*, words more apt than all the long eulogies which have honored Suger's memory (*Histoire*, pp. 190–91).

11. Erwin Panofsky counted thirteen different verses mentioning Suger by name, inscribed on the fabric of the twelfth-century building or its decorations (*Suger*, p. 29).

12. Suger, *De Consecratione* 5 (Panofsky, *Suger*, p. 105; Lecoy de la Marche, *Œuvres*, p. 228).

13. For a discussion and reconstruction of this early *confessio* see Crosby, *St.-Denis*, I: 99–104; and more recently, after extensive excavations, Formigé, *Abbaye Royale*, pp. 159–63.

14. The present altar in the choir, called the "autel de la Confession de Saint Denys," a rather haphazard nineteenth-century reconstruction built after the Revolution, presumably replaces the seventeenth-century construction. The precise location of the twelfth-century altar is uncertain, but the de Belleforest engraving, cited by Formigé to indicate a location in the middle of the choir, is difficult to interpret. See "Le vif Portraict de la grand'Eglise saint Denis," engraving by Fr. de Belleforest, 1573, published in Formigé, *Abbaye Royale*, p. 91, fig. 77.

15. Dom F. Jacques Doublet, *Histoire de l'Abbaye de S. Denys en France* (Paris, 1625), p. 289; Félibien, *Histoire*, pp. 398, 447.

16. For a list of the various inventories and a discussion of their usefulness, see W. Martin Conway, "The Abbey of Saint-Denis and its Ancient Treasures," *Archaeologia*, LXVI (1915): 103–04. The oldest known inventory, dated 1505 and abstracted in the inventory of 1634, was evidently based on a late-fifteenth-century inventory. See also Jules Labarte, *Histoire des Arts Industriels au Moyen Age et à l'époque de la Renaissance*, 2nd ed. (Paris, 1872–73), I: 246²; Henri Omont, "Inventaires du trésor et des objets précieux conservés dans l'église de l'abbaye de Saint Denys en 1505 et 1739," *Mémoires de la Société de l'Histoire de Paris et de l'Île-de-France*, XXVIII (1901): 163–212.

17. The important references for the altar are: Viollet-le-Duc, *Dictionnaire de l'Architecture*, II: 23–25, fig. 6; Labarte, *Arts Industriels*, I: 411–13; Léon Levillain, "L'Autel des Saints-Martyrs de la Basilique de Saint-Denis," *Bulletin Monumental*, LXXV (1911): 212–25; Conway, "Ancient Treasures," 114–15; Panofsky, *Suger*, pp. 169–76. Although Viollet-le-Duc and Panofsky have presented reconstructions of the altar, an adequate study of its place in the history of similar monuments has yet to be made.

18. The *pied* used by Doublet was 32.484 centimeters. See Levillain, "L'Autel," p. 214.

19. Suger, *De Administratione* 31 (Panofsky, *Suger*, pp. 54–55; Lecoy de la Marche, *Œuvres*, p. 193).

20. The inscription as quoted gives the accepted corrections by Labarte of the transcription in Doublet, *S. Denys*, p. 293 (Labarte, *Arts Industriels*, I: 413).

21. Panofsky assumed that the inscription was on the back of the monument and that it referred to the tabernacle (*Suger*, p. 170).

22. "Le devant du cercueil du milieu joignant ledit Autel est garny en la bordeure d'en bas

de plusieurs beaux esmaux sur cuivre doré, en façon d'applique de diverses façons, au-dessus desdits esmaux plusieurs belles agathes, les uns en façon de Camahieux à face d'hommes, et les autres en fond du cuve" (Doublet, *S. Denys*, p. 293).

23. "Notes taken by Nicholas Claude Fabry de Peirese, the learned antiquary of Aix-en-Provence, who visited Saint-Denis in the first quarter of the XVII century and the description given by the inventaire, itself, make it certain that Suger, in the decoration of this new shrine, had reused numerous elements coming from the antique *lectical* of the saints, Roman gems, remnants of *verroterie* cloisonnée (garnets or pastes fitted into gold cells) and other such ornaments. Among these readmitted elements was the Carolingian rock crystal (now in the British Museum)." (Comte Blaise de Montesquiou-Fezensac, "A Carolingian Rock Crystal from the Abbey of Saint-Denis at the British Museum," *The Antiquaries Journal*, XXXIV [1954] : 38-43).

24. Letter to the author from Erwin Panofsky, dateline Princeton, N.J., January 30, 1948.

25. Suger, *De Consecratione* 5 (Panofsky, *Suger*, pp. 106-07; Lecoy de la Marche, *Œuvres*, p. 229).

26. This passage continues with an account of how some of the jewels were acquired and reaffirms the hypothesis of a windfall permitting a change to a more elaborate and costly decoration:

> For not only did the very pontiffs—who wear them especially on account of the dignity of their office—consent, if they were present, to assign their pontifical rings, set with a wonderful variety of precious stones, to this panel; they even, if they were absent in lands overseas, sent them of their own accord, incited by the love of the Holy Martyrs. Also the illustrious King himself, offering of his own accord emeralds, pellucid and distinguished by markings—Count Thibaut, hyacinths and rubies—peers and princes, precious pearls of diverse colors and properties: [all these] invited us to complete the work in glorious fashion. [Suger, *De Consecratione* 5 (Panofsky, *Suger*, p. 107; Lecoy de la Marche, *Œuvres*, p. 229)]

27. Suger, *De Administratione* 31 (Panofsky, *Suger*, pp. 54-55; Lecoy de la Marche, *Œuvres*, p. 103). In the following chapter Suger also tells how he unexpectedly acquired gold and jewels for the Great Cross, ibid. 32 (Panofsky, *Suger*, pp. 57-59; Lecoy de la Marche, *Œuvres*, pp. 194-95).

28. Suger, *De Consecratione* 4 (Panofsky, *Suger*, p. 101; Lecoy de la Marche, *Œuvres*, p. 225).

29. Suger, *De Consecratione* 6-7 (Panofsky, *Suger*, pp. 113-21; Lecoy de la Marche, *Œuvres*, pp. 232-38).

30. Soon after the discovery of the relief I proposed "une date voisine de 1140," "Fouilles exécutées récemment dans la basilique de Saint-Denis," *Bulletin Monumental*, CV (1947) : 181. "Communication sur ses fouilles de la basilique de Saint-Denis. Séance du 9 juillet 1947," *Bulletin de la Société-Nationale des Antiquaires de France*, 1945-1949 (1950) : 253. A similar date was accepted by Marcel Aubert, "Le Portail Royal de Chartres. Essai sur la date de son exécution," *Miscellanea Leo van Puyvelde* (Brussels, 1949), p. 283. In his belief that the apostles of the relief followed the order of the statue-columns of the west façade, and with evident acceptance of Aubert's late date for these figures, Stoddard stated: "The Apostle bas-relief would seem to date from the late 1140's and possibly be part of a project left unfinished at Suger's death in 1151" (*West Portals*, p. 61). This later date was accepted by André Lapeyre, *Des Façades Occidentales de Saint-Denis et de Chartres aux Portails de Laon* (Thèse principale pour le doctorat ès lettres, Paris,

1960), p. 115, who wrote: "il fut sculpté, peut-être vers 1155"; by Bernhard Kerber, *Burgund und die Entwicklung der französischen Kathedralskulptur in zwölften Jahrhundert* (Recklinghausen, 1966), p. 46; and by Willibald Sauerländer, *Gotische Skulptur in Frankreich, 1140–1270* (Munich, 1970), p. 71. As a result the stylistic development of the beginning of early Gothic sclupture remains unnecessarily confused (see pp. 57–59, 68–71).

THE OBJECT

1. ". . . ascitis melioribus . . . pictoribus," Suger, *De Administratione* 14 (Panofsky, *Suger*, p. 42; Lecoy de la Marche, *Œuvres*, p. 186); "accitis fusoribus et electis sculptoribus," Suger, ibid. 27 (Panofsky, *Suger*, p. 46; Lecoy de la Marche, *Œuvres*, p. 188); "artifices peritiores de diversis partibus convocavimus," Suger, ibid. 32 (Panofsky, *Suger*, p. 56; Lecoy de la Marche, *Œuvres*, pp. 194–95).

2. Even though considerable attention has been given to the organization and functioning of medieval workshops, many critical details are still only vaguely understood. Some of the more useful studies are: Werner Jütter, *Ein Beitrage zur Geschichte der Bauhütte und des Bauwesens im Mittelalter* (Cologne, 1935); Louis Francis Salzmann, *Building in England down to 1540. A Documentary History* (Oxford, 1952); Douglas Knoop and G. P. Jones, *The Mediaeval Mason* (Manchester, 1953); Pierre du Colombier, *Les Chantiers des Cathédrales* (Paris, 1953); Marcel Aubert, "La construction au moyen âge," *Bulletin Monumental*, CXVI (1958) : 231–41, and CXIX (1961) : 7–42, 81–120, 181–209, 298–323; Jean Gimpel, *Les Bâtisseurs de Cathédrales* (Paris, 1959); or *The Cathedral Builders*, trans. Carl F. Barnes, Jr. (New York, 1961).

3. A bibliography of the study of ornament would serve no useful purpose here. It deserves its own critical treatment. Typical of the nineteenth-century handbooks, which appeared in great numbers, is Karl A. von Heideloff, *Die Ornamentik des Mittelalters*, 2 vols. (Nuremberg, 1844–47), with elaborate and expensive colored plates, skillfully drawn by the author, but without objective analysis. As recently as 1930 W. M. Flinders Petrie presented his corpus, *Decorative Patterns of the Ancient World* (London, 1930), which he had worked on for thirty years and hoped would be supplemented every twenty years or so. A glance at his plates and his attempts to identify and isolate different motifs will prove how confusing this study may become. Joan Evans's two-volume work, *Pattern. A Study of Ornament in Western Europe from 1180 to 1900*, 2 vols. (Oxford, 1931), is delightful reading, with many perceptive comments, but it is highly selective and can hardly be used for the study of specific motifs. Alois Riegl's *Stilfragen, Grundlegungen zu einer Geschichte der Ornamentik* (Berlin, 1893), remains a basic study for the identification of stylistic traits and for the evolution of style. Charles R. Morey, in his brief introduction to *Medieval Art* (New York, 1942), pp. 3–17, shows how useful ornament may be as "Morellian Characteristics."

4. The need for such a corpus was voiced by Hanns Swarzenski, *The Berthold Missal* (New York, 1943), p. 53. A careful and very useful study of Byzantine ornament based on minute examination of 256 manuscripts, ranging from the sixth through the fourteenth centuries, has been done by M. Alison Frantz, "Byzantine Illuminated Ornament. A Study in Chronology," *Art Bulletin*, XVI (1934), 43–76, with 26 plates. If similar studies exist for the art of western Europe at that time, they have not come to my attention.

5. For a very perceptive and useful classification of different types of ornament, with brief comments on their characteristics and stylistic or technical implications, see Wolfgang von Wersin and Walter Müller-Grah, *Das Elementare Ornament und seine Gesetzlichkeit, eine Morphologie des Ornaments* (Ravensburg, 1953).

6. Stoddard proposed to use ornamental sculpture as the basis for chronological relationships (*West Portals*). Unfortunately the more exhaustive examination of the ornament, included in his doctoral dissertation at Harvard University, is only summarized in his book.

7. For a valuable consideration of ornament and its cultural implications, see Franz Boas, *Primitive Art* (Irvington-on-Hudson, N.Y., 1951).

8. A fundamental study of Romanesque ornament, Jurgis Baltrušaitis, *La Stylistique Ornamentale dans la Sculpture Romane* (Paris, 1931), identifies the inherent rules that controlled decorative sculpture of that time. It does not presume to be a corpus of ornamental motifs.

9. In addition to the earlier references to the inventories of the Saint-Denis treasure and the plates in Félibien, *Histoire*, pp. 536–45, pls. I–VI, see Conway, "Ancient Treasures." More recently Comte Blaise de Montesquiou-Fezensac has discovered many additional fragments from the treasure. He is assembling his evidence and completing his work at the present time in Paris.

10. Wilhelm Worringer, *Formprobleme de Gotik* (Munich, 1927), trans. *Form in Gothic*, rev. ed. (New York, 1964); Lawrence Stone, *Sculpture in Britain. The Middle Ages* (Baltimore, 1955), pp. 8–9.

11. Morey, *Medieval Art*, pp. 7–8.

12. Gisela Richter, *Catalogue of Greek and Roman Antiquities in the Dumbarton Oaks Collection* (Cambridge, Mass., 1956), pp. 47–48, pl. XX. See also the first-century relief in the Lateran Museum, Rome, from the tomb of the Haterii: Pierre Gusman, *L'Art Décoratif de Rome de la Fin de la République au IVe siècle*, II (Paris, 1908), pls. 114–15; Erike Simon, *Ara Pacis Augustae* (Greenwich, Conn. [c. 1968]), figs. 3–5. For other Roman examples see Gusman, ibid., I, pls. 5, 22, 44, 51, 148.

13. For typical examples, see the Probianus diptych, ca. 400, and the consular diptych of Philoxenus, 525: Richard Delbrueck, *Die Consulardiptychen und Verwandte Denkmäler* (Berlin and Leipzig, 1929), pls. 33, 65.

14. See especially the Evangelary of Lothaire (Paris, Bib. Nat. Ms. Lat. 266); the Ada Handschrift I (Trier Stadtbibliothek Cod. 22); or the Drogo Sacramentary (Paris, Bib. Nat. Ms. Lat. 9428): Wilhelm Köhler, *Die Karolingischen Miniaturen* (Berlin, 1930–60), I, pls. 99–105, II, pls. 20–25, III, pls. 77–88. See also ivories of the Metz and Ada groups of the ninth and tenth centuries: Adolph Goldschmidt, *Die Elfenbeinskulpturen aus der Zeit der Karolingischen und Sächsischen Kaiser*, I (Berlin, 1914), pls. XVI, XVII, XXXIX–XI. Similar forms also exist in marble relief carvings of the ninth century now in museums in Naples and Sorrento: Émile Bertaux, *L'Art dans l'Italie Méridionale de la Fin de l'Empire Romain à la Conquête de Charles d'Anjou* (Paris, 1904), pp. 77, 80, 82, figs. 16–17, 19, 23.

15. Percy Ernst Schramm and Florentine Mütherich, *Denkmale der deutschen Könige und Kaiser* (Munich, 1962), p. 204, fig. 3.

16. As in the Gospel Book of Otto III (Manchester, John Rylands Library, MS 98): Hanns Swarzenski, "The Role of Copies in the Formation of the Styles of the Eleventh Century," *Romanesque and Gothic Art. Studies in Western Art*, I (Princeton, 1963), pl. VI, fig. 24; or on the portable altar of Henry II: Hans Thoma, *Schatzkammer der Residenz München* (Munich, 1958), fig. 5; and the Basel altar frontal in the Cluny Museum, Paris: Emma Medding-Alp, *Rheinische Goldshmiedekunst in Ottonischer Zeit* (Koblenz, 1952), fig. 15.

17. In metalwork see: the border of the top of a portable altar in the Walters Art Gallery, Baltimore (No. 53.77(3)), attributed to a Reichenau artist of the eleventh century (Fig. 55); the end of a reliquary also in the Walters Art Gallery (571519), identified as

Mosan and dated in the early twelfth century; among the works of Eilbertus of Cologne, the Victorschrein in Xanten, ca. 1129, the portable altar in the Vienna Welfenschatz, ca. 1130, and the Mauritius portable altar, ca. 1135: Otto von Falke and Heinrich Frau-berger, *Deutsche Schmelzarbeiten des Mittelalters* (Frankfurt am Main, 1904), pls. 25–26, 18–19, 20–22. See also objects attributed to Godefroid de Huy or his followers, such as the drawing of the Wibald altar now in the Archive de l'État, Liège: ibid., pl. 70; two reli-quaries from the Duthuit Collection now in the Petit Palais, Paris: ibid., p. 67, fig. 20; an enamel reliquary in the Cleveland Museum of Art: William M. Milliken, "A Reliquary of Champlevé Enamel from the Valley of the Meuse. The J. H. Wade Collection," *Bulletin of the Cleveland Museum of Art*, XIV [1927] : 49, 51–54; the Saint Andrew triptych in Trier: von Falke, *Schmelzarbeiten*, pl. 73; the Servatius shrine in Maastricht: ibid., pl. 71; a portable altar in Augsburg: ibid., pl. 77; and a processional cross in the treasury of the Cathedral of Liège. There are also a few examples of a similar design in stone relief sculpture, such as: the frame of a window on the south side of the choir of the Cathedral of Speyer, ca. 1100; on the border frame of the Holy Sepulchre relief in Gernrode, ca. 1100–20; Hermann Beenken, *Romanische Skulptur in Deutschland (11 und 12 Jahrhundert)* (Leipzig, 1924), pp. 60–61; on the Freckenhorst Font, ca. 1129; ibid., p. 80, fig. 40A.

18. See, for example: the top of the Deusdedit altar in Rodez: Meyer Schapiro, "A Relief in Rodez and the Beginnings of Romanesque Sculpture in Southern France," *Romanesque and Gothic Art. Studies in Western Art*, I (Princeton, 1963), pl. XIII, fig. 4; abaci from the chapter house of Saint-Étienne and the cloister of La Daurade, Toulouse: Paul Mesplé, *Toulouse. Musée des Augstins. Les Sculptures Romanes*, figs. 25–26, 28–29, 125–26; the Apocalypse capital from the porch of Saint-Benoît-sur-Loire: Arthur Kingsley Porter, *Romanesque Sculpture of the Pilgrimage Roads* (Boston, 1923), X, pl. 1417. Among the examples most similar to the apostle relief are: the Constantine and Saint Vincent capi-tals, and a colonnette and archivolt at Saint-Lazare, Autun: Denise Jalabert, "La Flore Romane Bourguignonne," *Gazette des Beaux-Arts*, 6th ser., LV [April, 1960], figs. 4, 13, 16, 25, 26; the Daniel and the Tobias capitals at Vézelay: Porter, *Pilgrimage Roads*, II, pls. 33, 45; the Judas capital, Saulieu: ibid., II, pl. 52; the Magi capital, Saint-Révérien: ibid., pl. 102; the archivolt of the south portal, Saint-Lazare, Avallon: ibid., pl. 140.

19. Denise Jalabert, "De Quelques Fleurs Sculptées à Toulouse au XIIᵉ siècle," *Bulletin Archéologique du Comité des Travaux Historiques et Scientifiques*, 1934–35 (1938), p. 639.

20. Cabrol and Leclercq, *Dictionnaire*, XIV, pt. 1 (1939), col. 1402.

21. Ceslaus Spicq, *Esquisse d'une Histoire de l'Exégèse Latine au Moyen Age* (Paris, 1944), p. 49. In the Kaiser-Friedrich-Museum a vertical pedestal with a stylized finial oc-cupies the center of a fountain of life on a Byzantine stone relief identified as fifth or sixth century: Max Hauttmann, *Die Kunst des Frühen Mittelalters* (Berlin, 1929), fig. 199. As the tree of life, a similar motif can be seen at Brive on a mid-twelfth-century capital de-scribed as having a "motif d'importation orientale très répandu et à variantes nombreuses" (Jules Roussel, *La Sculpture Française: Époque Romane* [Paris, 1927], p. 21, fig. 41).

22. Hugo of Saint-Victor, *Eruditionis Didascalicae*, 2.26, *Pat. Lat.*, CLXXVI, col. 762; and Henri de Lubac, *Corpus Mysticum: l'Eucharistie et l'Église au Moyen Age* (Paris, 1944), pp. 368–69.

23. Josef Strzygowski, "Die Pinienzapfen als Wasserspeier," *Mitteilungen des Kaiserlich Deutschen Archaeologischen Instituts Roemische Abteilung*, XVIII (1903) : 203–05. See also Wolfgang Braunfels, *Die Welt der Karolinger und ihre Kunst* (Munich, 1968), p. 133 and fig. 140.

24. Eugène F. A. Goblet Comte d'Alviella, *The Migration of Symbols* (Westminster, 1894; reprint ed., New York, 1956), pp. 107–13.

25. Waldemar Deonna, " 'Sacra Vitis'. La double vigne dionysiaque et les origines du rinceau, specialement du rinceau bouclé vertical," *Les Cahiers Techniques de l'Art*, II (1952) : 41. See also Gusman, *Art Décoratif*, II, pl. 105.

26. Gusman, in describing such a candelabrum on a fragment of stucco decoration of the first century in the Museo Nationale in Rome, wrote: "Ici la libation est offerte à Bacchus," and again, in reference to an adjacent design incorporating both pinecone and thyrsus: "empruntés au thyrse et à la pomme de pin, attributs bachiques en harmonie avec le caractère général de la composition qui se rapporte à Bacchus." See Gusman, *Art Décoratif*, II, pls. 72, 73. Flames resembling pinecones surmount a carved marble candelabrum from the Villa Borghese (ibid., I, pl. 20), and a candelabrum in a first-century terracotta frieze now in the Louvre (ibid., pl. 28). For additional examples see Charles Huelsen, "Porticus Divorum und Serapeum im Marsfelde," *Mitteilungen des Kaiserlich Deutschen Archaeologischen Instituts*, XVIII (1903) : 39, 41, 42.

27. This base, until recently in the Cluny Museum in Paris, is now in the Musée Lapidaire, or storage house, in the park behind the abbey church at Saint-Denis. See Crosby, *St.-Denis*, I, fig. 31a; Braunfels, *Welt der Karolinger*, figs. 28–29.

28. For line drawings copied after the stylized flora with the exaggerated spadix ornamenting a sacramentary ascribed to the scriptorium at Saint-Denis in the middle of the eleventh century (Bib. Nat. Ms. Lat. 9436), see Jalabert, "Fleurs à Toulouse," figs. 6, 10.

29. See Otto von Falke, Robert Schmidt, and Georg Swarzenski, *The Guelph Treasure* (Frankfurt am Main, 1930), p. 36; and Stone, *Sculpture in Britain*, p. 58.

30. The origin of this motif is probably to be found in the Scandinavian ribbon, or Jellinge styles of the tenth century. See Johannes Brøndsted, *Early English Ornament*, trans. Albany F. Major (London, 1924), figs. 193, 197.

31. Eusebius, *De Vita Constantini*, 3.38, *Pat. Lat.*, VIII, col. 59. For early examples of the vase capital see the Ariosti sarcophagus, representing Christ and the apostles, San Francesco, Ferrara, and the Barbatianus sarcophagus, Ravenna Cathedral, where the spandrels above the columns flanking Christ contain craters that appear to surmount the columns in a manner conforming to Eusebius's description of the Holy Sepulchre: Marion Lawrence, *The Sarcophagi of Ravenna* (New York, 1945), pp. 10, 22, figs. 18, 22, 39; also a Carolingian example found in the canon tables of Cologne Cathedral Library (Cod. 212, fol. 168ᵛ): E. Heinrich Zimmerman, *Vorkarolingische Miniaturen* (Berlin, 1916), fol. vol. I, pl. 43a; the canon tables of a Carolingian manuscript (Brit. Mus. Ms. Harley 2788, fols. 8ᵛ and 9ʳ) : Wilhelm Köhler, ed., *Medieval Studies in Memory of A. Kingsley Porter* (Cambridge, Mass., 1939), II, pl. XV.

32. "The *midst* of the edifice, however, was suddenly raised aloft by (twelve) columns representing the number of the Twelve Apostles," *De Consecratione* 5 (Panofsky, *Suger*, p. 105; Lecoy de la Marche, *Œuvres*, p. 227). In the early patristic works, the symbolic equation between columns and the apostles already had currency. Saint Ambrose specifically related the columns in a church to the apostles (*In Psalmum David CXVIII Expositio*, *Pat. Lat.*, XV, col. 1264). Saint Augustine best elaborated that symbolic relationship in *Enarrationes in Psalmos* 74, *Pat. Lat.*, XXXVI, col. 950.

33. See Goldschmidt, *Elfenbeinskulpturen*, II, pl. XLVI, fig. 160; and for the twelfth-century Bible of Mazarin (Paris, Bib. Nat. Ms. Lat. 7, fol. 353ᵛ, initial *P*) : Philippe Lauer, *Les Enluminures Romanes des Manuscrits de la Bibliothèque Nationale* (Paris, 1927), pl. XXXVI, fig. 4.

34. Almost identical designs appear on the relief of Cain and Abel, attached to one of the buttresses of the apse of the Cathedral of Verdun: Norbert Müller-Dietrich, *Die Ro-*

manische Skulptur in Lothringen (Berlin and Munich, 1968), fig. 43; and on a capital showing the sacrifice of Abraham from Saint-Médard, Soissons (Fig. 84) : René Louis, "Note sur quelques chapiteaux romans de l'ancien diocèse de Soissons," *Bulletin de la Société Archéologique, Historique et Scientifique de Soissons*, 4th ser., IV (1928–30), pl. following p. 93. Porter asserted that this motif originated in Spain (*Pilgrimage Roads*, I : 50, and VI, pl. 669 for the Silos Deposition relief, where it represents ground).

35. Marcel Aubert and Michèle Beaulieu, *Musée National du Louvre, Déscription raisonée des Sculptures du Moyen Age, de la Renaissance et des Temps modernes*, vol. I, *Moyen Age* (Paris, 1950), p. 56, fig. 50.

36. The survival of fragments of twelfth-century and later medieval copybooks and the recurrence of certain designs in works of art attributable to a geographic area such as the valley of the Meuse, attest to the use of pattern sheets as models by Gothic artists. See R. W. Scheller, *A Survey of Medieval Model Books* (Haarlem, 1963); and with particular reference to Mosan art, see François Masai, "Les manuscrits à peintures de Sambre et Meuse aux XIᵉ et XIIᵉ Siècles," *Cahiers de Civilisation Médiévale Xᵉ–XIIᵉ Siècles*, III (1960) : 188–89, n. 63. See also D. J. A. Ross, "A Late Twelfth-century Artist's Pattern-Sheet," *Journal of the Warburg and Courtauld Institutes*, XXV (1962) : 123.

37. See above, p. 22.

38. Henri Focillon, *L'Art des Sculpteurs Romans. Recherches sur l'histoire des formes* (Paris, 1931), pp. 71–72.

39. For further discussion of figures under arcades see below, pp. 59–63.

40. Goldschmidt, *Elfenbeinskulpturen*, II : 32, fig. 65.

41. Karl H. Usener, "Reiner von Huy und seine künstlerische Nachfolge," *Marburger Jahrbuch für Kunstwissenschaft*, VII (1933) : 86, 90, 97–98.

42. The triptych in the Petit Palais is usually dated in the 1160s; but no documentary evidence exists, to the best of my knowledge, to substantiate such a late date. See von Falke, *Schmelzarbeiten*, p. 67, fig. 20. Other examples include the portable altar from Stavelot and the reliquary of Saints Monulf and Valentin in the Brussels Royal Museum, both attributed to Godefroid's workshop and dated respectively ca. 1150 and 1165 (ibid., pls. 78, 81). A large projecting nose, with arched eyebrows in a low forehead, is present on the small head, found by Kenneth J. Conant in his excavations at Cluny and now in the Musée Ochier there, but there is no other resemblance to the Saint-Denis apostles. See Wixom, *Treasures from Medieval France*, p. 62, ill. 9; Kenneth J. Conant, *Cluny: les Églises et la Maison du Chef d'Ordre* (Mâcon, 1968), pl. XC, fig. 204. The Gloucester candlestick, dated in the early twelfth century and generally held to be of English provenance, contains a few heads with similar profiles. The attribution of the candlestick to the Mosan area has not found favor. See Charles Oman, *The Gloucester Candlestick* (London, 1958), pp. 5–12, pls. 12–14. Scholars have also usually dated the pedestal from Saint-Bertin in the 1160s or 1170s, but recent research suggests a date in the late 1140s soon after the completion of Suger's Great Cross (Philippe Verdier, "La grande croix de l'abbé Suger à Saint-Denis," *Cahiers de Civilisation Médiévale Xᵉ–XIIᵉ Siècles*, XIII [1970] : 25–26).

43. The black mastic was made with a powder of bituminous shist. See Pierre Quarré, "Les sculptures du tombeau de Saint Lazare à Autun et leur place dans l'art roman," *Cahiers de Civilisation Médiévale Xᵉ–XIIᵉ Siècles*, V (1962) : 173, n. 42.

44. The recent examinations of the sculpture of the central portal (summers of 1968, 1969, and 1970) established as original the head of the first or lowest Foolish Virgin on the left jamb of the central portal, the face of the left angel holding the veil supporting the dove (fourth archivolt, center), and the small heads inhabiting the foliate rinceau of the abaci of the capitals on the right side of the central portal. See my preliminary report, "The West Portals of Saint-Denis and the Saint-Denis Style," *Gesta*, IX, no. 2 (1970) : 1–11,

figs. 2, 4, 8, 15. For the heads from Saint-Denis in the Walters Art Gallery, the Fogg Art Museum, and the Louvre, see Marvin C. Ross, "Monumental Sculptures from St.-Denis. An identification of Fragments from the Portal," *The Journal of the Walters Art Gallery,* III (1940), figs. 7, 8, 11, 13, 14, and 19; and Crosby, *L'Abbaye Royale,* figs. 6–9.

45. In the central portal the most striking similarities in hair treatment occur in the work of the master of the central tympanum angels. Among the surviving examples see especially the hair of the angel of the tympanum holding the right arm of the cross and that of the manacled soul whom an angel pushes back toward Hell (first archivolt, right). Fragments of original beards and locks of hair that survive untouched, such as those lying on the shoulders of Christ, also appear stylistically analogous.

46. The nomenclature of these different garments can be confusing. I believe that normal twelfth-century clothing included, or could include: loose underwear, or *braies;* a shirt, chemise, or *chainse;* a tunic, blouse, or *bliaud;* and a mantle, *manteau.* The costume of the apostles, or what can be seen of it, apparently includes only the last two items. See Enlart, *Costume,* pp. 29–37; and Viollet-le-Duc, *Dictionnaire du Mobilier,* III : 38–61 (*"bliaut"*), and IV : 100–31 (*"manteau"*).

47. It has been described as an elastic material that clings to the body (Viollet-le-Duc, *Dictionnaire du Mobilier,* III : 44; Enlart, *Costume,* p. 36); as "the characteristic crumpled decoration of the stuff" (Joan Evans, *Dress in Mediaeval France* [Oxford, 1952], p. 7); as "wattling" (Porter, *Pilgrimage Roads,* I : 97–98, 155). Viollet-le-Duc also described it as a method of ironing "gaufrées d'après un procédé bien connu des blanchisseuses de fin, encore aujourd'hui" (*Dictionnaire du Mobilier,* III : 175), as did Enlart (*Costume,* p. 36). This last interpretation is favored today. Although the goffered fabric occurs commonly as part of the costumes of the statue-columns of the royal portals of the twelfth century, the same design appears on the socks of a figure on a capital from Cluny III (Porter, *Pilgrimage Roads,* II : 7), as well as those of the shepherds in the tympanum of the south portal of the west façade of Chartres Cathedral: Étienne Houvet, *Cathédrale de Chartres, Portail Occidental, ou Royal* (Chelles, 1919), pl. 55. This use contradicts the exclusive association of the fabric with aristocratic dress. Similar designs may be observed on sleeves of late Roman figures, in Carolingian art, and with increasing frequency in the dress of the eleventh and early twelfth centuries. Becoming the fashion in the mid-twelfth century early Gothic sculpture, the goffered fabric then disappeared from use before the end of the century.

For some late Roman examples see the statues of the Four Emperors now at St. Mark's in Venice: Louis Brehier, *La Sculpture et les Arts Mineurs Byzantins* (Paris, 1936), pl. 2; and consular diptychs such as those of Asturius, Rome, 449, or Severus, Rome, 470: Delbrueck, *Consulardiptychen,* pls. 4, 5. Ninth- and tenth-century examples include: the sleeves of Saint John in the Gospels from Saint Gumbert in Ansbach, Fulda, ca. 870 (Erlangen Universitätsbibliothek, Codex 141, fol. 101ᵛ); Marys at the Tomb (Cassel Landesbibliothek, Codex Theol. fol. 60); Saint Gregory (Leipzig Stadtbibliothek, Codex CXC): Adolph Goldschmidt, *German Illumination,* I *Carolingian Period* (Florence, Paris, and New York, 1928), pls. 58, 82b, 84b; and an ivory bookcover in the Victoria and Albert Museum of the ninth-tenth century: Goldschmidt, *Elfenbeinskulpturen,* I : 49, fig. 88. In the early eleventh century a similar pattern appears on sleeves of figures on the Hildesheim doors: Hermann Leisinger, *Romanesque Bronzes: Church Portals in Medieval Europe* (New York, 1957), pls. 21–23, 25, 33. In England, ca. 1140, the pattern also occurs on the sleeves of the kneeling woman in the Chichester relief showing Christ coming to Mary's house: Stone, *Sculpture in Britain,* pl. 40.

48. The term *orphreys* derived from the Latin, *aurifrigium,* evidently implies its early origins in Phrygia, *aurum Phrygium;* see James Robinson Planché, *A Cyclopaedia of Cos-*

tume (London, 1876), I : 381. For the history of their use and descriptions of Carolingian, Ottonian, and twelfth-century orphreys see Viollet-le-Duc, *Dictionnaire du Mobilier*, IV : 149–54.

49. Wilhelm Köhler, who coined the term "damp fold," described the arrangement as resembling the effect created by a dampened garment clinging in places to the form beneath and a resultant "piling up in angles of parallel folds." The groups of angular folds contrast "with long, sweeping folds, which frame and relate the groups with each other." The arrangement shows the "articulated body beneath and through the garments" and produces "the effect of round, solid figures full of life and energy" ("Byzantine Art in the West," *Dumbarton Oaks Papers*, I [1941] : 70–76, figs. 10–15).

50. See the forthcoming article, Sumner McK. Crosby and Pamela Blum, "Le portail central de la façade occidentale de Saint-Denis," *Bulletin Monumental*.

51. See Jacques Stiennon, *Art Mosan des XIe et XIIe siècles* (Brussels, n.d.), pp. 7, 10, 11, pls. 9, 12, 19; and Usener, "Reiner von Huy," pp. 77–89, 91–98, figs. 1, 14–18.

52. Mâle used this detail to date the relief sculpture, showing Noah and his sons leaving the ark, on the Cathedral of Modena. Now dated after 1140, those reliefs postdate the façade of Saint-Denis. See his "L'architecture et la sculpture en Lombardie à l'époque romane, à propos d'un livre récent," *Gazette des Beaux-Arts*, 4th per., XIV (1918) : 40.

53. Similar, if not identical, examples may be found as early as the late-fourth-century relief on the Theodosian obelisk in Istanbul: Richard Brilliant, *Gesture and Rank in Roman Art* (New Haven, 1963), p. 173, fig. 4.22. I have noted some examples on early Christian sarcophagi; see Giuseppe Wilpert, *I Sarcofagi Cristiani Antichi*, I (Rome, 1929), pls. CXIII (in Arles), CXXVII (in the Museo delle Terme, Rome), CXXIX (S. Damaso). The gesture becomes more frequent in Romanesque art. See for example: the figure of Saint John on an ivory book cover of a late tenth-century evangelary (Munich, Bayerische Staatsbibliothek Clm. 4451): Wilhelm Messerer, *Der Bamberger Domschatz* (Munich, 1952), pp. 46–47, figs. 9, 11; the figure of Judas in the miniature of the Celestial Jerusalem in the Beatus of Saint-Sever; Lauer, *Enluminures Romanes*, pl. XXIII; figures on the baptismal font by Renier de Huy in Saint-Bartholomew, Liège: Hanns Swarzenski, *Monuments of Romanesque Art. The Art of Church Treasures in North-western Europe* (Chicago, 1954), pl. 111, fig. 255; the figure in front of Saint Luke in the initial *P*, fol. 68, of the Bible of Citeaux, 1109: Charles Oursel, *Miniatures Cisterciennes (1109–1134)* (Mâcon, 1960), pl. XVIII; figures on three capitals at Saint-Lazare, Autun (the Stoning of Saint Stephen, the Second Temptation of Christ, and the Annunciation to Saint Anne): Denis Grivot and George Zarnecki, *Gislebertus, Sculptor of Autun* (Paris and London, 1961), pls. 28, 37. The same gesture is made by the angel of the Annunciation to the Shepherds, on the south portal of the west façade of Chartres Cathedral: Houvet, *Portail Occidental*, pl. 55. Lawrence Stone observes that the same gesture by an apostle on the west façade of Lincoln Cathedral could have had its origin in English miniatures: *Sculpture in Britain*, p. 74, pl. 53.

54. See especially the two groups of apostles in the central tympanum of the west façade at Saint-Denis (Fig. 69).

55. See Brilliant, *Gesture*, pp. 23–25.

56. "In spite of their stocky character the twelve Apostles are clearly related to the jamb figures of the right portal of the façade. . . . So close is the affinity between Apostles and monumental jamb statues in arrangement of drapery, carving of folds, and general articulation of forms that one is forced to conclude that the sculptor utilized the right portal as model for the bas-relief" (Stoddard, *West Portals*, p. 60).

57. See above, p. 44, n. 44, and below, p. 67. The drawings, executed by Antoine Benoit before 1717, are in the Bibliothèque Nationale, Paris (Ms. fr. 15634, fol. 33ff). They were

published by Bernard de Montfaucon, *Les Monumens de la Monarchie Françoise*, I (Paris, 1729), pls. XVI–XVIII.

58. The mean measurement of the figures of the apostles of the bas-relief approximates 32 centimeters, with the maximum height of 33 centimeters, while the two Walters Art Gallery heads measure 35 centimeters and 36 centimeters, respectively.

59. For a discussion of such copybooks, see above, p. 40, n. 36.

60. The plates in Montfaucon present the figures in groups, which have been assumed to represent the statue-columns as seen on the three portals. There is no proof, however, that the order of the figures follows their order on the portal embrasures.

61. Curt F. Bühler, "The Apostles and the Creed," *Speculum*, XXVIII (April 1953): 335–39. A traditional but not absolute order of the apostles according to the *Credo* was: Peter, Andrew, James, John, Thomas, James, Phillip, Bartholomew, Matthew, Simon, Thaddeus, Mathias. They are so represented on the Welfenschatz portable altar, ca. 1130: von Falke, *Schmelzarbeiten*, pl. 17. Suger was certainly aware of this symbolism for his friend Jocelinus, bishop of Soissons, wrote in some detail about the *symbolum*, as the *Credo* was called (*Expositio in Symbolum*, *Pat. Lat.*, CLXXXVI, cols. 1479–88). Rupertus of Deutz gave their order according to their missions: Peter, Mark, Thomas, Matthew, Bartholomew, Andrew, John, Simon, Judas, James, Phillip, Mathias, Paul (*De Vita Vere Apostolica* 4.6, *Pat. Lat.*, CLXX, cols. 645–46).

In the twelfth century when the liturgical year began on Michelmas, the following calendrical sequence obtained: Andrew (Nov. 30), Thomas (Dec. 21), John (Dec. 26), Mathias (Feb. 24), Philip (May 1), James the Less (May 1), Peter (June 30), Paul (June 30), James the Major (July 25), Bartholomew (Aug. 24), Matthew (Sept. 21), Simon (Oct. 28).

In the Beatus of Saint-Sever the illumination depicting the Celestial Jerusalem represents each apostle below a demi-figure representing one of the Twelve Tribes of Israel: Lauer, *Enluminures Romanes*, pl. XXIII. I have not been able to find any sequence that seems similar to the one on the bas-relief, although the lintel of Châteauneuf has Saint Peter in the center. See below, p. 60 and Fig. 80.

62. As stated by Saint Augustine, "Qui enim disputat, verum discernit a falso" (*Contra Cresconium* 1.15.19., *Pat. Lat.*, XLIII, col. 457). In regard to the "dialogue," see especially Fritz Saxl, "Frühes Christentum und spätes Heidentum in ihren Künstlerischen Ausdrucksformen. I: "Der Dialog als Thema der Christlichen Kunst," *Wiener Jahrbuch für Kunstgeschichte*, n.s., II (1923): 64–77; and Elisabeth Rosenbaum, "Dialog," *Reallexikon zur Deutschen Kunstgeschichte*, ed. Otto Schmitt, III (Stuttgart, 1954), cols. 1400–08; and see below, pp. 63–65.

63. For a summary of Abelard's influence on medieval teaching, see S. R. Smith, "Peter Abelard," *New Catholic Encyclopedia* (New York, 1967), I : 15–17; P. Michaud-Quantin and J. A. Weisheipt, "Dialectics in the Middle Ages," ibid., IV : 846–49.

64. See, for example, the stained glass medallion showing the Quadriga of Aminadab in the chapel of Saint Peregrinus at Saint-Denis: Louis Grodecki, "Les vitraux allégoriques de Saint-Denis," *Art de France*, I (1961): 25. See also Maurice Prou, *Manuel de Paléographie* (Paris, 1924), pp. 193–200; and Paul Deschamps, "Étude sur la paléographie des inscriptions lapidaires de la fin de l'époque Mérovingienne aux dernières années du XII⁰ siècle," *Bulletin Monumental*, LXXXVIII (1929): 5–86.`

65. Notable objects of the 1120s or 1130s with similar irregular inscriptions include: the Victorschrein in Xanten, ca. 1129, and the Mauritius portable altar in Siegburg, ca. 1135, both by Eilbertus: von Falke, *Schmeltzarbeiten*, pls. 20–22, 25; the Saint Hadelinus reliquary in Visé: Usener, "Reiner von Huy," p. 94, figs. 17, 18; and the metal lock inscribed

with the name *Varnerius* on an ivory casket in the Louvre: Goldschmidt, *Elfenbein-skulpturen*, III, pl. XXIII, fig. 63a.

66. For an illustration of this mosaic see Formigé, *Abbaye Royale*, fig. 95.

67. See my article, "Masons' Marks at Saint-Denis," *Mélanges offerts à René Crozet* (Poitiers, 1966), II : 711-17.

68. The exception is the incised name, *Jacobus*, on the abacus of column 9 (Fig. 21).

69. Lapeyre, *Façades*, pp. 115-16.

70. The earliest examples of raised letters that I have noted are the ivory carving of Saint Michael, ca. 400, in the British Museum: Ormonde M. Dalton, *Catalogue of the Ivory Carvings of the Christian Era* (London, 1909), pl. VI, fig. 11; and the consular diptych of Areobindus, dated 506 (one panel is in the Louvre, the other in Milan): Del-brueck, *Consulardiptychen*, pls. 13, 14. In stone the earliest examples known to me are two eighth-century fragments, one in the Museo Archeologio in Milan, the other in the Vati-can: Gian Piero Bognetti, "Sul Tipo e il Grado di Civiltà dei Langobardi in Italia, se-condo i Dati dell'Archeologia e della Storia del Arte," *Frühmittelalterliche Kunst in den Alpenländern*, Akten zum III. Internationalen Kongress für Frühmittelalterforschung (Olten and Lausanne, 1954), figs. 23, 26. There are many examples in ivory and metal during the ninth, tenth, and eleventh centuries.

THE ARTIST AND HIS STYLE

1. See above, p. 43.

2. Müller-Dietrich, *Lothringen*, p. 9. This study is restricted to the departments of Meuse, Moselle, Meurthe-et-Moselle, and Vosges.

3. Guibert de Nogent, *De Vita Sua* 3.3, *Pat. Lat.*, CLVI, col. 910; or *Self and Society in Medieval France*, p. 149.

4. Suger, *De Administratione* 32 (Panofsky, *Suger*, p. 59; Lecoy de la Marche, *Œuvres*, p. 196).

5. In characteristic fashion Suger's reference to the Great Cross omits the details that would allow an accurate reconstruction, *De Administratione* 32 (Panofsky, *Suger*, pp. 56-61, 176-78; Lecoy de la Marche, *Œuvres*, pp. 194-96). The inventory of the abbey's treasures in 1634 provides a fairly detailed, but often enigmatic description, which has attracted the attention of many scholars without producing a satisfactory solution. A sampling of the bibliography includes: Félibien, *Histoire*, p. 174; Labarte, *Arts Industriels*, I : 413-18; Conway, "Treasures," pp. 139-40; Émile Mâle, "La part de Suger dans la création de l'iconographie du moyen âge," *Revue de l'art ancien et modern*, XXXV (1914) : 92-98; Émile Mâle, *L'Art Religieux du XIIᵉ Siècle en France* (Paris, 1928), pp. 153-57; Marcel Lau-rent, "Godefroid de Claire et la Croix de Suger á l'Abbaye de Saint-Denis," *Revue Archèolo-gique*, 5th ser., XIX (1924) : 79-87; and, more recently, Rosalie Green, "Ex Ungue Le-onem," *De Artibus Opuscula XL. Essays in Honor of Erwin Panofsky*, ed. Millard Meiss (New York, 1961), pp. 157-69. Verdier, "La grande croix," gives a French translation of Suger's chapter about the cross and a transcription of the 1634 inventory.

6. Marcel Aubert, *Suger*, p. 88. Otto Cartellieri, *Abt Suger von Saint-Denis*. 1081-1151 (Berlin, 1898), p. 137, no. 80, remarks on relations between Saint-Denis and Liège in 1133 and again in 1136.

7. William R. Lethaby, "The Part of Suger in the Creation of Mediaeval Iconography," *The Burlington Magazine*, XXV (1914) : 206-07; Egid Beitz, *Rupertus von Deutz. Seine Werke und die bildende Kunst* (Cologne, 1930), pp. 64-70; Grodecki, "Vitraux," pp. 24, 28, 30-31.

8. "Romanesque": Henri Guingot, "La Représentation des Douze Apôtres dans l'Ima-

gerie Populaire d'Épinal," *Artisans et Paysans de France. Recueil d'Études d'Art Populaire* (Strasbourg and Paris, n.d.) : 166. "Late Romanesque": Ernst Gall, review of Crosby, *L'Abbaye Royale*, *Art Bulletin*, XXXVII (1955) : 139. "Transitional": Jurgis Baltrušaitis, *Réveils et Prodiges. Le gothique fantastique* (Paris, 1960), p. 26. "Both Romanesque and Gothic": Crosby, *Abbaye Royale*, p. 55.

9. See especially Focillon, *Sculpteurs Romans,* passim.

10. Bernard de Clairvaux, *Apologia ad Guillelmum Sancti-Theoderici Abbatem* 12, *Pat. Lat.*, CLXXXII, cols. 914–16, or trans. George G. Coulton, *Life in the Middle Ages* (Cambridge, 1930), IV : 172–74, and partially reprinted by Elizabeth G. Holt, *A Documentary History of Art,* vol. I, *The Middle Ages and the Renaissance* (New York, 1957), p. 21.

11. Henri Focillon, *Art d'Occident. Le Moyen Age Roman et Gothique* (Paris, 1938), p. 98, or *Art of the West in the Middle Ages,* vol. I, *Romanesque Art,* ed. Jean Bony, trans. Donald King (New York, London, 1963), p. 105.

12. Among others see: Henry Adams, *Mont-Saint-Michel and Chartres* (Boston and New York, 1904), pp. 320–46; Henry Osborn Taylor, *The Mediaeval Mind* (London, 1911), I : 392–414; Étienne Gilson, *The Spirit of Mediaeval Philosophy,* trans. A. H. C. Downes (New York, 1936), pp. 269–303.

13. See especially: Edgar de Bruyne, *Études d'Esthétiques Médiévales* (Brugge, 1946). III : 3–29; also Panofsky, *Suger,* pp. 19–24; von Simson, *Gothic Cathedral,* pp. 50–55.

14. See David Knowles, *The Evolution of Medieval Thought* (London, 1962), pp. 120–30.

15. Jean Bony, *French Cathedrals* (London, 1951), pp. 5–7; von Simson, *Gothic Cathedral,* pp. xix–xxii; 227–28.

16. See Marion Lawrence, "Columnar Sarcophagi in the Latin West," *Art Bulletin*, XIV (1932) : 160, 164. For the symbolism of the Roman arch as the *Porta Triumphalis* or *Arcus Divorum* see E. Baldwin Smith, *Architectural Symbolism of Imperial Rome and the Middle Ages* (Princeton, 1956), pp. 30–37. Pagan arcaded sarcophagi with figures sometimes represented the deceased with the Muses, as on the marble sarcophagus in the Campo Santo, Pisa: Lawrence, "Columnar Sarcophagi," p. 180, fig. 66.

17. For the early popularity and symbolism of the apostles see above, p. 15.

18. Not enough attention has been given to Suger's extensive travels. In 1118, for instance, he was in Montpellier and in 1137 in Bordeaux. He made at least three trips to Italy. See Cartellieri, *Abt Suger,* pp. 127–32; and Crosby, *L'Abbaye Royale,* p. 30. Two characteristic examples of sarcophagi with apostles under arches, which he could have seen are in the Museum of Christian Art, Arles, dated in the second half of the fourth century: Wilpert, *Sarcofagi,* I : 49–50, pl. XXXII, fig. 3, XXXVIII, fig. 1. (See also Fig. 74.) Two other examples are in San Francesco in Ravenna: Lawrence, *The Sarcophagi of Ravenna,* pp. 13–17, figs. 25, 26. Another one, no. 138 in the Lateran Museum, is dated ca. 330–40: Wilpert, *Sarcofagi,* I : 50–51, pl. XXXII, fig. 1.

19. Suger was "offered" to the monastic life in front of this altar and refers to Charles the Bald's frontal panel as "beautiful and precious." In *De Administratione* 33 he described the additional embellishments he ordered for the high altar, when he also transformed the Carolingian frontal panel into a retable (Panofsky, *Suger,* pp. 60–68, 179–82; Lecoy de la Marche, *Œuvres,* pp. 196–98). Excellent reproductions of the fifteenth-century painting by the Master of Saint Gilles, by which the lost panel is known, appear in the article by Conway, "Treasures," pls. II, XI. See also the detail of the painting (Fig. 75). Unfortunately the painting shows the altar covered by a cloth, so that Suger's new side panels and frontal cannot be seen. According to the inventories of the Saint-Denis treasure, those panels each had three figures under arches in conformity with the Carolingian panel. Comparison of the figures with those of the apostle bas-relief would have been very

revealing. In the 1140s, with the new choir under construction, the panel given to the abbey by Charles the Bald must have been removed from the altar. Quite possibly it was cleaned and restored in the abbey's workshops, where the artist of the bas-relief could have easily examined it.

20. Marcel Aubert, "Saint-Benoît-sur-Loire," *Congrès Archéologique de France*, XCIII, *Orléans*, 1930 (Paris, 1931), pp. 653–54; Porter, *Pilgrimage Roads*, X : 1421–22. The altar was destroyed in 1534. It has been suggested that Suger may have spent two years at Saint-Benoît-sur-Loire between 1104 and 1106, to continue his studies; but there is no proof of this. No other evidence documents his presence at the famous abbey; but we may assume at least a visit during his many trips in this region. See Cartellieri, *Abt Suger*, p. 127, no. 5; and Aubert, *Suger*, p. 5, n. 15.

21. A. K. Porter suggested that the turreted canopies were "probably a development of those which had been characteristic of Spanish monuments of the eleventh century" (*Pilgrimage Roads*, I : 165, n. 1); but for other theories see Jurgis Baltrušaitis, "Villes sur arcatures," *Urbanisme et Architecture, Études écrites et publiées en l'honneur de Pierre Lavedan* (Paris, 1954), pp. 31–40; and John Summerson, *Heavenly Mansions and Other Essays on Architecture* (New York 1963), pp. 1–28.

22. I know of no documentation dating this lintel. Scholars often compare it to the nearby lintel with seated apostles at Charlieu, of 1094. See Porter, *Pilgrimage Roads*, I : 133, and II, pls. 2, 4; also Marcel Aubert, *La Bourgogne; La Sculpture* (Paris, 1930), I : 67–68, and III, pls. 192–93, fig. 3.

23. Cartellieri, *Abt Suger*, 138, no. 87.

24. No accurate date can be assigned these two figures. A. K. Porter simply says "advanced" twelfth century, *Pilgrimage Roads*, I : 23, n. 1, and VII, pl. 914.

25. Cartellieri, *Abt Suger*, 139, nos. 94–95.

26. A. K. Porter notes that the canons of Saint-Hilaire returned to their church in the middle of the eleventh century and that these figures were part of an embellishment undertaken at that time. He assigns a similar date to the Azay-le-Rideau figures, *Pilgrimage Roads*, I : 23, n. 1 and VII, pls. 896, 912.

27. A date soon after 1110 is generally accepted for this tomb and the unusual altar frontal at Airvault. A. K. Porter saw a strong "Lombard" influence in this sculpture, *Pilgrimage Roads*, I : 304, and VII, pls. 903, 964.

28. The tomb of Saint Junien, in the church of that name in the Haute-Vienne, shows twelve Elders seated under massive arcades. The pedestals under their feet, the turreted arcade, and the geometrical ornament of the columns belong to this Loire-Poitou tradition; but its date—soon after 1150—identifies it as a variant of this local type, rather than as a possible prototype for the Saint-Denis relief. See Porter, *Pilgrimage Roads*, I : 156, and IV, pl. 450.

29. For examples see the work of Eilbertus of Cologne, such as the Victorschrein in Xanten, ca. 1129, the Welfenschatz portable altar, ca. 1130, and the München-Gladbach portable altar, ca. 1135: von Falke, *Schmelzarbeiten*, pls. 18–19, 23–25. See also the Mauritius portable altar (Fig. 79) and an early twelfth-century casket in the Metropolitan Museum of New York: A. McC. and J. B., "A Romanesque Châsse," *The Bulletin of the Metropolitan Museum of Art*, XIX (1924), figs. on pp. 84, 86.

30. The three plaques in the Louvre are numbered: Inv. nos. 2008–10. Both Molinier and Goldschmidt wrote that the identification of the three saints unquestionably associated the ivories with the abbey church and possibly with Suger. Goldschmidt proposed a date ca. 1145; Molinier one not before 1150. See Goldschmidt, *Elfenbeinskulpturen*, IV : 20 and pl. XIV, no. 61a-c; Émile Molinier, *Histoire Générale des Arts Appliqués à l'Industrie*, vol. I, *Ivoires* (Paris, 1896), p. 162. Similar openwork arcades with figures occur

on a twelfth-century ivory diptych in the Chambéry Cathedral treasury: Adolph Gold-schmidt and Kurt Weitzmann, *Die Byzantinischen Elfenbeinskulpturen des X–XIII Jahrhunderts*, II (Berlin, 1934): 78–79, pl. LXII, no. 222; and on a mid twelfth-century bronze reliquary casket in the Xanten Cathedral treasury: Hermann Schnitzler, *Rheinische Schatzkammer*, vol. II, *Die Romanik* (Düsseldorf, 1959), pp. 48–49; pl. 162.

31. Unquestionably of French origin, "ces petits reliefs sont inspirés par l'orfèvrerie et la qualité de leur style indique une direction de recherches vers l'art mosan" (Louis Grodecki, *Ivoires Français* [Paris, 1947], p. 62, pl. XVIII).

32. See above, p. 53.

33. See: Edmond Le Blant, *Les Sarcophages Chrétiens de la Gaule* (Paris, 1886), no. 81 from Clermont, pl. XIX; no. 89 from Rodez, pl. XXII; nos. 149 and 153 from Toulouse, pls. XXXVII, XXXIX; nos. 156 and 157 from Saint-Michel-du-Touche, pls. XLI, XLII; no. 173 from Beziers, pl. XLIII, fig. 1; no. 189 from Narbonne, pl. XLIII, fig. 2; no. 193 from Mas-Saint-Antonin, pl. XLVIII.

34. Goldschmidt, *Elfenbeinskulpturen*, I: 32–33, pl. XXIV. These ivory plaques are identified with the style of the late Liuthard group and must, therefore, have been carved in northern Europe. This casket is often identified as having belonged to Otto I.

35. For the Toulouse apostles, see Linda Seidel, "A Romantic Forgery: The Romanesque 'Portal' of Saint-Étienne in Toulouse," *Art Bulletin*, L (1968): 33–42. For the Vézelay pair, see Adolf Katzenellenbogen, "The Central Tympanum at Vézelay," *Art Bulletin*, XXVI (1944): 141–51. The Basel apostle relief is usually dated in the eleventh century, but I know of no documentary evidence for such a date, and the style seems much more characteristic of the twelfth century; see Hans Reinhardt, *Das Münster zu Basel* (Burg-bei-Magdeburg, 1928), p. 17. Elisabeth Rosenbaun, "Dialog," col. 1404, mentioned a date ca. 1060.

36. Von Falke, *Schmelzarbeiten*, pl. 20. On the Mauritius altar three apostles, at the bottom left, are arranged as a group of three, an unusual concept possibly related to the grouping of Saints Matthew, James, and Phillip on the Saint-Denis bas-relief, but the relationship of the seated figures to the arcades derives from the "classic" tradition. The difference between a dialogue and a declaration may be seen by comparison with the top of the Welfenschatz portable altar, signed by Eilbertus. Here the apostles are shown as they participate in the declaration of the *Credo* (von Falke, *Schmelzarbeiten*, pl. 17).

37. Karl Young, *The Drama of the Medieval Church* (Oxford, 1933), I: 80, n. 1, and 548.

38. For the Cluny retable, see Usener, "Reiner von Huy," pp. 124–30. The Bamberger apostles are described by Artur Weese, *Die Bamberger Domskulpturen: Ein Beitrag zur Geschichte der deutschen Plastik des XIII Jahrhunderts* (Strasbourg, 1914), p. 48.

39. Mâle, *L'Art Religieux du XII^e Siècle en France* (Paris, 1928), pp. 183–84.

40. See my articles, "The Creative Environment," *Ventures*, V, no. 2 (1965): 10–15; and "An International Workshop in the Twelfth Century," *Journal of World History*, X, no. 1 (1966): 19–30.

41. *De Administratione* 34 (Panofsky, *Suger*, pp. 72–73; Lecoy de la Marche, *Œuvres*, p. 204).

42. See Stoddard, *West Portals*, pls. XII², XIII²,³, XIV², XV³.

43. Adelheid Heimann, "The Capital Frieze and Pilasters of the Portail Royal, Chartres," *Journal of the Warburg and Courtauld Institutes*, XXXI (1969), pls. 35e, 37e, 38d.

44. Lapeyre, *Façades*, pp. 92, 132, 158.

45. Ibid., p. 115.

46. See Willibald Sauerländer, "Sculpture on Early Gothic Churches: The State of Research and Open Questions," *Gesta*, IX, no. 2 (1970): 33–38.

47. See Pierre Quarré, "La sculpture des anciens portails de Saint-Bénigne de Dijon," *Gazette des Beaux-Arts*, 6th per., L (1957): 193. The tympanum is now in the Musée Archéologique of Dijon.

48. The capital is now in the Musée Lapidaire of the former church of Saint-Léger, Soissons. See above, p. 38, n. 34.

49. Among the most noticeable examples are the triptych in the Petit Palais in Paris, see above, p. 43, nn. 40–42; the portable altar of Stavelot, and the Koblenz Pentecost retable in the Cluny Museum: Usener, "Reiner von Huy," figs. 26–31, 42–49; and the pedestal from Saint-Bertin in the Saint-Omer museum: Swarzenski, *Monuments of Romanesque Art*, pls. 178–79.

50. Examples are given above, pp. 32–33, nn. 12–18.

51. See Swarzenski, *Monuments of Romanesque Art*, pls. 219, 220, figs. 518, 519.

52. See above, p. 20.
198).

53. *De Administratione* 33 (Panofsky, *Suger*, pp. 62–65; Lecoy de la Marche, *Œuvres*, p. 198).

APPENDIX 2

1. The following selections from the literature suggest the range and complexity of the topic. Viollet-le-Duc, *Dictionnaire de l'Architecture*, VII: 532–61 ("proportion"). Frederic M. Lund, *Ad Quadratum. A Study of the Geometrical Bases of Classic and Medieval Religious Architecture* (London, 1921). Johnny Roosval, "Ad Triangulum, ad Quadratum," *Gazette des Beaux-Arts*, 6th ser., XXVI (1944): 149–62. Paul Frankl, "The Secret of the Medieval Masons"; with Erwin Panofsky, "An Explanation of Stornaloco's Formula," *Art Bulletin*, XXVII (1945): 46–64. James S. Ackerman, "'Ars Sine Scientia Nihil est.' Gothic Theory of Architecture at the Cathedral of Milan," *Art Bulletin*, XXXI (1949): 84–111. Maria Velte, *Die Anwendung der Quadratur und Triangulatur bei der Grund- und Aufrissgestaltung der gotischen Kirchen* (Basel, 1951). George H. Forsyth, Jr., *The Church of St. Martin at Angers* (Princeton, 1953), pp. 218–21. Ernest Levy, "Appendix on the Proportions of the South Tower of Chartres Cathedral," in von Simson, *The Gothic Cathedral*, pp. 235–65; and von Simson, ibid., pp. 196–200. George Lesser, *Gothic Cathedrals and Sacred Geometry*, 2 vols. (London, 1957). Elizabeth R. Sunderland, "Symbolic Numbers and Romanesque Church Plans," *Journal of the Society of Architectural Historians*, XVIII (1959): 94–103. Bernard G. Morgan, *Canonic Design in English Medieval Architecture* (Liverpool, 1961). Elisa Maillard, *Eglises du XIIᵉ au XVᵉ siècle. Les Cahiers du Nombre d'Or*, III (Paris, 1964). Sumner McK. Crosby, "Crypt and Choir Plans at Saint-Denis," *Gesta*, V (1965): 4–8. Walter Horn and Ernest Born, "The 'Dimensional Inconsistencies' of the Plan of Saint Gall and the Problem of the Scale of the Plan," *Art Bulletin*, XLVIII (1966): 285–307. Turpin C. Bannister, "The Constantinian Basilica of Saint Peter at Rome," *Journal of the Society of Architectural Historians*, XXVII (1968): 33–38. Sumner McK. Crosby, "The Plan of the Western Bays of Suger's New Church at Saint-Denis," *Journal of the Society of Architectural Historians*, XXVII (1968): 39–43. Kenneth J. Conant, *Cluny*, pp. 140–46.

2. See above, pp. 41–42.

Bibliography

ABBREVIATIONS

MGH *Monumenta Germaniae Historica*
Pat. Lat. *Patrologiae cursus completus . . . series Latina.* Edited by Jacques
 Paul Migne (Paris, 1844–80)

Ackerman, James. " 'Ars Sine Scientia Nihil est.' Gothic Theory of Architecture at the Cathedral of Milan." *Art Bulletin,* XXXI (1949) : 84–111.
Adams, Henry. *Mont-Saint-Michel and Chartres.* Boston and New York: Houghton Mifflin Co., 1904.
Alviella, Eugène F. A. Goblet, Comte d'. *The Migration of Symbols.* Westminster, 1894. Reprint. New York: University Books, 1956.
Ambrose, Saint. *In Psalmum David CXVIII Expositio. Pat. Lat.,* XV, cols. 1197–1526.
Aubert, Marcel. "Les autels en métal doré du Danemark à l'époque romane." *Bulletin Monumental,* LXXXVI (1927) : 137–44.
———. *La Bourgogne; La Sculpture.* 3 vols. Paris: Éditions G. Van Oest, 1930.
———. "La construction au moyen âge. Loges d'Allemagne, maçons et francs-maçons en Angleterre." *Bulletin Monumental,* CXVI (1958) : 231–41; CXIX (1961) : 7–42, 81–120, 181–209, 297–323.
———. "Le Portail Royal de Chartres. Essai sur la date de son exécution." *Miscellanea Leo van Puyvelde.* Brussels: Éditions de la Connaissance, 1949, pp. 281–84.
———. "Saint-Benoît-sur-Loire." *Congrès Archéologique de France.* Vol. XCIII, *Orléans,* 1930 (1931), pp. 569–656.
———. *Suger.* Rouen: Éditions de Fontenelle, Abbaye S. Wandrille, 1950.
Aubert, Marcel, and Beaulieu, Michèle. *Musée National du Louvre, Déscription raisonnée des Sculptures du Moyen Age, de la Renaissance et des Temps modernes.* Vol. I, *Moyen Age.* Paris: Éditions des Musées Nationaux, 1950.
Augustine, Saint. *Contra Cresconium Grammaticum partis Donati. Pat. Lat.,* XLIII, cols. 445–594.
———. *Enarrationes in Psalmos. Pat. Lat.,* XXXVI–XXXVII.

Baltrušaitis, Jurgis. *Réveils et Prodiges. Le gothique fantastique*. Paris: Armand Colin, 1960.

——. *La Stylistique Ornamentale dans la Sculpture Romane*. Paris: Ernest Leroux, 1931.

——. "Villes sur arcatures." *Urbanisme et Architecture. Études écrites et publiées en l'honneur de Pierre Lavedan*. Paris: H. Laurens, 1954, pp. 31–40.

Bannister, Turpin C. "The Constantinian Basilica of Saint Peter at Rome." *Journal of the Society of Architectural Historians*, XXVII (1968) : 33–38.

Beenken, Hermann. *Romanische Skulptur in Deutschland (11 und 12 Jahrhundert)*. Leipzig: Klinkhardt & Biermann/Verlag, 1924.

Beitz, Egid. *Rupertus von Deutz. Seine Werke und die bildende Kunst*. Veröffentlichungen des Kölnischen Geschichtsvereins, IV. Cologne: Creutzer & Co., 1930.

Bernard de Clairvaux, Saint. *Apologia ad Guillelmum Sancti-Theoderici Abbatem. Pat. Lat.* CLXXXII, cols. 895–918. For translation see Coulton, *Life in the Middle Ages*.

Bertaux, Émile. *L'Art dans l'Italie Méridionale de la Fin de l'Empire Romain à la Conquête de Charles d'Anjou*. Paris: Albert Fontemoing, 1904.

Boas, Franz. *Primitive Art*. Irvington-on-Hudson, N.Y.: Capitol Publishing Co., 1951.

Bognetti, Gian Piero. "Sul Tipo e il Grado di Civiltà dei Langobardi in Italia, secondo i Dati dell'Archeologia e della Storia del Arte." *Frühmittelalterliche Kunst in den Alpenländern*. Akten zum III. Internationalen Kongress für Frühmittelalterforschung. Olten and Lausanne: Urs Graf-Verlag, 1954, pp. 41–75.

Bony, Jean. *French Cathedrals*. London: Thames and Hudson, 1951.

Braunfels, Wolfgang. *Die Welt der Karolinger und ihre Kunst*. Munich: Verlag Georg D. W. Callway, 1968.

Bréhier, Louis. *La Sculpture et les Arts Mineurs Byzantins*. Paris: Les Éditions d'Art et d'Histoire, 1936.

Brilliant, Richard. *Gesture and Rank in Roman Art. The Use of Gesture to Denote Status in Roman Sculpture and Coinage*. New Haven: The Connecticut Academy of Arts & Sciences, 1963.

Brøndsted, Johannes. *Early English Ornament*. Translated by Albany F. Major. London and Copenhagen: Hachette and Levin & Munksguard, 1924.

Bruyne, Edgar de. *Études d'Esthétiques Médiévales*. 3 vols. Brugge: De Tempel, 1946.

Bühler, Curt F. "The Apostles and the Creed." *Speculum*, XXVIII (April 1953) : 335–39.

Cabrol, Fernand, and Leclercq, Henri. *Dictionnaire d'archéologie chrétienne et de liturgie.* 15 vols. Paris: Librairie Letouzeyet Ané, 1907–53.

Cartellieri, Otto. *Abt Suger von Saint-Denis 1081–1151.* Historische Studien, XI. Berlin: E. Ebering, 1898.

Chateaubriand, François A. R., V^te^ de. *Génie du Christianisme.* 7th ed. 5 vols. Paris: Le Normant, 1822–23.

Colombier, Pierre du. *Les Chantiers des Cathédrales.* Paris: A. et J. Picard 1953.

Conant, Kenneth J. *Cluny: les Églises et la Maison du Chef d'Ordre.* Medieval Academy of America. Mâcon: Imprimerie Protat Frères, 1968.

Conway, W. Martin. "The Abbey of Saint-Denis and its Ancient Treasures." *Archaeologia,* LXVI (1915) : 103–58.

Coulton, George Gordon. *Life in the Middle Ages.* 4 vols. Cambridge: Cambridge University Press, 1930.

Crosby, Sumner McK. *L'Abbaye Royale de Saint-Denis.* Paris: Paul Hartmann, 1953.

——. *The Abbey of St.-Denis, 475–1122,* I. New Haven: Yale University Press, 1942.

——. "Communication sur ses fouilles de la basilique de Saint-Denis. Séance du 9 juillet 1947." *Bulletin de la Société Nationale des Antiquaires de France,* 1945–49. (1950), p. 253.

——. "The Creative Environment." *Ventures.* Magazine of the Yale Graduate School. V, no. 2 (1965) : 10–15.

——. "Crypt and Choir Plans at Saint-Denis." *Gesta,* V (1966) : 4–8.

——. "Fouilles exécutées récemment dans la basilique de Saint-Denis." *Bulletin Monumental,* CV (1947) : 167–81.

——. "An International Workshop in the Twelfth Century." *Journal of World History,* X, no. 1 (1966) : 19–30.

——. "Masons' Marks at Saint-Denis." *Mélanges offerts à René Crozet.* 2 vols. Edited by Pierre Gallais and Yves-Jean Riou. Poitiers: Société d'Études Médiévales, 1966, II : 711–17.

——. "The Plan of the Western Bays of Suger's New Church at Saint-Denis." *Journal of the Society of Architectural Historians,* XXVII (1968) : 39–43.

——. "Sous le dallage de l'Abbaye Royale de Saint-Denis." *Archeologia,* XIV–XV (1967) : 34–38, 71–75.

——. "The West Portals of Saint-Denis and the Saint-Denis Style." *Gesta,* IX, no. 2 (1970) : 1–11.

Crosby, Sumner McK., and Blum, Pamela Z. "Le portail central de la façade occidentale de Saint-Denis." *Bulletin Monumental,* forthcoming.

Dalton, Ormonde M. *Catalogue of the Ivory Carvings of the Christian Era with Examples of Mohammedan Art and Carvings in Bone in the Department of British Mediaeval Antiquities and Ethnography of the British Museum.* London: Trustees of the British Museum, 1909.

Delbrueck, Richard. *Die Consulardiptychen und Verwandte Denkmäler.* Berlin and Leipzig: Verlag von Walter de Gruyter & Co., 1929.

Deonna, Waldemar. " 'Sacra Vitis.' La double vigne dionysiaque et les origines du rinceau, specialement du rinceau bouclé vertical." *Les Cahiers Techniques de l'Art,* II (1952) : 1–64.

Deschamps, Paul. "Étude sur la paléographie des inscriptions lapidaires de la fin de l'époque Mérovingienne aux dernières années du XIIe siècle." *Bulletin Monumental,* LXXXVIII (1929) : 5–86.

Doublet, Dom F. Jacques. *Histoire de l'Abbaye de S. Denys en France.* Paris: Chez Michel Soly, 1625.

Duchesne, Louis M. O. *Les Fastes Episcopaux de l'ancienne Gaule.* 3 vols. Paris: A. Fontemoing, 1900–15.

Enlart, Camille. *Manuel d'Archéologie Française.* Vol. III, *Le Costume.* Paris: Auguste Picard, 1916.

Evans, Joan. *Dress in Mediaeval France.* Oxford: Clarendon Press, 1952.

———. *Pattern. A Study of Ornament in Western Europe from 1180 to 1900.* 2 vols. Oxford: Clarendon Press, 1931.

Eusebius. *De Vita Constantini. Pat. Lat.,* VIII, cols. 9–92.

Falke, Otto von, and Frauberger, Heinrich. *Deutsche Schmelzarbeiten des Mittelalters und andere Kunstwerke der Kunst-Historischen Ausstellung zu Düsseldorf 1902.* Frankfurt am Main: Joseph Baer & Co. and Heinrich Keller, 1904.

Falke, Otto von; Schmidt, Robert; and Swarzenski, Georg, eds. *The Guelph Treasure: The Sacred Relics of Brunswick Cathedral formerly in the Possession of the Ducal House of Brunswick-Lüneburg.* Frankfurt am Main: Anstalt A. G., 1930.

Félibien, Michel. *Histoire de l'Abbaye Royale de Saint-Denys en France.* Paris: Chez Frédéric Leonard, 1706.

Fleury, Michel, and Lenord, François. "Les Bijoux Mérovingiens d'Arnegonde." *Art de France,* I (1961) : 7–18.

Fleury, Michel. "Communication. Nouvelle campagne de fouilles de sépultures de la basilique de Saint-Denis, Séance du 9 mai, 1958." *Académie des Inscriptions et Belles-Lettres* (Comptes Rendus), L (1959) : 137–48.

Focillon, Henri. *Art d'Occident. Le Moyen Age. Roman et Gothique.* Paris: Armand Colin, 1938. Translation by Donald King. *Art of the West in the Middle Ages.* Vol. I, *Romanesque Art.* Edited by Jean Bony. London and New York: Phaidon, 1963.

———. *L'Art des Sculpteurs Romans. Recherches sur l'histoire des formes.* Paris: Librairie Ernest Leroux, 1931.

Formigé, Jules. *L'Abbaye Royale de Saint-Denis.* Paris: Presses Universitaires de France, 1960.

———. "Les travaux récents de la basilique de Saint-Denis. Séance du 3 avril, 1957." *Académie des Beaux-Arts,* 1956–57 (Paris, 1958), pp. 77–92.

Forsyth, George H., Jr. *The Church of St. Martin at Angers.* Princeton: Princeton University Press, 1953.

Frankl, Paul. "The Secret of the Medieval Masons"; with Erwin Panofsky, "An Explanation of Stornaloco's Formula." *Art Bulletin,* XXVII (1945) : 46–64.

Frantz, M. Alison. "Byzantine Illuminated Ornament. A Study in Chronology." *Art Bulletin,* XVI (1934) : 43–76.

Gall, Ernst. Review of Sumner McK. Crosby, *L'Abbaye Royale de Saint-Denis. Art Bulletin,* XXXVII (1955) : 137–39.

Gilson, Étienne. *The Spirit of Mediaeval Philosophy.* Translated by A. H. C. Downes. New York: Charles Scribner's Sons, 1936.

Gimpel, Jean. *Les Batisseurs de Cathédrales.* Paris: Éditions du Seuil, 1959. Translation by Carl F. Barnes, Jr. *The Cathedral Builders.* New York: Grove Press, 1961.

Godet, P. "Denys l'aréopagite (Le pseudo-)." *Dictionnaire de Théologie Catholique.* Edited by A. Vacant and E. Mangenot. Paris: Letouzey et Ané, 1920, IV, part 1, pp. 435–36.

Goldschmidt, Adolph. *Die Elfenbeinskulpturen aus der Zeit der Karolingischen und Sächsischen Kaiser. VIII–XI Jahrhunderts.* 4 vols. Berlin: Bruno Cassirer, 1914–26.

———. *German Illumination.* 2 vols. Florence: Casa Editrice; Paris: Pegasus Press; New York: Harcourt, Brace, 1921.

Goldschmidt, Adolph, and Weitzmann, Kurt. *Die Byzantinischen Elfenbeinskulpturen des X–XIII Jahrhunderts.* 3 vols. Berlin: Bruno Cassirer, 1930–34.

Green, Rosalie B. "Ex Ungue Leonem." *De Artibus Opuscula XL. Essays in Honor of Erwin Panofsky.* Edited by Millard Meiss. New York: New York University Press, 1961, pp. 157–69.

Gregory of Tours. *Gregorii Turonensis Opera. Historia Francorum* and *Liber in Gloria Martyrum.* Edited by Wilhelmus Arndt and Bruno

Krusch. *Scriptores Rerum Merovingiarum,* I, *MGH.* Hanover, 1885. Translation by Ormonde M. Dalton. *The History of the Franks by Gregory of Tours.* 2 vols. Oxford: Clarendon Press, 1927.

Griffe, Élie. *La Gaule chrétienne à l'époque romaine,* 3 vols. Paris: A. et J. Picard, 1947–65.

Grivot, Denis, and Zarnecki, George. *Gislebertus, Sculptor of Autun.* Paris and London: The Trianon Press, in association with Collins, 1961.

Grodecki, Louis. *Ivoires Français.* Paris: Librairie Larousse, 1947.

———. "Les vitraux allégoriques de Saint-Denis." *Art de France,* I (1961) : 19–46.

Guibert de Nogent. *De Vita Sua. Pat. Lat.,* CLVI, cols. 837–962. Translation by C. C. Swinton Bland. *Self and Society in Medieval France.* Edited by John F. Benton. New York and Evanston: Harper Torchbook, 1970.

Guilhermy, Ferdinand Baron de. *Monographie de l'Église Royale de Saint-Denis. Tombeaux et Figures Historiques.* Paris: Librairie Archéologique de V. Didron, 1848.

Guingot, Henri. "La Représentation des Douze Apôtres dans l'Imagerie Populaire d'Épinal." *Artisans et Paysans de France. Recueil d'Études d'Art Populaire.* Strasbourg and Paris, n.d., pp. 163–74.

Gusman, Pierre. *L'Art Décoratif de Rome de la Fin de la République au IVe siècle.* 3 vols. Paris: Ch. Eggiman, 1909–14.

Hauttmann, Max. *Die Kunst des Frühen Mittelalters.* Berlin: Propyläen, 1929.

Heideloff, Karl A. von. *Die Ornamentik des Mittelalters.* 2 vols. Nuremberg: J. A. Stein, 1844–47.

Heimann, Adelheid. "The Capital Frieze and Pilasters of the Portail Royal, Chartres." *Journal of the Warburg and Courtauld Institutes,* XXXI (1969) : 73–102.

Holt, Elizabeth G. *A Documentary History of Art.* Vol. I, *The Middle Ages and the Renaissance.* New York: Doubleday Anchor Book, 1957.

Horn, Walter, and Born, Ernest. "The 'Dimensional Inconsistencies' of the Plan of Saint Gall and the Problem of the Scale of the Plan." *Art Bulletin,* XLVIII (1966) : 285–307.

Houvet, Étienne. *Cathédrale de Chartres, Portail Occidental, ou Royal.* Chelles: Helio. A. Foucheux, 1919.

Huelsen, Charles. "Porticus Divorum und Serapeum im Marsfelde." *Mitteilungen des Kaiserlich Deutschen Archaeologischen Instituts,* XVIII (1903) : 17–57.

Hugo of Saint-Victor. *Eruditionis Didascalicae. Pat. Lat.,* CLXXVI, cols. 741–838.

Jalabert, Denise. "La Flore Romane Bourguignonne." *Gazette des Beaux-Arts,* 6th series, LV (1960) : 193–208.

———. "De Quelques Fleurs Sculptées à Toulouse au XIIe siècle." *Bulletin Archéologique du Comité des travaux historiques et scientifiques,* 1934–35 (Paris, 1938), pp. 619–39.

Jocelinus. *Expositio in Symbolum. Pat. Lat.,* CLXXXVI, cols. 1479–88.

Jütter, Werner. *Ein Beitrage zur Geschichte der Bauhütte und des Bauwesens im Mittelalter.* . . . Pamphlet. Cologne, 1935.

Katzenellenbogen, Adolf. "The Central Tympanum at Vézelay, its Encyclopedic Meaning and its Relation to the first Crusade." *Art Bulletin,* XXVI (1944) : 141–51.

Kerber, Bernhard. *Burgund und die Entwicklung der französischen Kathedralskulptur im zwölften Jahrhundert.* Münster studien zur Kunstgeschichte. Recklinghausen: Aurel Bongers, 1966.

Knoop, Douglas, and Jones, G. P. *The Mediaeval Mason.* Manchester: Manchester University Press, 1949.

Knowles, David. *The Evolution of Medieval Thought.* London: Longmans, 1962.

Kohler, Charles, ed. *Étude critique sur le texte de la vie latine de Sainte-Geneviève de Paris. Vita Beate Genovefe Virginis.* Bibliothèque de l'École des Hautes Études, XLVIII. Paris, 1881.

Köhler, Wilhelm. "Byzantine Art in the West." *Dumbarton Oaks Papers,* I (1941) : 63–87.

———. *Die Karolingischen Miniaturen.* 3 vols. and 3 fols. Berlin: B. Cassirer, 1930–60.

———. ed. *Medieval Studies in Memory of A. Kingsley Porter.* 2 vols. Cambridge, Mass.: Harvard University Press, 1939.

Künstle, Karl. *Ikonographie der Christlichen Kunst,* I. Freiburg im Breisgau: Herder & Co., 1928. *Ikonographie der Heiligen,* II. Freiburg-im-Breisgau, 1926.

Kurth, Godefroid. "De l'autorité de Grégoire de Tours." *Études Franques.* 2 vols. Paris: H. Champion; Brussels: A. Dewit, 1919, II : 117–206.

Labarte, Jules. *Histoire des Arts Industriels au Moyen Age et à l'époque de la Renaissance.* 2 vols. 2nd ed. Paris: V. A. Morel & Cie, 1872–73.

Lapeyre, André. *Des Façades Occidentales de Saint-Denis et de Chartres aux Portails de Laon* (Thèse principale pour le doctorat ès lettres). Paris: Université de Paris, Faculté des Lettres, 1960.

Lauer, Philippe. *Les Enluminures Romanes des Manuscrits de la Bibliothèque Nationale.* Paris: Éditions de la Gazette des Beaux-Arts, 1927.

Lauer, Philippe, and Samaran, Ch. *Les Diplômes Originaux des Mérovingiens.* Paris: Ernest Leroux, 1908.

Laurent, Marcel. "Godefroid de Claire et la Croix de Suger à l'Abbaye de Saint-Denis." *Revue Archéologique,* 5th series, XIX (1924) : 79–87.

Lawrence, Marion. "Columnar Sarcophagi in the Latin West. Ateliers, Chronology, Style." *Art Bulletin,* XIV (1932) : 103–85.

———. *The Sarcophagi of Ravenna.* New York: College Art Association of America in conjunction with the *Art Bulletin,* 1945.

Le Blant, Edmond. *Les Sarcophages Chrétiens de la Gaule.* Collection des Documents Inédits sur l'histoire de France, 3rd series. Paris: Imprimerie Nationale, 1886.

Lecoy de la Marche, Albert, ed. *Œuvres Complètes de Suger.* Paris: Libraire de la Société de l'histoire de France, 1867.

Leisinger, Hermann. *Romanesque Bronzes; Church Portals in Medieval Europe.* New York: Praeger, 1957.

Lesser, George. *Gothic Cathedrals and Sacred Geometry.* 2 vols. London: Alec Tiranti, 1957.

Lethaby, William R. "The Part of Suger in the Creation of Medieval Iconography." *The Burlington Magazine,* XXV (1914) : 206–07.

Levillain, Léon. "L'Autel des Saints-Martyrs de la Basilique de Saint-Denis." *Bulletin Monumental,* LXXV (1911) : 212–25.

———. "Les plus anciennes églises abbatiales de Saint-Denis." *Mémoires de la Société de l'Histoire de Paris et de l'Île de France,* XXXVI (1909) : 143–222.

Levy, Ernest. "Appendix on the Proportions of the South Tower of Chartres Cathedral." In Otto von Simson. *The Gothic Cathedral.* Bollingen Series, XLVIII. New York: Pantheon Books, 1956.

Loenertz, Raymond Joseph. "La légende Parisienne de S. Denys l'Aréopagite." *Analecta Bollandiana,* LXIX. Brussels, 1951, pp. 234–37.

Louis, René. "Note sur quelques chapiteaux romans de l'ancien diocèse de Soissons." *Bulletin de la Société Archéologique, Historique et Scientifique de Soissons,* 1928–30, 4th series, IV (1931) : 95–99.

Lubac, Henri de. *Corpus Mysticum: l'Eucharistie et l'Église au Moyen Âge.* Paris: Aubier, 1944.

Lund, Frederic Macody. *Ad Quadratum: A Study of the Geometrical Bases of Classic and Medieval Religious Architecture. . . .* London: B. T. Batsford, 1921.

McC., A., and B., J. "A Romanesque Châsse." *The Bulletin of the Metropolitan Museum of Art, New York,* XIX (1924) : 84–86.

Maillard, Elisa. *Eglises du XII^e au XV^e siècle. Les Cahiers du Nombre d'Or,* III. Paris: Tournon & C^{ie}, 1964.

Mâle, Émile. "L'architecture et la sculpture en Lombardie à l'époque romane, à propos d'un livre récent." *Gazette des Beaux-Arts,* 4th period, XIV (1918) : 35–46.

———. *L'Art Religieux du XII^e Siècle en France.* Paris: Armand Colin, 1928.

———. "La part de Suger dans la création de l'iconographie du moyen âge." *Revue de l'art ancien et moderne,* XXXV (1914) : 91–102, 161–68, 253–62, 339–49.

Masai, François. "Les manuscrits à peintures de Sambre et Meuse aux XI^e et XII^e siècles. Pour une critique d'origine plus méthodique." *Cahiers de Civilisation Médiévale X^e–XII^e Siècles,* III (1960) : 169–89.

Medding-Alp, Emma. *Rheinische Goldschmiedekunst in Ottonischer Zeit.* Koblenz: Rheinisches Kultur-Institut, 1952.

Mesplé, Paul. *Toulouse, Musée des Augustins. Les Sculptures Romanes.* Paris: Éditions des Musées nationaux, 1961.

Messerer, Wilhelm. *Der Bamberger Domschatz in seinem Bestande bis zum Ende der Hohenstaufen-Zeit.* Munich: Hirmer Verlag München, 1952.

Michaud-Quantin, P., and Weisheipl, J. A. "Dialectics in the Middle Ages." *New Catholic Encyclopedia.* New York: McGraw Hill, 1967, IV : 846–49.

Milliken, William M. "A Reliquary of Champlevé Enamel from the Valley of the Meuse. The J. H. Wade Collection." *Bulletin of the Cleveland Museum of Art,* XIV (1927) : 49, 51–54.

Molinier, Émile. *Histoire Générale des Arts Appliqués à l'Industrie.* 4 vols. Paris: Librairie Centrale des Beaux-Arts, 1896–1911.

Molsdorf, Wilhelm. *Christliche Symbolik der Mittelalterlichen Kunst.* Leipzig: Karl W. Hiersemann, 1926.

Montesquiou-Fezensac, Comte Blaise de. "A Carolingian Rock Crystal from the Abbey of Saint-Denis at the British Museum." *The Antiquaries Journal,* XXXIV (1954) : 38–43.

Montfaucon, Bernard de. *Les Monumens de la Monarchie Françoise.* 5 vols. Paris: Chez Julien-Michel Gandouin and Pierre-François Giffart, 1729–33.

Morey, Charles R. *Medieval Art.* New York: W. W. Norton & Co., 1942.

Morgan, Bernard George. *Canonic Design in English Mediaeval Architecture; The Origins and Nature of Systematic Architectural Design in England 1215–1515,* Liverpool: Liverpool University Press, 1961.

Müller-Dietrich, Norbert. *Die Romanische Skulptur in Lothringen.* Kunstwissenschaftliche studien, XLI. Berlin and Munich: Deutscher Kunstverlag, 1968.

Oman, Charles. *The Gloucester Candlestick*. London: Victoria and Albert Museum, 1958.

Omont, Henri. "Inventaires du trésor et des objects précieux conservés dans l'église de l'abbaye de Saint Denys en 1505 et 1739." *Memoires de la Société de l'histoire de Paris et de l'Île de France,* XXVIII (1901) : 163–212.

Oursel, Charles. *Miniatures Cisterciennes (1109–1134)*. Mâcon: Protat Frères, 1960.

Pachtère, Félix G. de. *Paris à l'époque Gallo-Romaine*. Paris: Imprimerie nationale, 1912.

Panofsky, Erwin. *Abbot Suger*. Princeton: Princeton University Press, 1946.

Pertz, Karl A. F., ed. *Diplomata Imperii*, I. *MGH*. Hanover, 1872.

Petrie, W. M. Flinders. *Decorative Patterns of the Ancient World*. London: University College, 1930.

Planché, James Robinson. *A Cyclopædia of Costume*. 2 vols. London: Chatto and Windus, 1876.

Porter, Arthur Kingsley. *Romanesque Sculpture of the Pilgrimage Roads*. 10 vols. Boston: Marshall Jones Co., 1923.

Prou, Maurice, *Manuel de Paléographie Latine et Française*. 4th ed. Paris: Auguste Picard, 1924.

Quarré, Pierre. "La sculpture des anciens portails de Saint-Bénigne de Dijon." *Gazette des Beaux-Arts,* 6th period, L. (1957) : 177–94.

———. "Les sculptures du tombeau de Saint Lazare à Autun et leur place dans l'art roman." *Cahiers de civilisation Médiévale Xᵉ–XIIᵉ Siècles,* V (1962) : 169–74.

Quicherat, Jules E. J. *Histoire du Costume en France*. Paris: Hachette et Cⁱᵉ, 1875.

Reinhardt, Hans. *Das Münster zu Basel*. Burg-bei-Magdeburg: A. Hopfer, 1928.

Richter, Gisela. *Catalogue of Greek and Roman Antiquities in the Dumbarton Oaks Collection*. Cambridge, Mass.: Harvard University Press, 1956.

Riegl, Alois. *Stilfragen, Grundlegungen zu einer Geschichte der Ornamentik*. Berlin: G. Siemens, 1893.

Roosval, Johnny. "Ad Triangulum, ad Quadratum." *Gazette des Beaux-Arts,* 6th series, XXVI (1944) : 149–62.

Rosenbaum, Elisabeth. "Dialog." *Reallexikon zur Deutschen Kunstgeschichte*. 5 vols. In progress. Edited by Otto Schmitt. Stuttgart: J. B. Metzler, 1933– . Vol. III (1954) : 1400–08.

Ross, D. J. A. "A Late Twelfth-century Artist's Pattern-Sheet." *Journal of the Warburg and Courtauld Institutes*, XXV (1962) : 119–28.

Ross, Marvin C. "Monumental Sculptures from St.-Denis. An Identification of Fragments from the Portal." *The Journal of the Walters Art Gallery*, III (1940) : 91–109.

Roussel, Jules. *La Sculpture Française: Époque Romane*. Paris: Éditions Albert Morancé, 1927.

Rowe, Margaret T. J. "Fragments from the Tomb of an Unknown Bishop of Saint Denis, Paris." *The Bulletin of the Needle and Bobbin Club*, LII (1969) : 26–33.

Rupertus of Deutz. *De Vita Vere Apostolica*. *Pat. Lat.*, CLXX, cols. 609–64.

Salzmann, Louis Francis. *Building in England down to 1540. A Documentary History*. Oxford: Clarendon Press, 1952.

Sauerländer, Willibald. *Gotische Skulptur in Frankreich, 1140–1270*. Munich: Hirmer Verlag München, 1970.

———. "Sculpture on Early Gothic Churches: The State of Research and Open Questions." *Gesta*, IX, no. 2 (1970) : 32–48.

Saxl, Fritz. "Frühes Christentum und spätes Heidentum in ihren Künstlerischen Ausdrucksformen." *Wiener Jahrbuch für Kunstgeschichte*, new series, II (1923) : 63–121.

Schapiro, Meyer. "A Relief in Rodez and the Beginnings of Romanesque Sculpture in southern France." *Romanesque and Gothic Art, Studies in Western Art*, I. Edited by Millard Meiss. Acts of the Twentieth International Congress of the History of Art. Princeton: Princeton University Press, 1963, pp. 40–66.

———. "The Romanesque Sculpture of Moissac, I." *Art Bulletin*, XIII (1931) : 249–350.

Scheller, R. W. *A Survey of Medieval Model Books*. Teylers Tweed Genootschap, n.s. XVII. Haarlem: De Erven F. Bohn N.V., 1963.

Schnitzler, Hermann. *Rheinische Schatzkammer*. 2 vols. Düsseldorf: Verlag L. Schwann, 1957–59.

Schramm, Percy Ernst, and Mütherich, Florentine. *Denkmale der deutschen Könige und Kaiser. Ein Beitrag zur Herrschergeschichte von Karl dem Grossen bis Friedrich II 768–1250*. Munich: Prestel Verlag, 1962.

Seidel, Linda. "A Romantic Forgery: The Romanesque 'Portal' of Saint-Étienne in Toulouse." *Art Bulletin*, L (1968) : 33–42.

Simon, Erike. *Ara Pacis Augustae*. Greenwich, Conn.: New York Graphic Society, [c. 1968].

Smith, E. Baldwin. *Architectural Symbolism of Imperial Rome and the Middle Ages*. Princeton: Princeton University Press, 1956.

Smith, S. R. "Peter Abelard." *New Catholic Encyclopedia.* New York: Mc-Graw Hill, 1967, IV : 15–17.

Spicq, Ceslaus. *Esquisse d'une Histoire de l'Exégèse Latine au Moyen Age.* Paris: Librairie Philosophique J. Vrin, 1944.

Stiennon, Jacques. *Art Mosan des XI^e et XII^e siècles.* Brussels: Fondation Cultura, n.d.

Stoddard, Whitney S. *The West Portals of Saint-Denis and Chartres. Sculpture in the Île-de-France from 1140 to 1190. Theory of Origins.* Cambridge, Mass.: Harvard University Press, 1952.

Stone, Lawrence. *Sculpture in Britain. The Middle Ages.* The Pelican History of Art. Baltimore, Md.: Penguin Books, 1955.

Strzygowski, Josef. "Die Pinienzapfen als Wasserspeier." *Mitteilungen des Kaiserlich Deutschen Archaeologischen Instituts Roëmische Abteilung,* XVIII (1903) : 185–206.

Suger, Abbot. *De Administratione.* See Panofsky, Erwin. *Abbot Suger;* Lecoy de la Marche, Albert. *Œuvres Complètes de Suger.*

———. *De Consecratione.* See Panofsky, Erwin. *Abbot Suger;* Lecoy de la Marche, Albert. *Œuvres Complètes de Suger.*

———. *Litterae encyclicae conventus sancti Dionysii de morte Sugerii abbatis.* See Lecoy de la Marche, Albert. *Œuvres Complètes de Suger.*

Summerson, John. *Heavenly Mansions and Other Essays on Architecture.* New York: W. W. Norton and Co., 1963.

Sunderland, Elizabeth Read. "Symbolic Numbers and Romanesque Church Plans." *Journal of the Society of Architectural Historians,* XVIII (1959) : 94–103.

Swarzenski, Hanns. *The Berthold Missal.* New York: The Pierpont Morgan Library, 1943.

———. *Monuments of Romanesque Art. The Art of Church Treasures in North-western Europe.* Chicago: University of Chicago Press, 1954.

———. "The Role of Copies in the Formation of the Styles of the Eleventh Century." *Romanesque and Gothic Art. Studies in Western Art,* I. Edited by Millard Meiss. Acts of the Twentieth International Congress of the History of Art. Princeton: Princeton University Press, 1963, pp. 7–18.

Taylor, Henry Osborne. *The Mediaeval Mind.* 2 vols. London: Macmillan and Co., 1911.

Théry, Gabriel. *Études Dionysiennes.* 2 vols. Paris: J. Vrin, 1932.

Thoma, Hans. *Schatzkammer der Residenz München.* Munich: Schlösser, Görten und Seen, 1958.

Usener, Karl H. "Reiner von Huy und seine Künstlerische Nachfolge." *Marburger Jahrbuch für Kunstwissenschaft,* VII (1933) : 77–134.

Velte, Maria. *Die Anwendung der Quadratur und Triangulatur bei der Grund- und Aufrissgestaltung der gotischen Kirchen.* Basler Studien zur Kunstgeschichte, VIII. Basel: Verlag Birkhäuser, 1951.

Verdier, Philippe. "La grande croix de l'abbé Suger à Saint-Denis." *Cahiers de Civilisation Médiévale Xᵉ–XIIᵉ Siècles,* XIII (1970) : 1–31.

Vieillard-Troiekouroff, May. "L'Architecture en France du temps de Charlemagne." *Karl der Grosse.* Vol. III, *Karolingische Kunst.* Edited by Wolfgang Braunfels and Herman Schnitzler. Düsseldorf: L. Schawnn, 1965, pp. 336–73.

Viollet-le-Duc, Eugène. *Dictionnaire raisonné de l'Architecture Française.* 10 vols. Paris: B. Bance and A. Morel, 1854–68.

———. *Dictionnaire raisonné du Mobilier Français,* 6 vols. Paris: Librairie Gründ et Maguet, 1871–75.

Von Simson, Otto. *The Gothic Cathedral.* Bollingen Series, XLVIII. New York: Pantheon Books, 1956.

Weese, Artur. *Die Bamberger Domskulpturen. Ein Beitrag zur Geschichte der deutschen Plastik des XIII Jahrhunderts.* Strasbourg: J. H. E. Heitz, 1914.

Wersin, Wolfgang von, and Müller-Grah, Walter. *Das elementare Ornament und seine Gesetzlichkeit, eine Morphologie des Ornaments.* Ravensburg: Otto Maier, 1953.

Wilpert, Giuseppe. *I Sarcofagi Cristiani Antichi.* 2 vols. and plates. Rome: Tipografia Poliglotta Vaticana, 1929–32.

Wixom, William. *Treasures from Medieval France.* Cleveland: Cleveland Museum of Art, 1967.

Worringer, Wilhelm. *Formprobleme der Gotik.* Munich: R. Piper & Co., 1927. English translation, *Form in Gothic.* Edited by Sir Herbert Read. Rev. ed. New York: Schocken Books, 1964.

Young, Karl. *The Drama of the Medieval Church.* 2 vols. Oxford: Clarendon Press, 1933.

Zimmerman, E. Heinrich. *Vorkarolingische Miniaturen,* text and 4 folio vols. Berlin: Deutscher Verein für Kunstwissenschaft, 1916.

Index

Illustrations

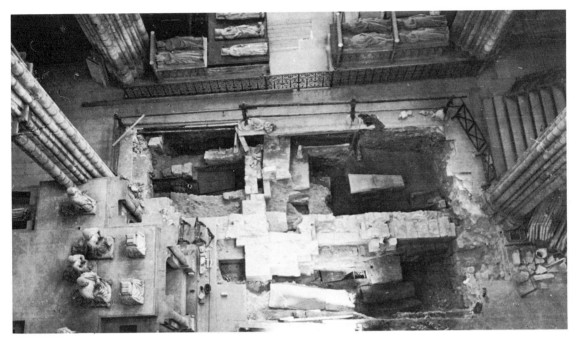

1. Excavation of south transept, from above

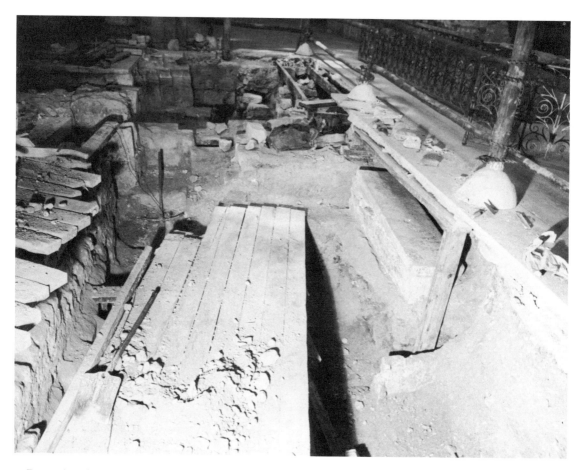

2. Excavation of south transept, from the east

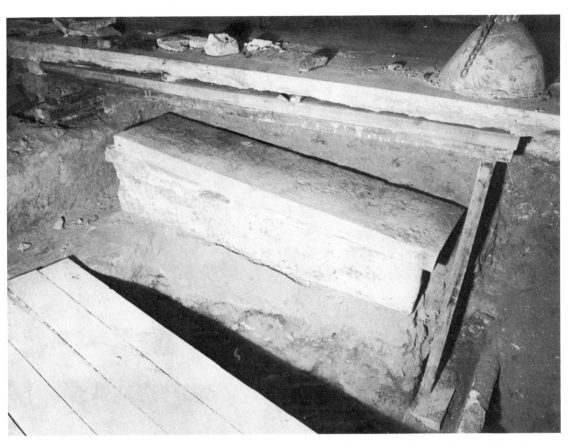

3. Plaster sarcophagus with stone lid as discovered

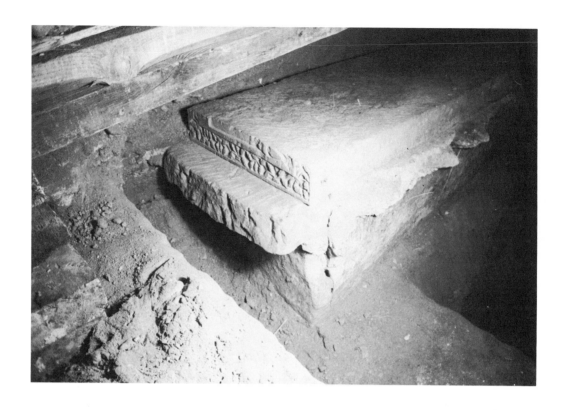

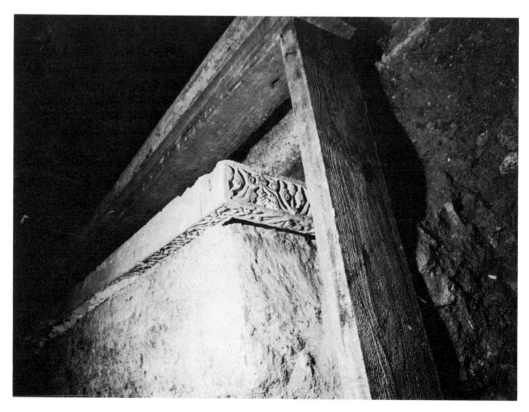

4. A, carved end of stone lid as discovered; B, the same

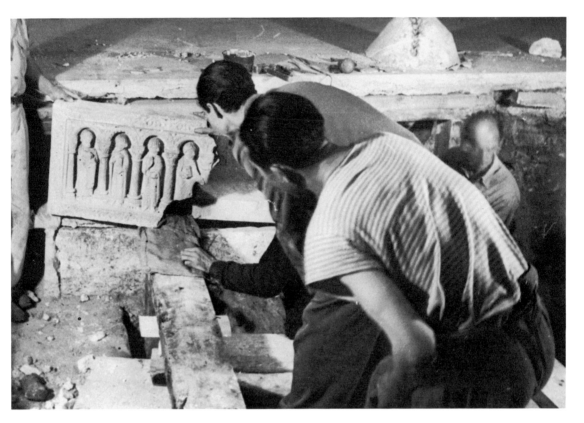

5. The discovery of the bas-relief, June 4, 1947

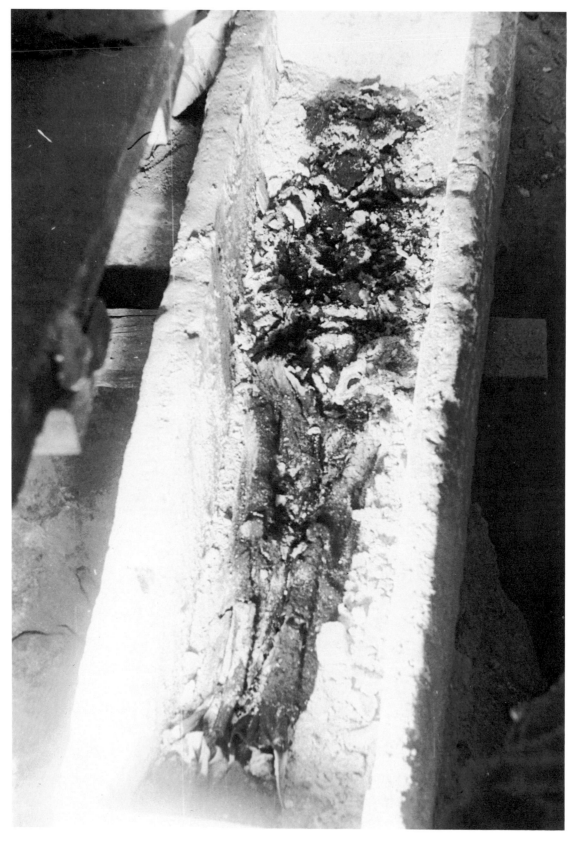

6. Contents of plaster sarcophagus after removal of lid

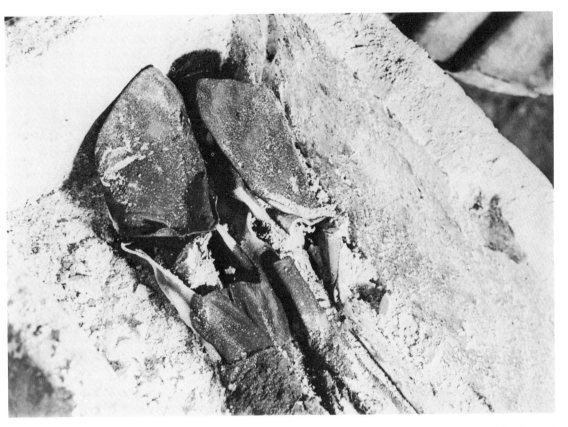

7. Boots, or *estivaux*, of the deceased

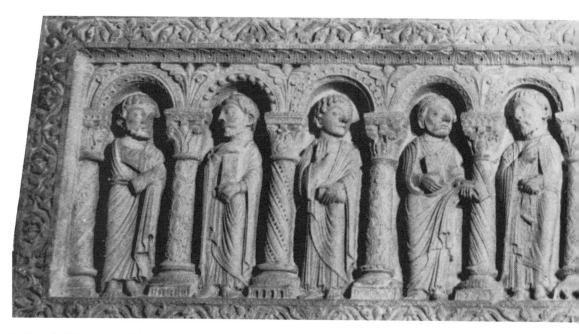

8. Bas-relief from below, left portion

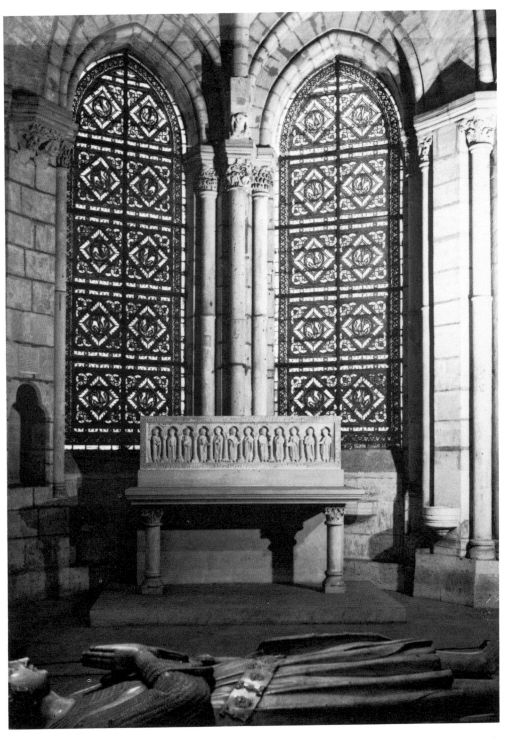

9. Bas-relief as displayed today in the chapel of Saint-Osmana, Saint-Denis

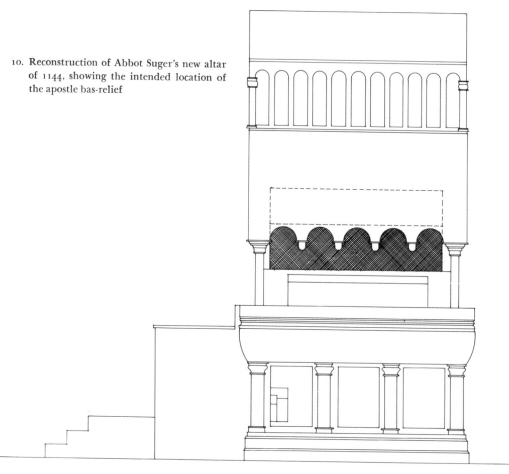

10. Reconstruction of Abbot Suger's new altar of 1144, showing the intended location of the apostle bas-relief

South elevation

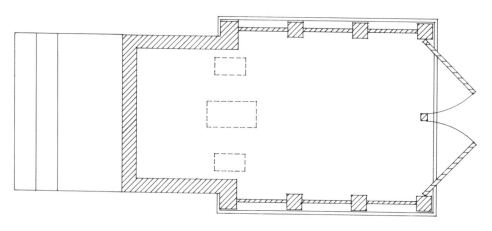

Plan at base level

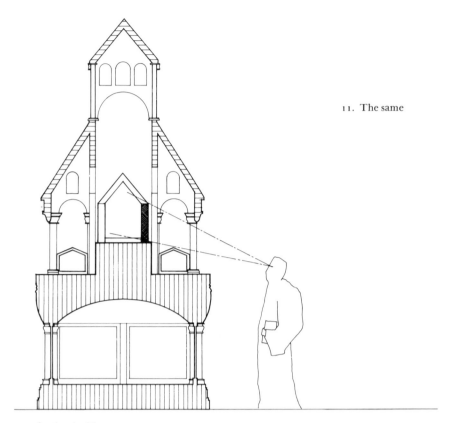

11. The same

Section looking east

Plan at tabernacle level

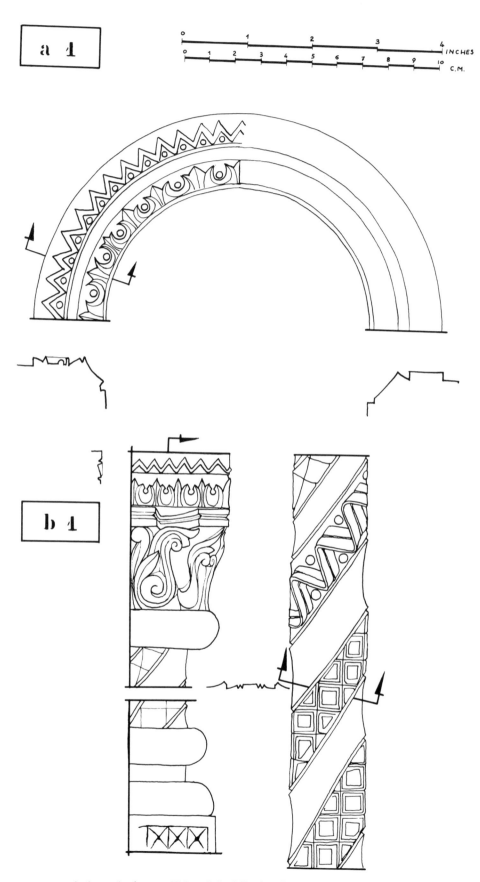

12. Arch 1 and column 1. This and the following diagrams are keyed to Fig. 86

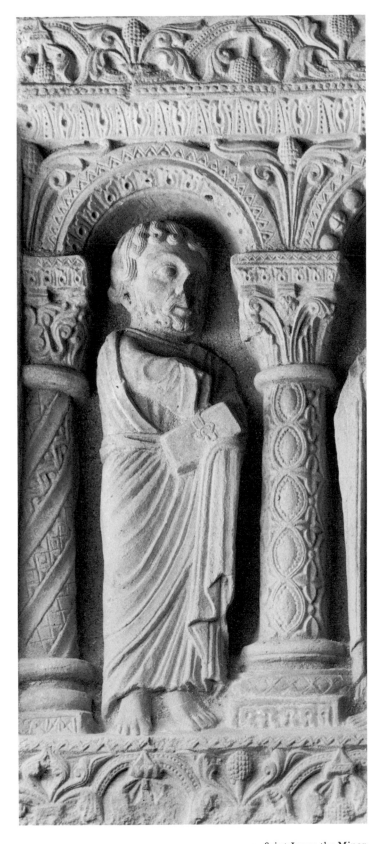

13. Saint James the Minor

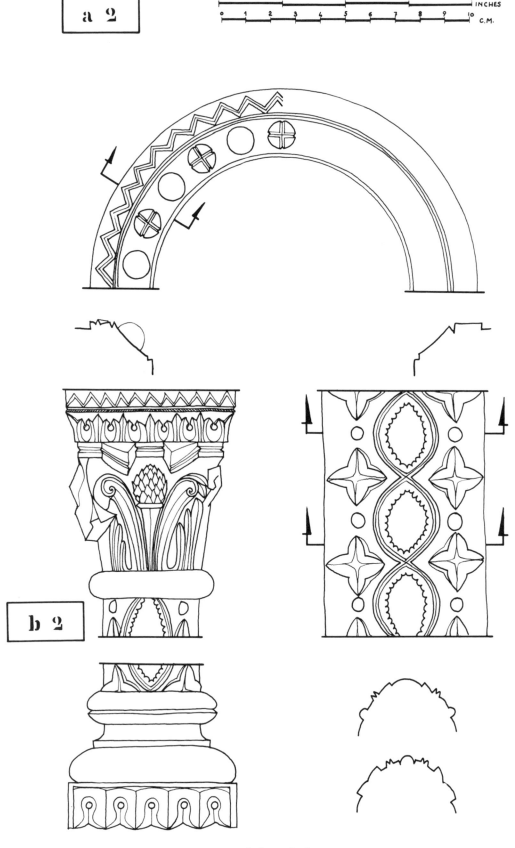

14. Arch 2 and column 2

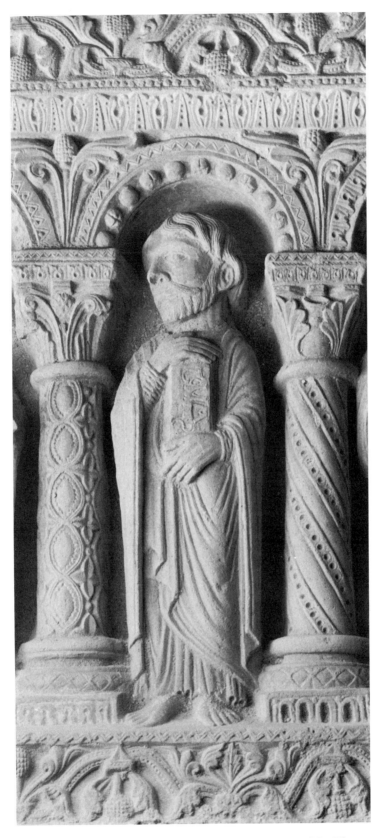

15. Saint Thomas

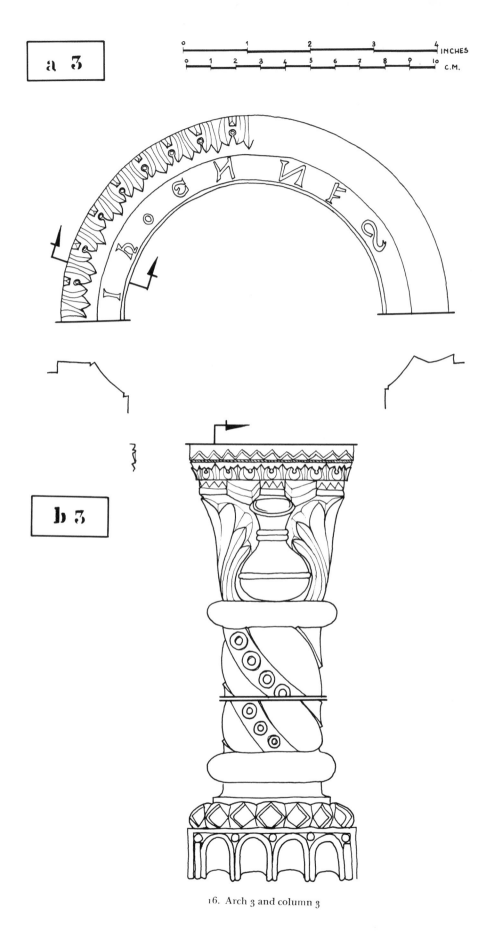

16. Arch 3 and column 3

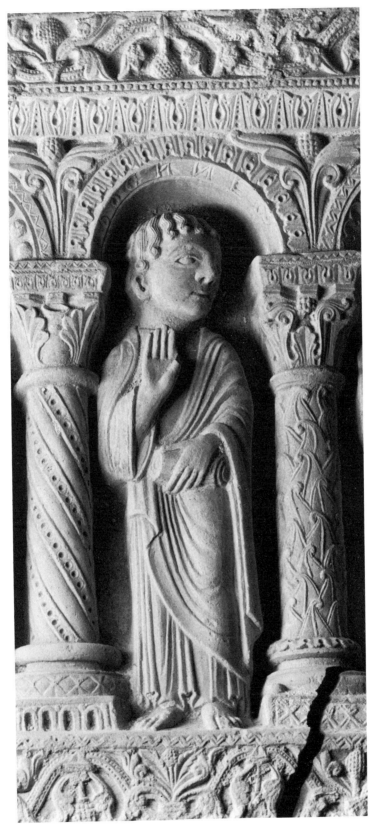

17. Saint John

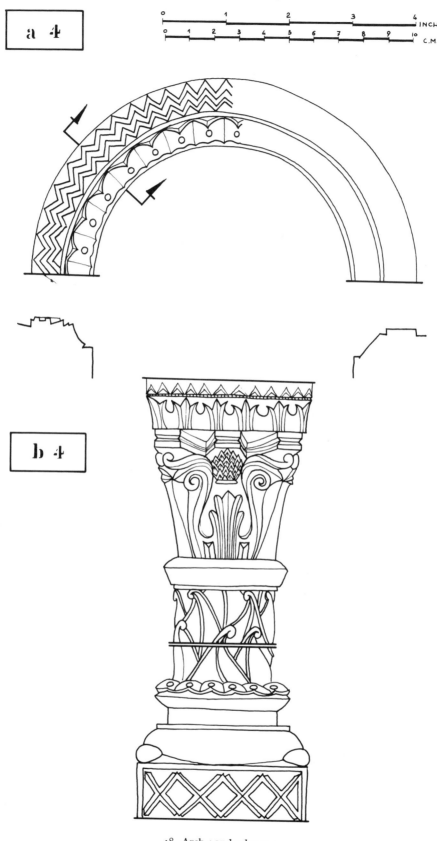

a 4

0 1 2 3 4
INCHES

0 1 2 3 4 5 6 7 8 9 10
C.M.

b 4

18. Arch 4 and column 4

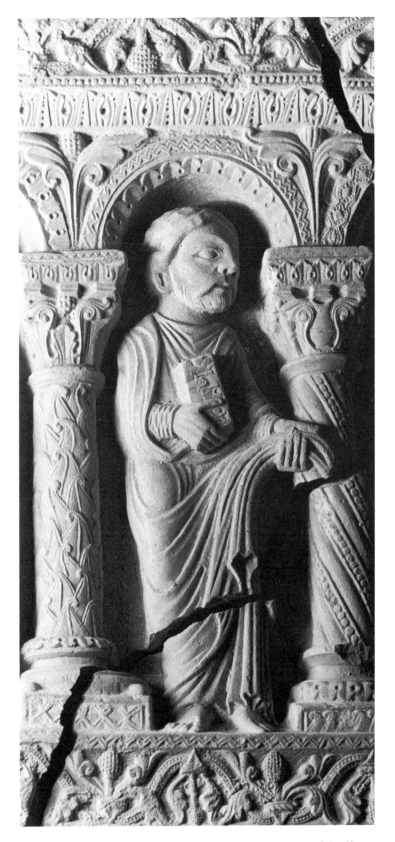

19. Saint Simon

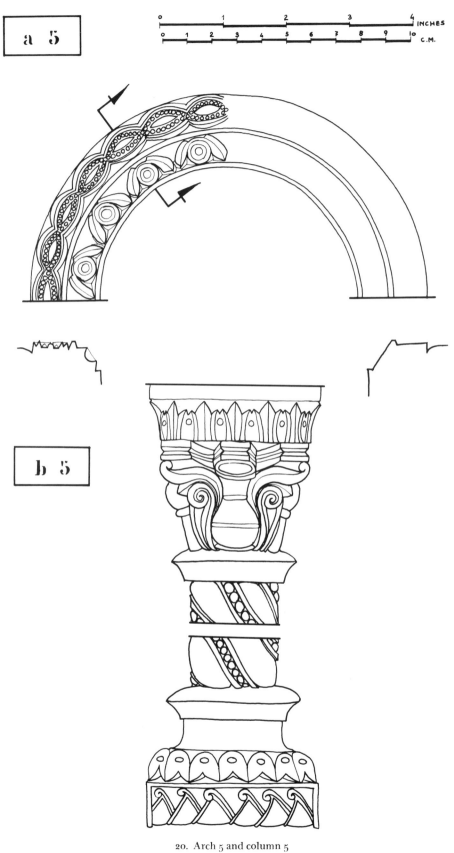

a 5

b 5

20. Arch 5 and column 5

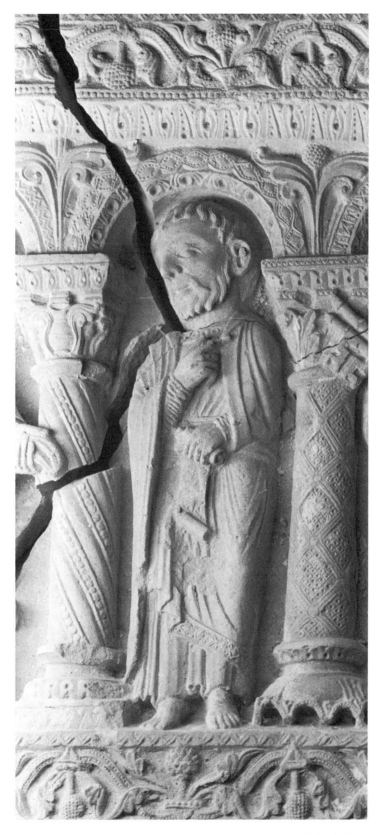

21. Saint Andrew

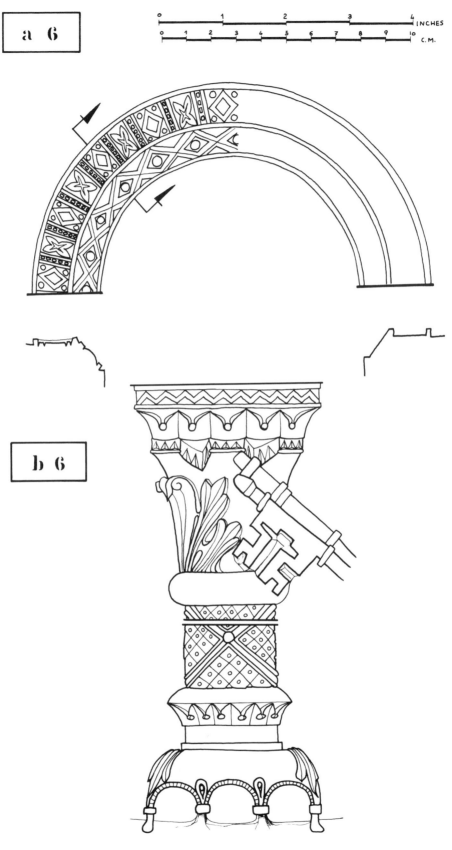

22. Arch 6 and column 6

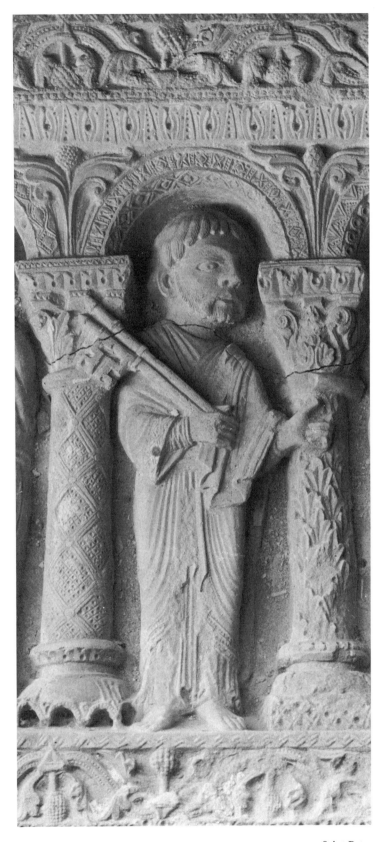

23. Saint Peter

24. Saints James the Minor, Thomas, John, and Simon, with decoration on the book covers

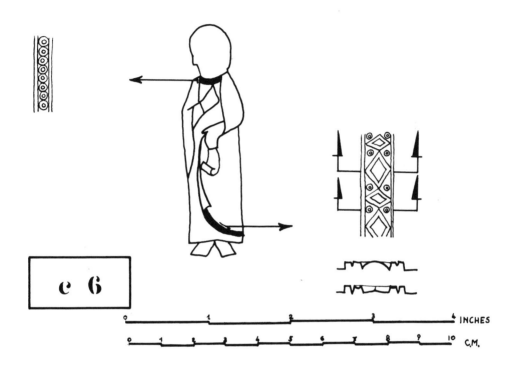

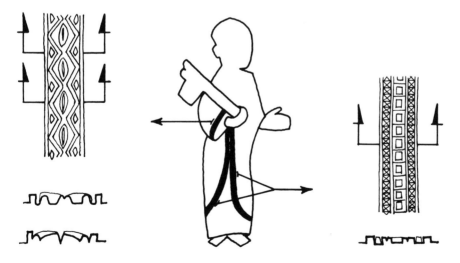

25. Saints Andrew and Peter, with details of garment border ornament

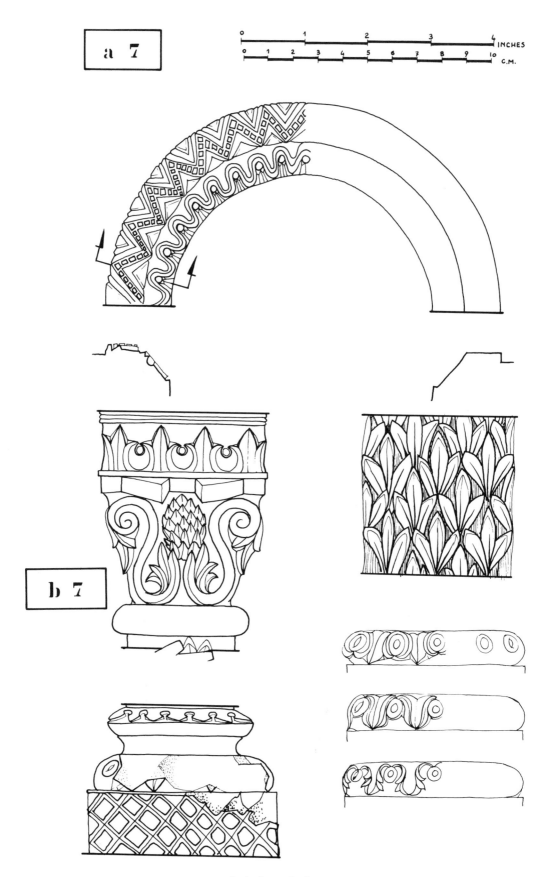

26. Arch 7 and column 7

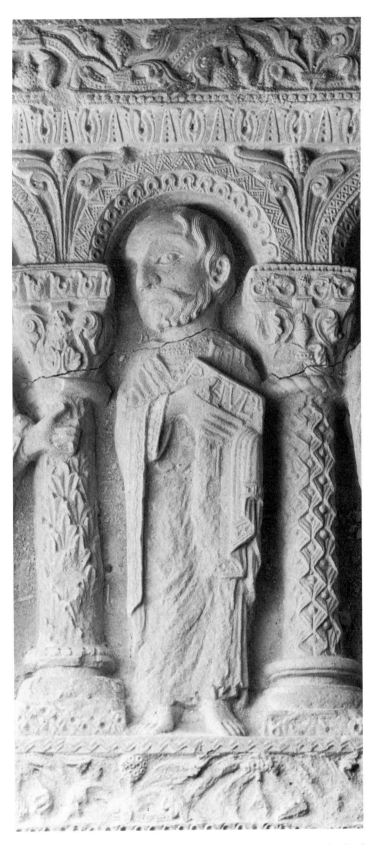

27. Saint Paul

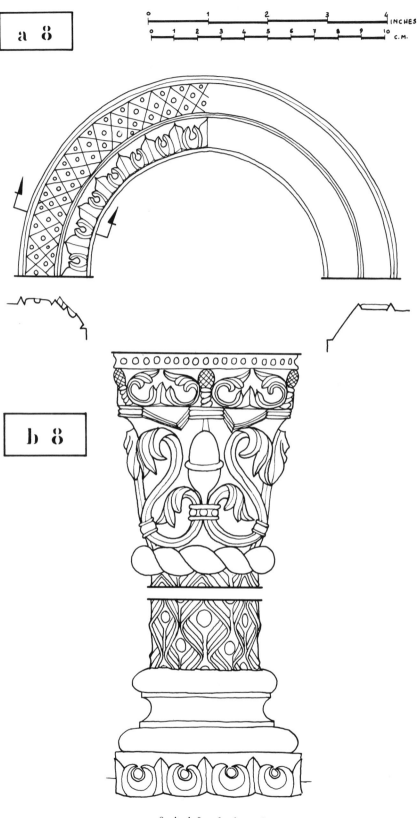

a 8

b 8

INCHES
C.M.

28. Arch 8 and column 8

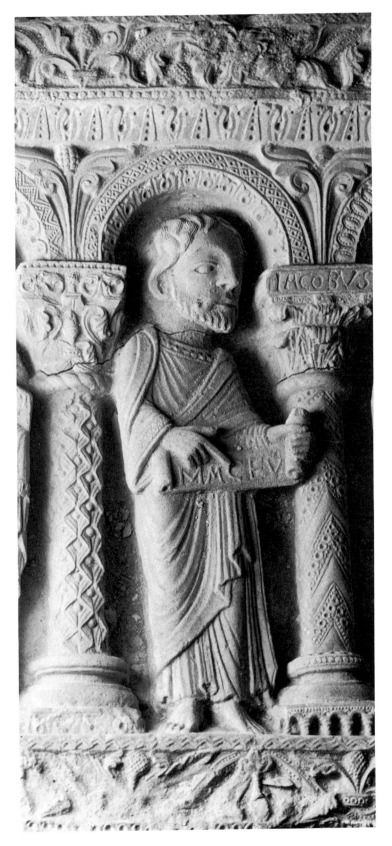

29. Saint Matthew

30. Saints Paul and Matthew, with details of garment border ornament

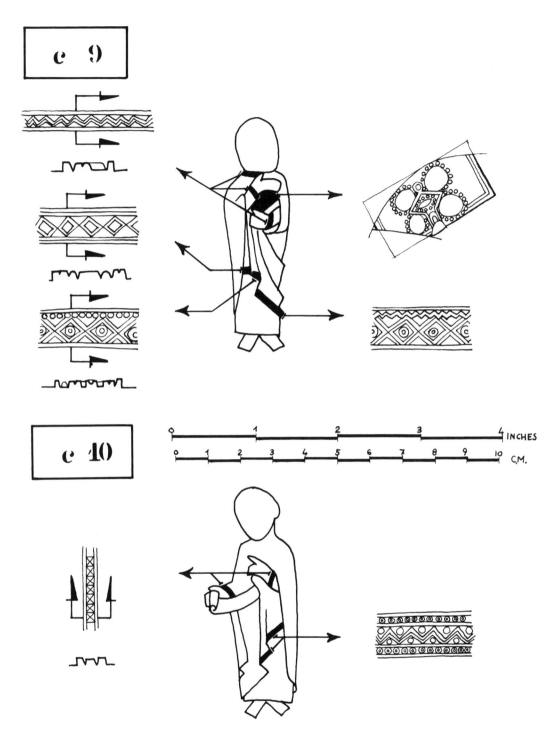

31. Saints James the Major and Philip, with details of garment border ornament

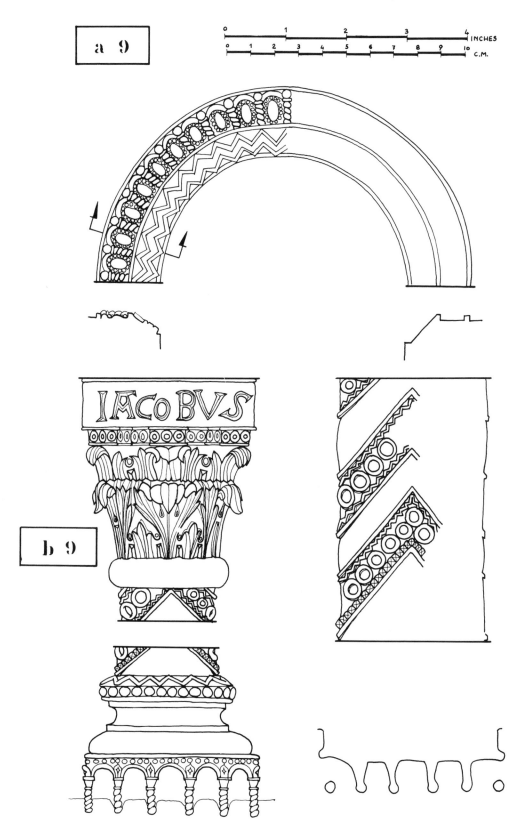

a 9

b 9

IACOBVS

32. Arch 9 and column 9

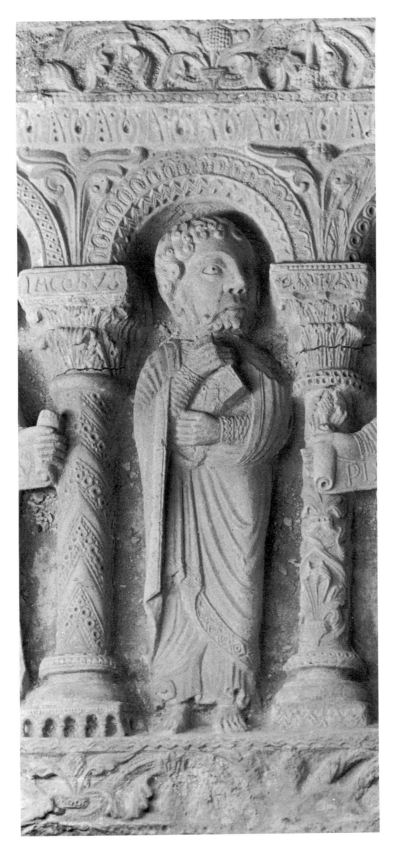

33. Saint James the Major

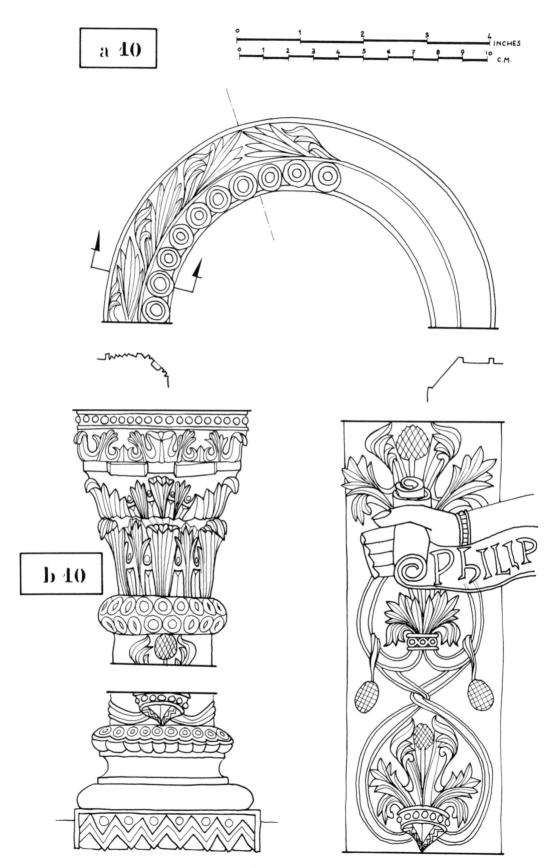

a 10

b 10

PhILIP

34. Arch 10 and column 10

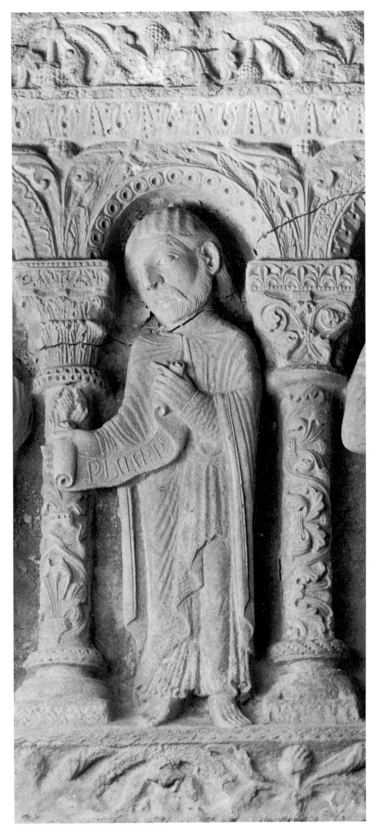

35. Saint Philip

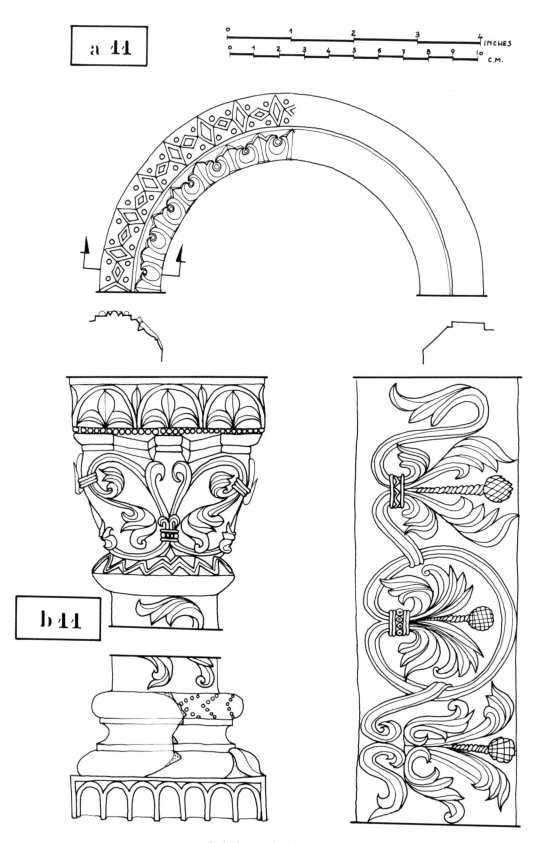

36. Arch 11 and column 11

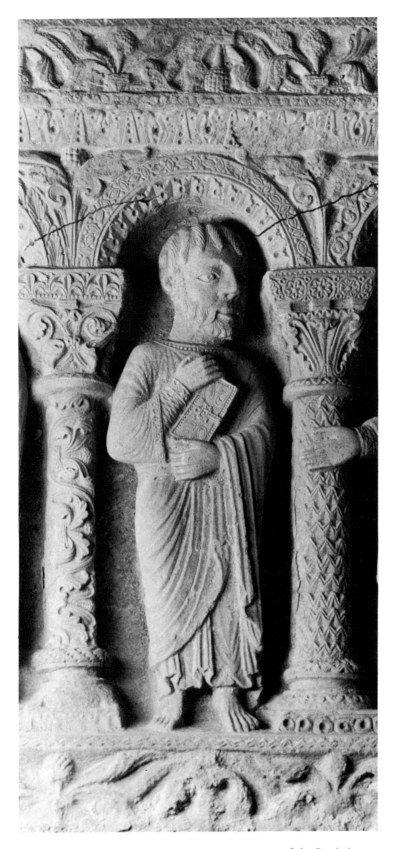

37. Saint Bartholomew

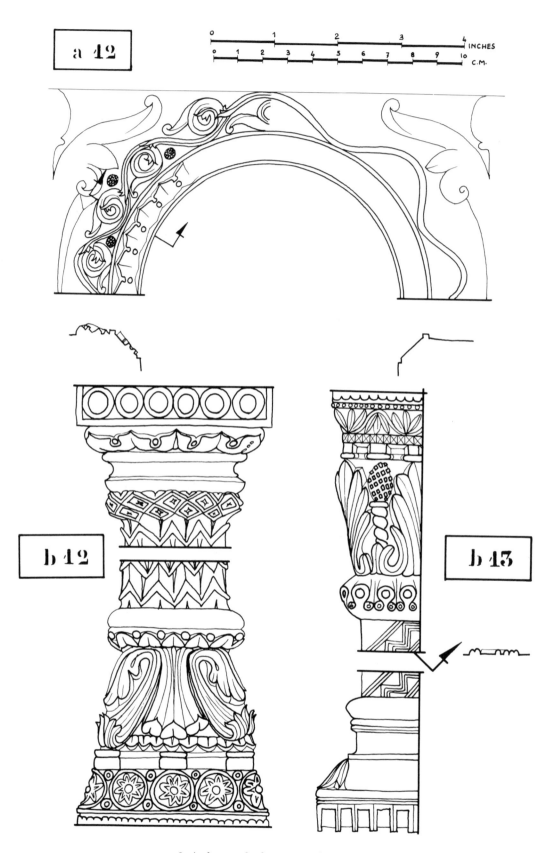

38. Arch 12, and columns 12 and 13

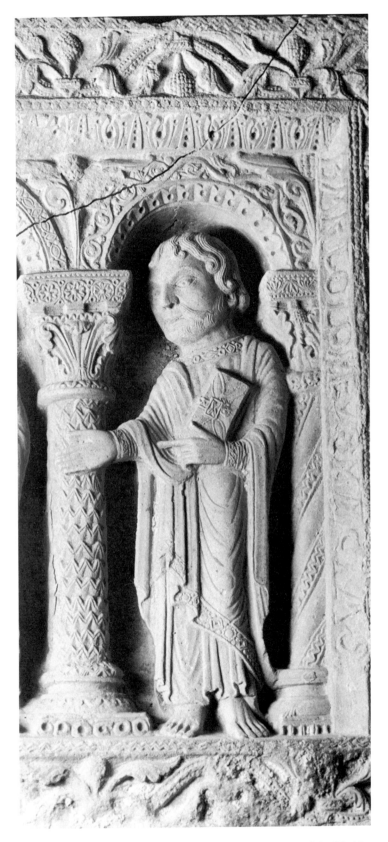

39. Saint Mathias

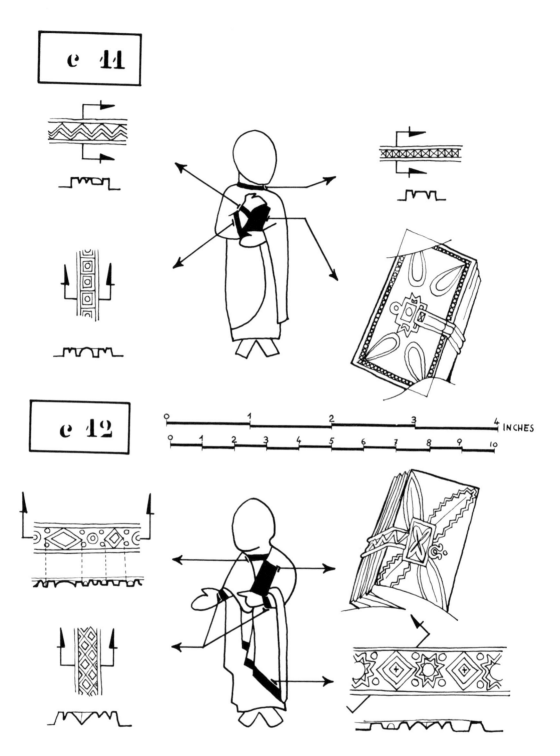

40. Saints Bartholomew and Mathias, with details of garment border ornament

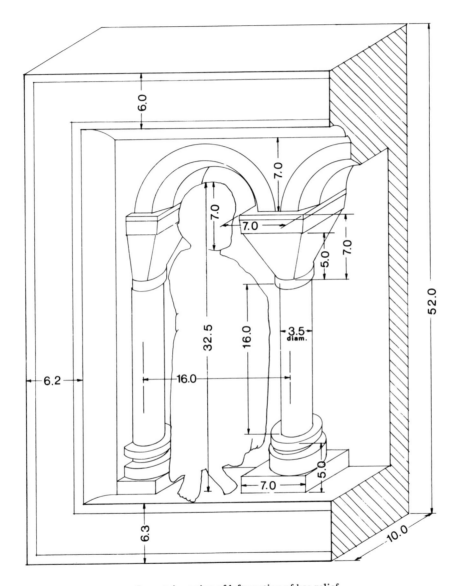

41. Isometric section of left portion of bas-relief

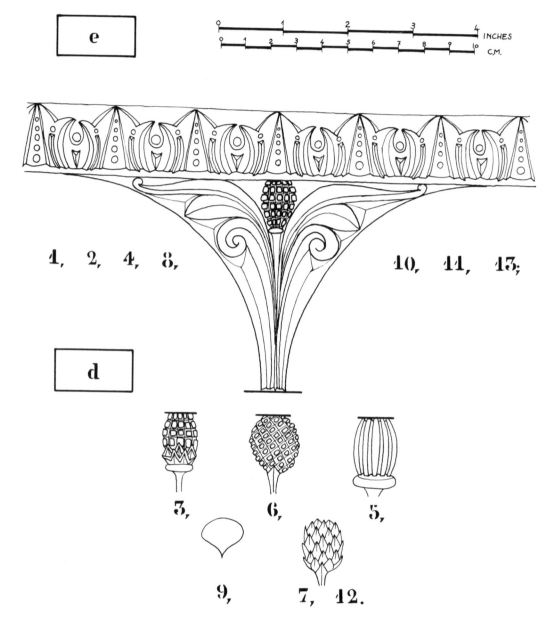

42. Ornament of spandrels and inner palmette border

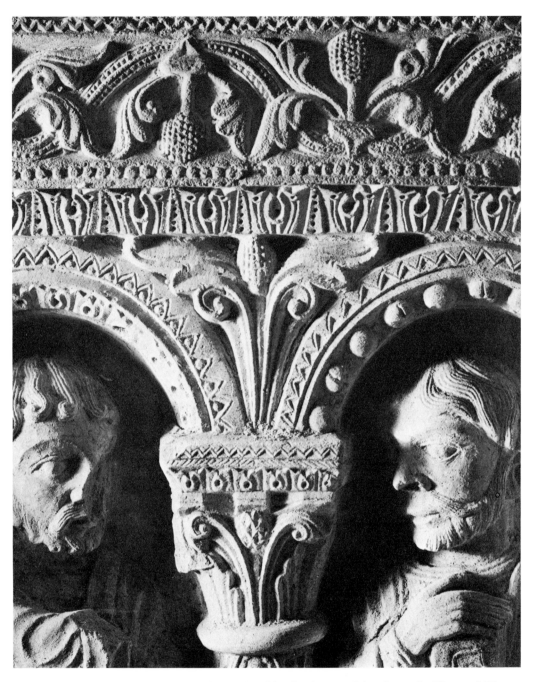

43. Spandrel and borders between Saints James the Minor and Thomas

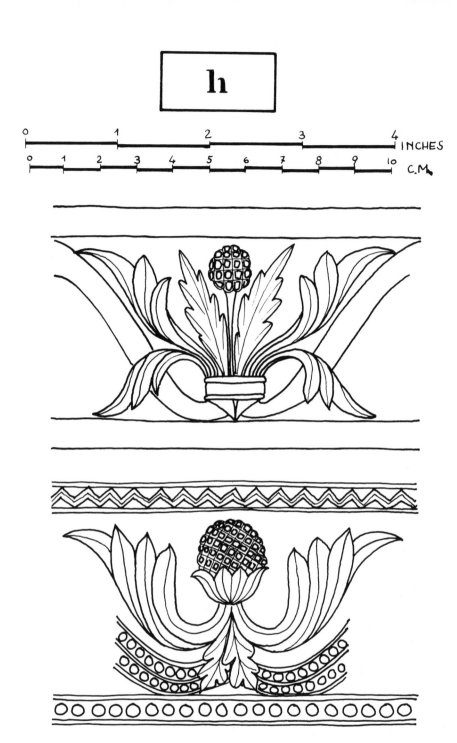

44. Upper border motifs

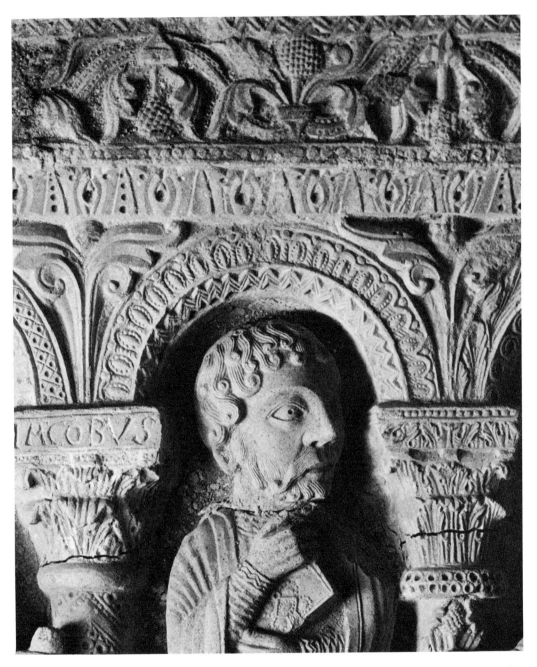

45. Head of Saint James the Major

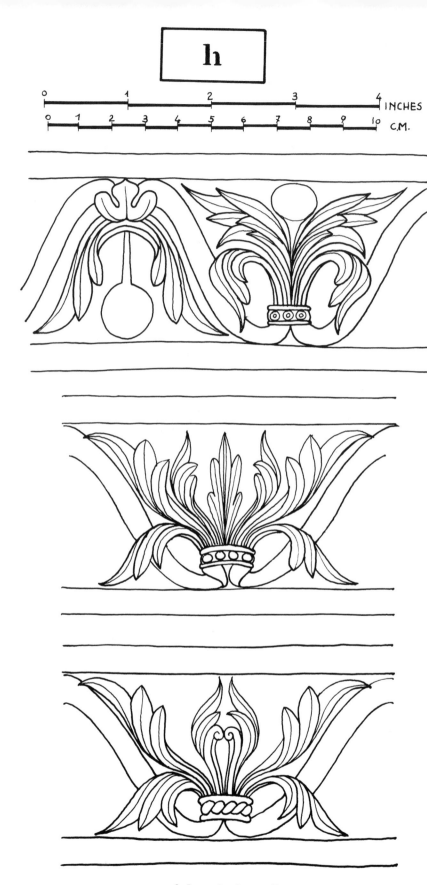

46. Lower border motifs

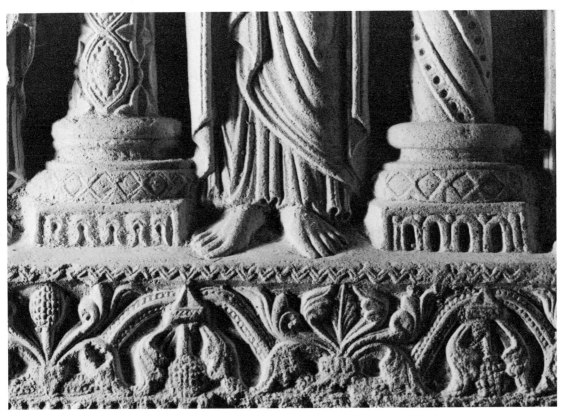

47. Feet of Saint John and portion of lower border

g 1

0 1 2 3 4 INCHES
0 1 2 3 4 5 6 7 8 9 10 CM

g 2

48. Decorative motifs of unfinished right end

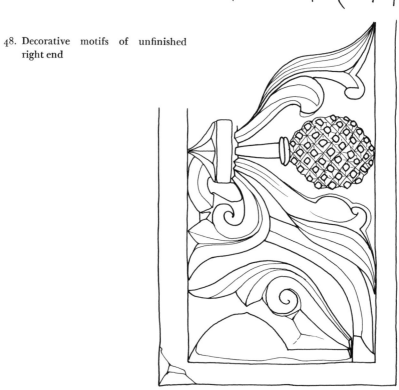

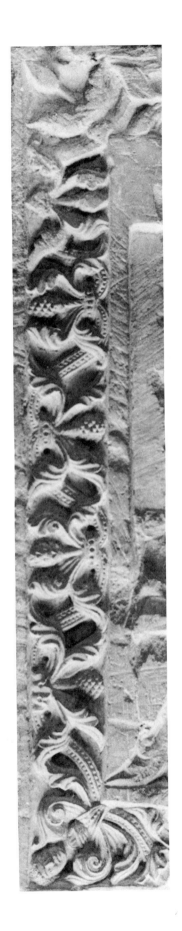

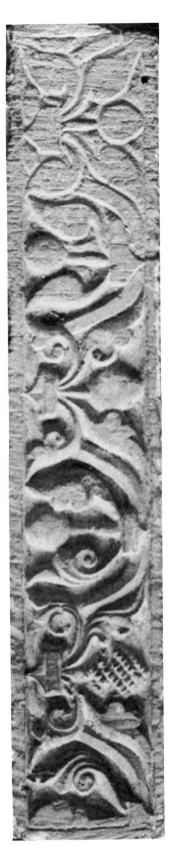

49. The carved ends. A, right; B, left

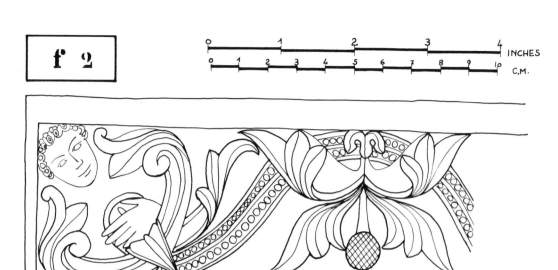

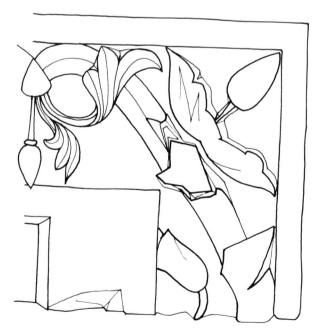

50. Decorative motifs of unfinished left end

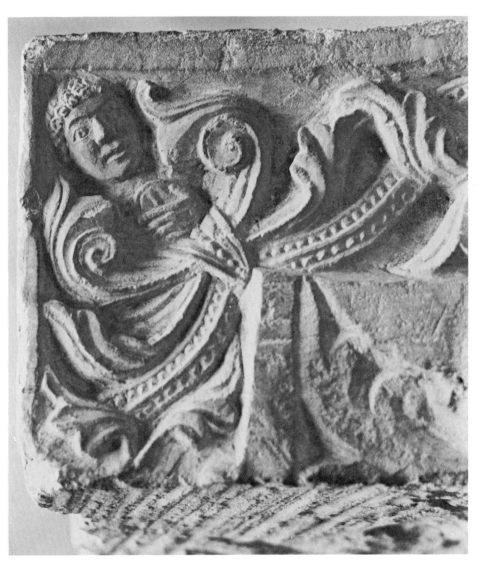

51. Decorative motifs with mask on upper corner of left end

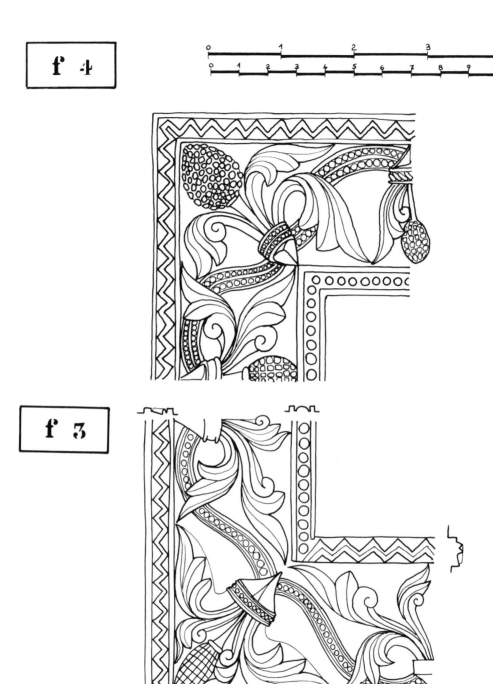

52. Corner designs of outer border

f 6

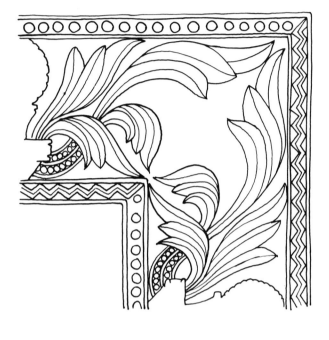

f 5

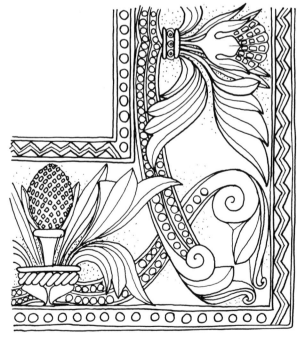

53. Corner designs of outer border

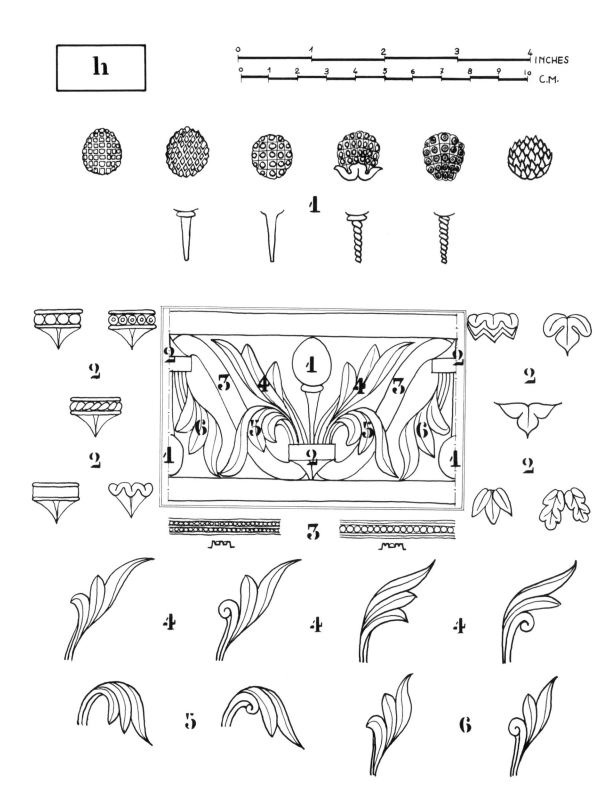

54. Palmette-rinceau motif of outer border

55. Sections along original line of break. A, right edge as seen from above; B, left portion

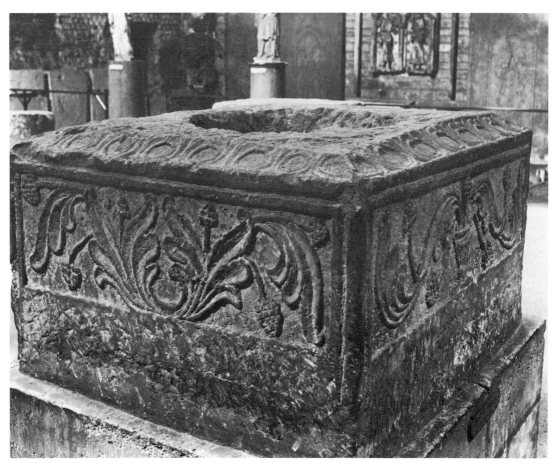

56. Column base from the nave arcade of the eighth-century church, now in storage at Saint-Denis

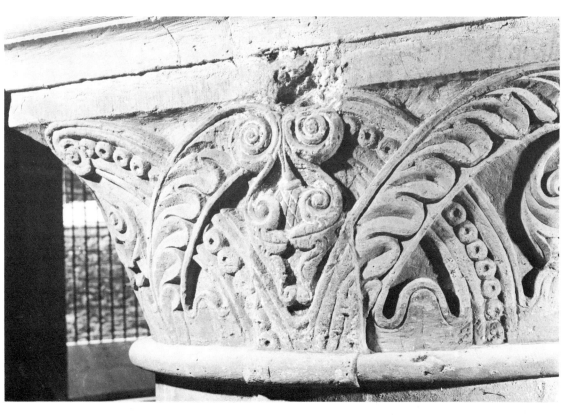

57. Hemicycle capital from crypt ambulatory at Saint-Denis, 1140–42, showing original central portion with the remainder of the design recut during the nineteenth-century restorations

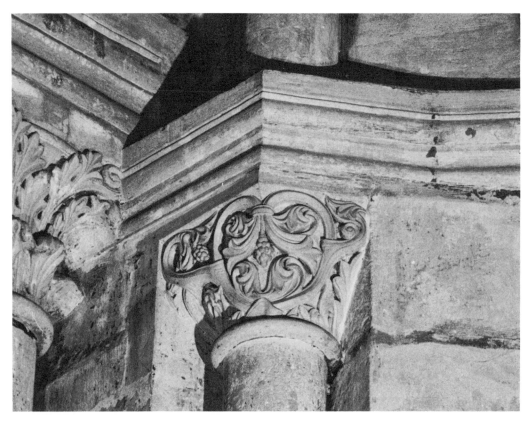

58. Capitals with palmette-pinecone motif from Saint-Denis, 1140–44. A, from choir radiating chapel; B, from crypt radiating chapel, original design recut in nineteenth century

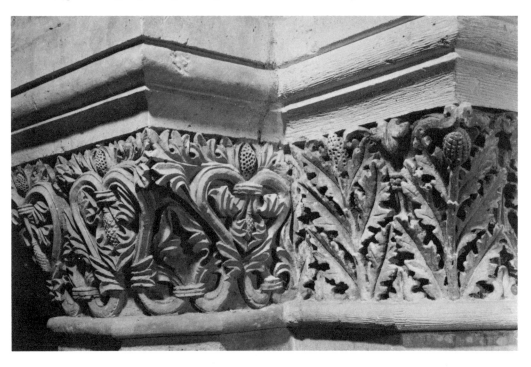

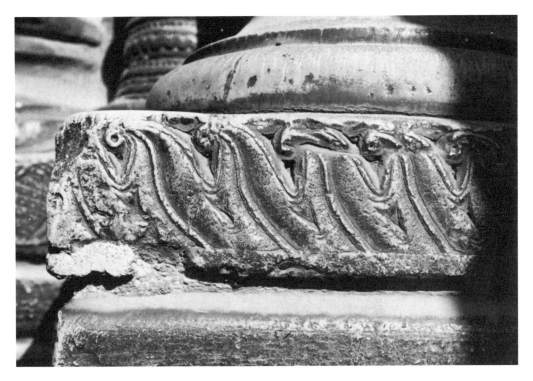

59. A, decorated plinth below base of embrasure column of the south portal of the west façade at Saint-Denis, 1137–40; B, the same

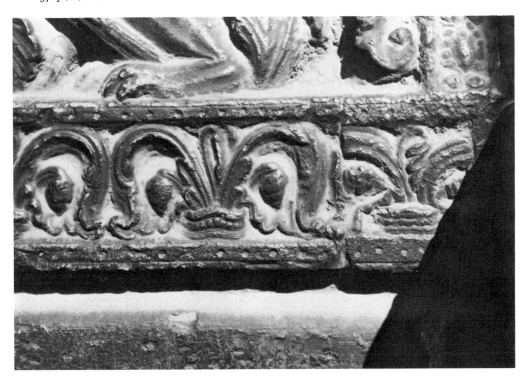

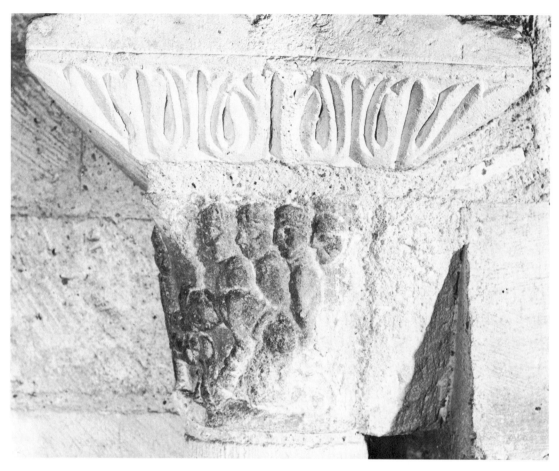

60. Capital from the crypt arcade at Saint-Denis, 1140–42, with scene of monks standing behind the Goth, Galla, on his knees before Saint Benedict

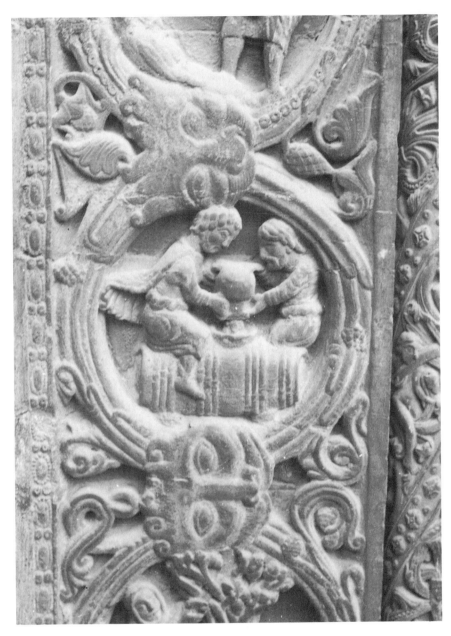

61. Medallion of the month of September from the left jamb of the right portal of the west
façade at Saint-Denis, 1137–40

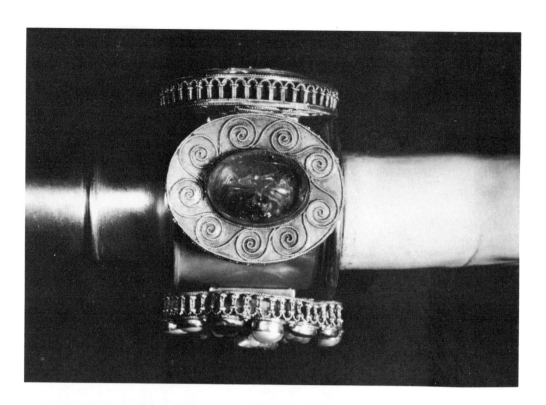

62. A, detail of band below symbolic hand of justice from Saint-Denis treasury, twelfth century. Galerie d'Apollon, Louvre Museum, Paris. B, carved ninth-century crystal gem, reused as part of decoration of the Saint-Denis altar. British Museum, London.

63. Fragment of the border of the mid-twelfth-century Moses window from the chapel of Saint-Peregrinus, Saint-Denis. The foliate axial motif, a nineteenth-century restoration, was mistakenly placed upside down.

64. Ornamental designs from a tenth-century copybook from the Loire region. Ms. Regin. Lat. 596, fol. 27ᵛ, Biblioteca Apostolica Vaticana, Vatican City.

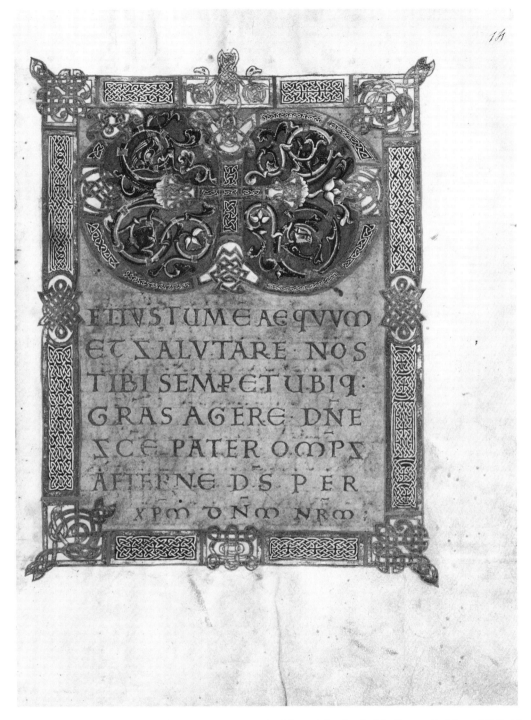

EIVSTVM E AEQVVM
ET ZALVTARE · NOS
TIBI SEMP ET VBIQ:
GRAS AGERE · DNE
ZCE PATER O·MPZ
AETENE DS PER
XPM DNM NRM:

65. Decorative initial from a mid-eleventh-century missal from Saint-Denis. Ms. Lat. 9436, fol. 14, Bibliothèque Nationale, Paris.

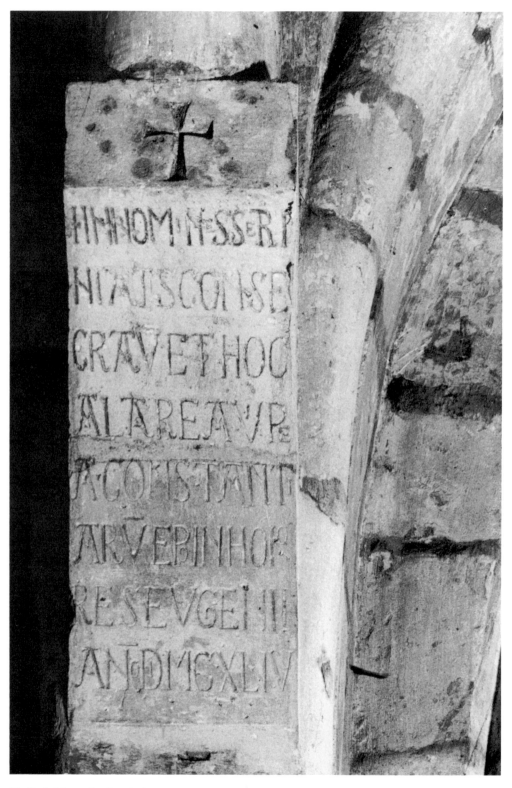

66. Corbel from the chapel of Saint Eugenius, Saint-Denis, with dedicatory inscription of June 11, 1144

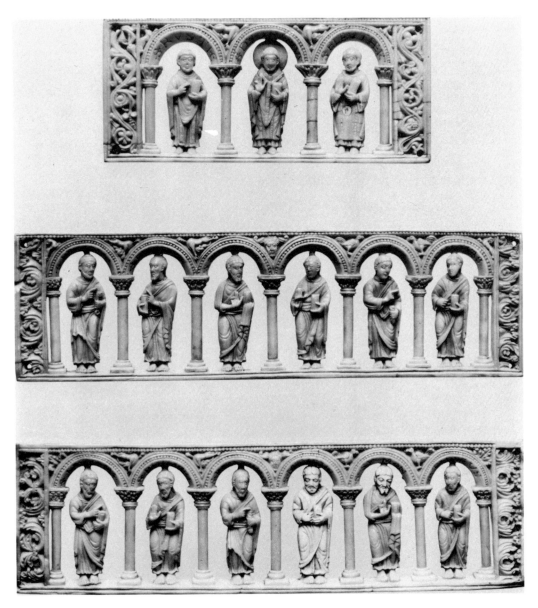

67. Ivory plaques from twelfth-century casket from Saint-Denis, with Saints Rusticus, Dionysius, Eleutherius, and the Twelve Apostles. Louvre Museum, Paris.

68. Altar of Saint-Firmin, as installed at Saint-Denis by Jules Formigé in 1958

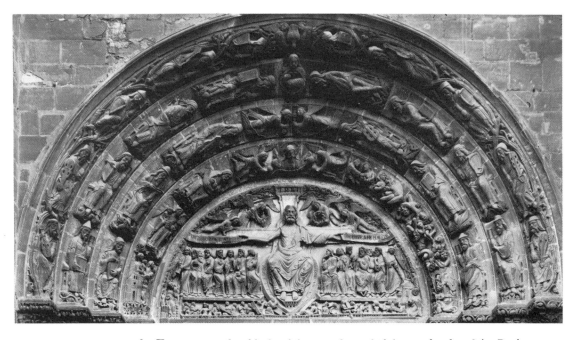

69. **T**ympanum and archivolts of the central portal of the west façade at Saint-Denis, 1137–40

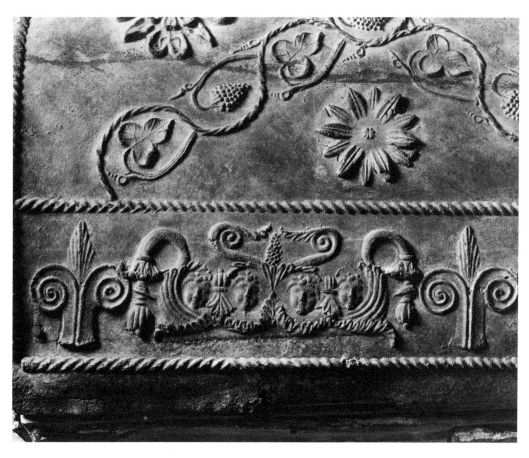

70. Detail from the cover of a Roman lead sarcophagus, second-third century A.D. Dumbarton Oaks, Washington, D.C.

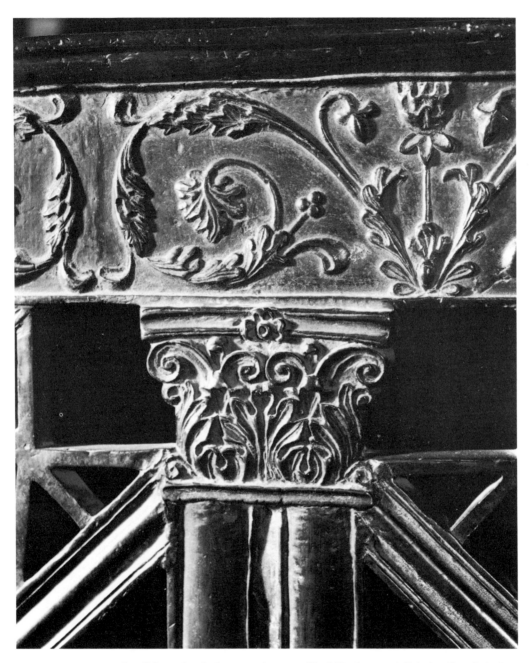

71. Detail from the ninth-century bronze grills of Charlemagne's Palatine Chapel, Aachen

72. A–C, details of decoration of colonnettes between the statue-columns of the west portals, Chartres Cathedral, 1145–55

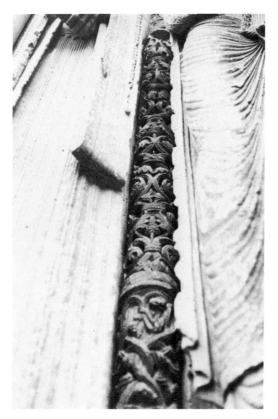

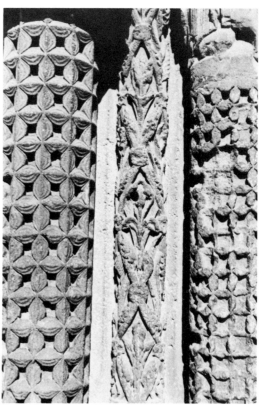

73. Top of an eleventh-century portable altar from Reichenau, Germany. The Walters Art Gallery, Baltimore.

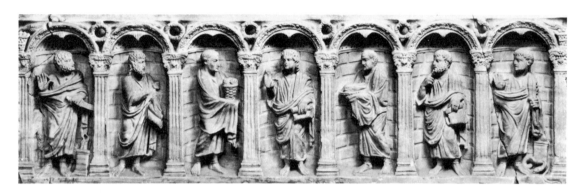

74. Marble sarcophagus, ca. 350–80. Museum of Christian Art, Arles.

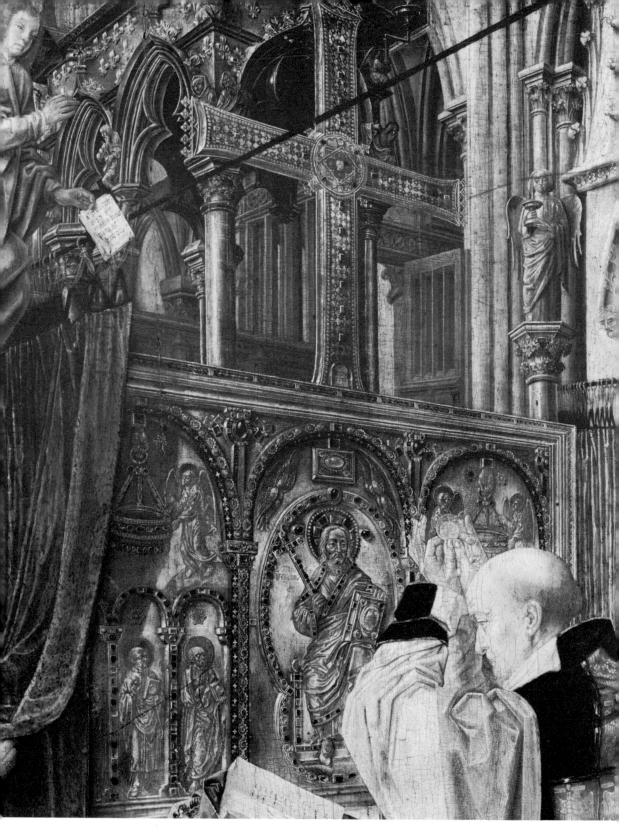

75. **Detail of** *The Mass of Saint Gilles*, **by the Master of Saint Gilles (French). National Gallery, London. It shows the high altar at Saint-Denis with the frontal of Charles the Bald, as it was in the fifteenth century.**

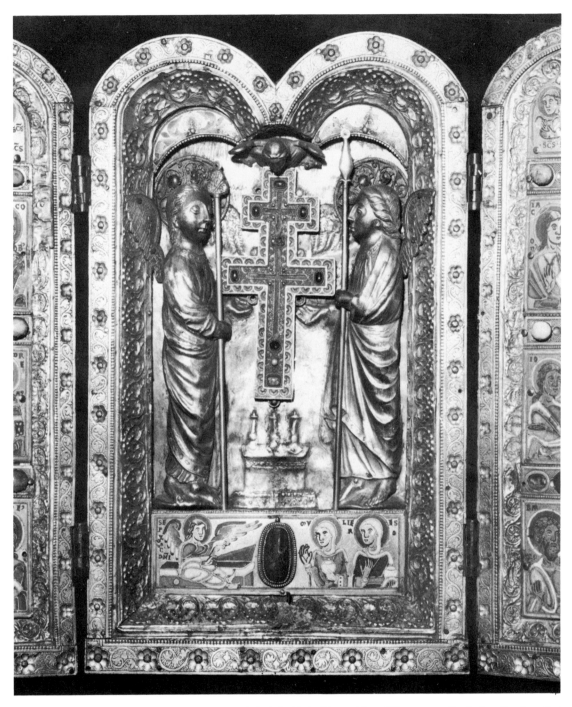

76. Detail of a triptych attributed to a follower of Godefroid de Huy, mid-twelfth century. Duthuit collection, Petit Palais, Paris.

77. Detail of the baptismal font by Renier de Huy, ca. 1110. Saint Bartholomew's, Liège.

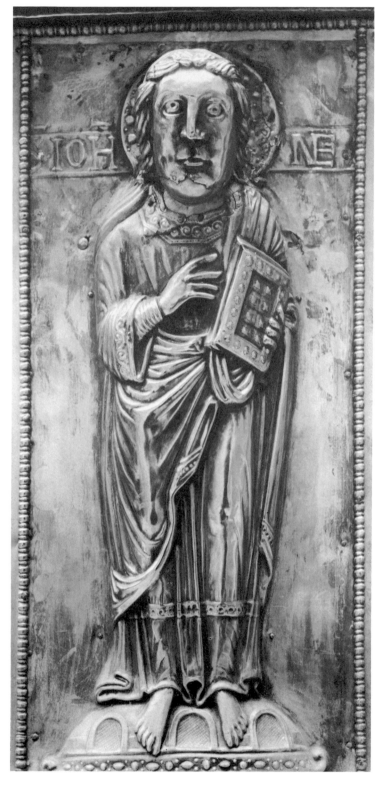

78. Saint John. Detail from the Victorschrein by Eilbertus of Cologne, ca. 1129. Saint-Victor Cathedral, Xanten.

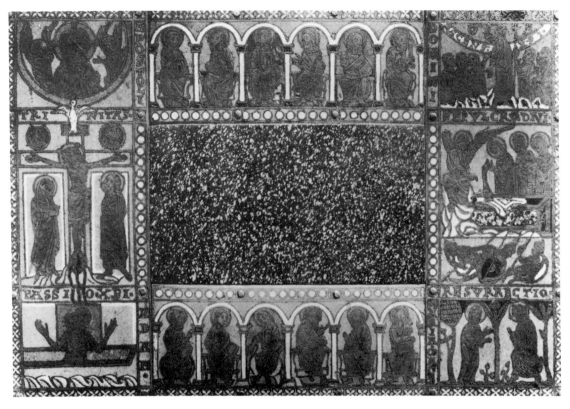

79. Top of the Mauritius portable altar by Eilbertus of Cologne, ca. 1135. Siegburg parish church.

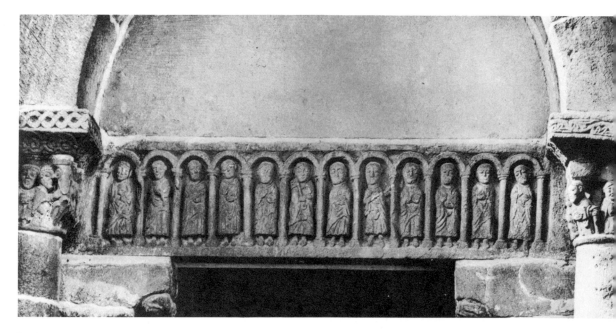

80. South portal, Châteauneuf-sur-Loire (Saône-et-Loire), showing the Twelve Apostles with Saint Peter in the center, lat[e] eleventh or early twelfth century

81. Tomb of Abbot Pierre de Saine-Fontaine, d. 1110. Church of Airvault (Deux-Sèvres).

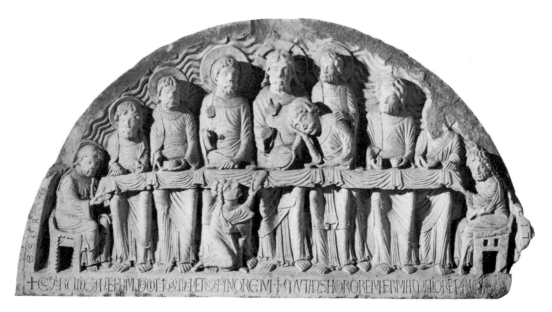

82. **Tympanum with the Last Supper from the portal of the refectory of Saint-Bénigne, Dijon, ca. 1145.**
Musée Archéologique, Dijon.

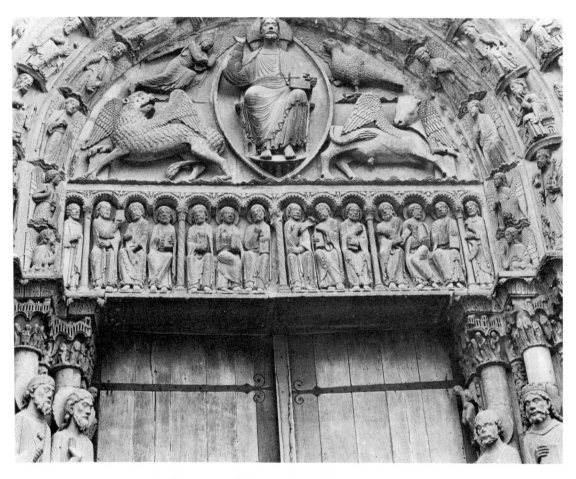

83. Tympanum of the central portal of the west façade of Chartres Cathedral, ca. 1145–55

84. Capital with scenes of the Sacrifice of Abraham, from the cloister of Saint-Médard in Soissons, mid-twelfth century. Musée Lapidaire of the former church of Saint-Léger, Soissons.

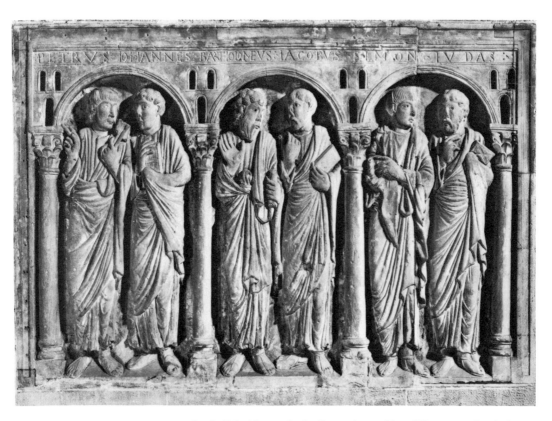

85. Relief with apostles *in disputatione,* mid-twelfth century. Basel minster.